# Praise for *CIRCL*

"This book is powerful and inspiring. Joanna van der Gra
of the artist, even without showing the artwork. I hav
reading the author's descriptions makes me want to visit the places she talks about."
**Marilou Tapp, Gibsons, British Columbia, Canada**

"*Circles* is a family memoir, and what a story it is! Gisèle van Waterschoot van der Gracht was one of the Netherlands' most intriguing, sometimes notorious, and always flamboyant, artists—and a Nazi occupation survivor. *Circles* gave me an insider's understanding of how this artist's determination allowed her to devise ways to survive despite constant surveillance. Gisèle was a free spirit whose 'circle' expands to include all who read this book."
**Marianne Kehoe, Author of *Sidewalk Symphony***

"Poignantly penned, meticulously crafted, *Circles* emotionally carries readers back to the horrors of World War II and the struggles of a great Dutch patriot and artist. Gisèle's stalwart essence, grim determination, and heroic character radiate from the pages of this family memoir. Of interest not only to historians, but to those who value integrity of spirit, this book is a must read."
**Harrington M., Merida, Yucatan, Mexico**

"The author masterfully incorporates her family's, friends', and her own memories into a delightful story of a woman who lived life to the utmost."
**Jo Proulx de Nuñez, Merida, Yucatan, Mexico**

"The pages of this book unfold easily. And when you finish, you are left with the sense of having met an exceptional woman—one who never gave up and who made the best of what was within her reach. She found happiness and joy in the people and situations surrounding her. Reading about her has indeed enlightened my life and given me a deeper understanding and appreciation of what is important."
**Kathleen Fitzgerald de Vega, Merida, Yucatan, Mexico**

"This story and its characters will stay with me. John Robert van der Gracht was able to share his emotional memories with his daughter, and these inspired this beautiful memoir."
**Frances Begley, North Vancouver, British Columbia, Canada**

"We all know someone like Gisèle. They storm into our lives, amuse us with their wit, and befuddle us. And, far too quickly, they are gone. Gisèle played that role perfectly for the author, who weaves her complex tale of love and admiration, but also with a jeweler's eye for cant, through the testimonies of her father and her father's sister, as well as Gisèle's art, and her personal conversations with Gisèle. Joanna pulls us deeper and deeper into the circles that represented Gisèle's life until we feel as if we belong in one of those circles ourselves."
**Steve Cotton, blog author, "Expatriate—In the Key of Steve,"**
**Barra de Navidad, Jalisco, Mexico**

"The author has crafted this memoir with a combination of skill and passion, and her talent for deftly portraying Gisèle's vibrant, roguish, and unconventional personality compels the reader to continue reading the story of her exceptional life. The historical background to Gisèle's story has been impeccably presented as a fascinating story of a true heroine, an artiste and an unpredictable, but always charming, woman who epitomizes all of those characteristics one attributes to a 'Grande Dame' of a bygone age."

**Marion Bale, Ontario, Canada**

"I couldn't put *Circles* down until I'd finished. I felt a personal connection with Gisèle and her circles because my own mother lost relatives during the Nazi Final Solution. My roots grow from deep below my consciousness and form questions about the conflict between the Nazis and the Jews. Because I am descended from a French Jewish grandmother and German Lutherans on my father's side, I feel so 'encircled' by this book."

**Rev. Dr. Gary W. Hartman, Merida, Yucatan, Mexico**

"Beginning with her father's painful recollections of the liberation of Amsterdam as a member of the Canadian Army at the end of WWII and his meeting Gisèle, the author is mesmerized by this incredible woman. For fifty years, Joanna has gathered information from her own relatives, friends of Gisèle and Gisèle herself. She then writes a captivating story."

**Nancy Walters, Merida, Yucatan, Mexico**

"The author's earlier book, *Magic Made in Mexico,* was instrumental in my decision to move there. Now, she offers us *Circles.* From the first pages, you feel like you are opening a family album. As you turn each page, you not only enter into the adventurous life of this free-thinking, contemporary Dutch woman, but you also enter within—within your own heart, your own humanness—to ask the only question that matters: *What is life about if not saving and celebrating your own and other lives?*"

**José Arruda, Merida, Yucatan, Mexico**

"This book really hits home for me. I first met Gisèle in the summer of 1983, when I was staying in London. I soon realized that this 72-year-old whirlwind had way more energy for life than I ever would. However, for the week that I was there, I grabbed onto her coattails and let her whirl me around her world. She never stopped looking at things with wonder, and always focused on the smaller, beautiful things. Her favourite things of course were circles. These showed up everywhere—in her art, in her house, and in her collections from nature. Joanna van der Gracht-de Rosado has captured Gisèle's spirit for all to experience."

**Craig Stout, Kamloops, British Columbia, Canada**

"*Circles* offers riveting accounts of experiences during the Nazi occupation of the Netherlands. It paints a compelling portrait of an independent female artist caught in harm's way and how she weathers the horrors of World War II and its wake. After reading *Circles,* Gisèle's Herengracht 401 apartment should become a mecca."

**Linda Lindholm, author of *Widow's Key*, Merida, Yucatan, Mexico**

"The author shares the extraordinary story of her aunt Gisèle, whose century-long life as an artist and writer is told through the memories of her family. Here is an up close and personal look at a woman who experienced the fear, want, and loss that comes with war and yet continued on. By putting one foot in front of the other, Gisèle makes a path to a full and beautiful life."

**Melissa Adler, Merida, Yucatan, Mexico**

"This is a moving story of a fascinating woman. The Canadian author presents Gisèle's life as remembered through letters, family journals, family, and friends. The second half of the book details Gisèle's post-war life as an artist, promoter of culture, her interactions with her circle of friends and finally, the author's personal story of Gisèle. An easy read about a fascinating woman living in interesting times."

**Ross Russell, Merida, Yucatan, Mexico**

"Perhaps unlike any such book I've ever read. The author manages to recreate conversations, events, and scenes in an almost novelistic fashion. Though the dialog cannot be transcripts of actual conversations, it's written with respect for the facts and a fluidity that gives *Circles* the feeling of a fast-paced novel. *Circles* is eminently readable and enjoyable.

**Kim G., blog author, "Gringo Suelto," Boston, Mass., U.S.**

"The author weaves family memories, art, world history, World War II, the Nazi occupation of the Netherlands, and insights about survival, resourcefulness, relationships, friendships, and love into a rich and complex tapestry. This is a fine tribute to a one-of-a-kind woman."

**Benjamin Ramirez Cervantes, Merida, Yucatan, Mexico**

"*Circles* follows the ripple effects of how one family is affected for generations by Gisèle's courage, determination, and tenacious hold on life for herself and those around her. The story is more than well researched—its words jump from the page and envelope the reader with the realities of risk and resilience."

**Lorraine Baillie Bowie, Author of *Win at Love*, Merida, Yucatan, Mexico**

"*Circles* inspires us to take risks and to live on our own terms. There are enough compelling stories in this biography to inspire several books. This fascinating family memoir inspires us to take risks and to live on our own terms."

**Marc Olson, blog author, "An Alaskan in Yucatan," Merida, Yucatan, Mexico**

"I loved this book! The story is engaging, pulling you into the lives of the characters. Although the characters were real people, the book reads like a novel. I enjoyed all the historical details and learned a lot, which is what I love to take away from stories set in different historical contexts. This book touched my heart more than once."

**Martine Rheaume, Merida, Yucatan, Mexico**

# DEDICATIONS

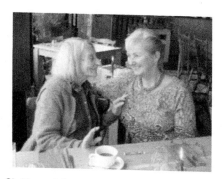

Gisèle and Joanna, the Netherlands 2009

*This book is dedicated to my aunt:*
*Gisèle van Waterschoot van der Gracht*
*She created Circles—*
*Circles of family, of friends, of art.*
*She took small things and made them big.*

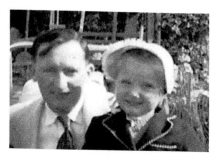

John and Joanna, Canada 1956

*And it honors the memory of my father:*
*John Robert van der Gracht*
*He loved his family*
*and his country.*
*I wish we'd all had more time with him.*

# CIRCLES

## A FAMILY MEMOIR

HAMACA
PRESS

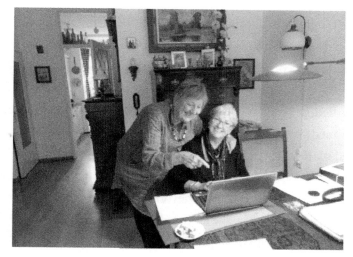

Hanneke and Joanna, the Netherlands, 2014

# FOREWORD

### By Hanneke Siewe-Corbet

When Joanna van der Gracht de Rosado, my friend of forty-plus years, asked me to read her manuscript, I soon understood that *Circles* was more than reminiscence about the life of her Dutch aunt. Secreted into the pages, I recognized my own story and the universal experience of everyone who lived through World War II.

The Nazi occupation of the Netherlands profoundly impacted my childhood and later, I wondered how people—who lived far away from the fighting—could possibly understand what we endured during that time. Now, through the recollections of Joanna's Dutch-Canadian father, I can see how the war affected his family and that it continues to do so even after all these years.

*Circles* brought back many memories and challenged me to reconsider my long-held assumptions.

Gisèle risked everything to feed and protect her Jewish friends. Until the end

of the war, she hid them in her tiny apartment on the Herengracht, one of the main canals in Amsterdam. Had they been found, they all would have been killed. Such trauma is hard to overcome, but Gisèle did not allow danger and privation to stifle her independent and courageous spirit. She went on to achieve artistic excellence and until she died, at one hundred years of age, her curiosity and whimsical view of life never waned.

She moved in the elite circles of not only the art world, but those of nobility and political fame. However, she felt equally comfortable in the company of students and everyday people. Her unwavering devotion to her friends did not depend on their economic or social status—she admired talent, warmth and intelligence—and always looked for heart. Unfortunately, throughout her long life manipulative people did take advantage of her generosity, but she shrugged off the setbacks and moved on.

Joanna wrote to Gisèle in 2009 requesting permission to write her story. Her aunt's letter of authorization arrived and six years of research ensued in the Netherlands, Canada and online.

In 2014, to corroborate the details Joanna has included in her book, she and I met in Bussum, my Dutch birthplace. I found myself intrigued by the colorful tales about this unusual, talented, generous woman for whom I developed great respect.

Indeed, *Circles* is inspiring on many levels and reviewing Joanna's story has gifted me with a better understanding and empathy for everyone who lived during the years of World War II.

# AUTHOR'S PREFACE

Circles celebrates the century-long life of my aunt, Gisèle van Waterschoot van der Gracht.

Passion for art, lust for life, and uncommon courage are but three of the traits that made her as unique as a fingerprint. Although she passed away in 2013, her circles of family, friends, and artists from all over the world remain steadfastly loyal to her memory.

I first heard about Gisèle from her first cousin, my father John. The two maintained correspondence until he died in 1982, at which point my sister and I picked up the thread.

Although I intended to write a straightforward biography, the emotion that Gisèle's story evokes compelled me to recreate the real-time voices and conversations of those who shared their insights with me. In doing so, I found myself compiling a four-part family memoir.

▶▶ Part I begins with the arrival of a letter addressed to my father. The contents trigger his poignant memories of World War II and particularly those of meeting Gisèle during the liberation of Amsterdam.

▶▶ Part II describes what John's sister, Missy, discovered about Gisèle in the yellowing pages of a family journal.

▶▶ Part III centers around Gisèle's art and her international lifestyle. The fine points of this narrative come from the friends she considered to be the family she chose.

▶▶ Part IV details my personal time with Gisèle during the last decade of her life. She lived one hundred years, but really, she never grew old.

Her story challenges us to live a productive, honorable life, and to be respectful of cultural, religious and political diversity.

—JvdGdR

# PART I

# JOHN'S STORY

Private John Robert van der Gracht,
19 years old, 1939

# CHAPTER ONE

# The Mystery

*North Vancouver, Canada: December 1962*

The postman's whistle shrilled and an avalanche of Christmas cards tumbled through the mail slot. They skidded along the freshly waxed floor, and I crouched down to stop them before they reached the stairway. When I stood up again, there must have been thirty white envelopes fanned out around my feet. Half buried in the pile, I spied a delft-blue one. It looked like a patch of sky peeking through a cloud bank.

I gathered all the seasonal greetings into my arms and put them into a wicker basket by the mantle—except the lone blue one. After holding it for a moment, I let my fingers trace over the Dutch stamps. I could tell that more than a card lay hiding inside. I wanted to pry open the back flap and see for myself, but I had to ask my father first. After all, his name, not mine, was written above our home address.

Vera Lynn's classic wartime ballad, "The White Cliffs of Dover," played softly on the hi-fi, and I followed the sound straight to the den. Through the doorway, I saw Dad working at his desk. He must have sensed me watching him because his head popped up. I blew him a kiss and his eyebrows lifted.

"Well, this is an unexpected treat," he said. "What brings you here?"

I zigzagged across the braided rug trying not to tread on any of the bills, subscription forms, or ledgers he'd left strewn about. When I got close enough, I showed him the mysterious piece of mail. I felt a twinge of loss when his hand plucked it from mine.

My father examined the Dutch envelope under his reading lamp. The crease between his eyes deepened. I wanted him to tell me who'd sent the card, but he didn't seem to remember that I was in the room. I leaned over and touched his arm. "Can we open it now?" I asked.

No response. He switched off the light, stopped the music and carried the envelope away. Without glancing towards me, he crossed through the living room and slipped into his bedroom. I heard the lock engage.

What a relief to see my mother moving towards me. "Have you seen your father?" she asked. "I want to know if he's ready for supper."

When I told her where Dad had gone, she shook her head and called to him through the closed door. We waited, but he didn't respond, so she took my hand and led me to the dining room. The smells coming from the covered dishes on the

sideboard promised a delicious meal.

"Help me serve," Mom said. "I've made meatloaf, the way you kids like it, with bacon strips along the top, and there's apple crisp for dessert."

I heard the TV switch off and scurrying slippers on the stairs. My brothers and sisters rushed to the table like a litter of hungry puppies. They pulled out their chairs and settled into their places—girls on one side, boys on the other. "Should we wait for Dad?" one of them asked.

My mother's eyes turned towards the bedroom door—still shut. She began passing plates. "Your father is resting," she said, "but I'm sure he'll be along soon."

Halfway through the meal, Daddy joined us, but he didn't smile and joke like usual. He took his place at the head of the table and pushed his food around the plate. I wondered if he had a headache because he kept rubbing his forehead.

When they were done, the younger kids looked to Mom for a clue about what to do next.

"If you've finished your meal, off you go," she said and they sprang away like rabbits released from a cage.

But I lagged behind. I could see a rectangular outline through my father's white shirt pocket. I felt unnerved by his reluctance to open the mysterious piece of mail.

Mom placed her hand on top of his. "John, she's nine now. I think our daughter is old enough to hear the story, don't you?" Watching my father's face for any sign of contradiction, she reached over and took the still-sealed envelope away from him.

She wiped the butter knife on her serviette and used the blade to cut a neat slit through the folded top. From inside, she pulled out a card embossed with a picture of an old-fashioned Dutch street scene and a single sheet of writing paper. Her eyes scanned the page, and then she placed both items down in front of Dad.

"From Gisèle," she said, "and Wolfgang."

When my father didn't move towards either one, I had to sit on my hands so I wouldn't grab them. I wondered why hearing from this Gisèle person had upset him so much.

What's more, I could see the shape of something else still lying inside the envelope. I pointed to the dark shadow, and Mom urged Dad to take a look. He pulled the gap wider, peered inside, and his body involuntarily jerked backwards. He closed

his eyes for a moment and slowly tipped the open side towards me.

I saw ashes in there, and I'm sure my face must have gone as grey as the burnt whatever-it-was. I felt desperate for an explanation.

Dad's hands trembled as he tried to light an unfiltered Players. Mom took the cigarette from him, got the smelly thing burning, and placed it between his fingers. He brought it to his lips and inhaled deeply.

For once, I didn't make a face when the smoke blew my way. Just as I'd done an hour earlier, I begged for more information. He lifted me onto his lap and neither the acrid cloud nor his scratchy wool sweater would dislodge me from my place. I felt that if I didn't anchor him down, his distress might lift him up and carry him away, just like one of Peter Pan's lost boys.

After taking a few more drags, Dad ground the butt into his ashtray and looked at me. "She lives in Amsterdam," he said. "Her name is Gisèle."

"Why would she send a card with soot inside?" I asked.

My father's eyes swung away from me and he stared at the watercolor Granddad had painted of Emperor penguins he'd seen in Antarctica. I knew Dad liked how the marble-topped buffet placed underneath the painting reflected the stark scene.

Still looking at the painting, he responded to my probing with a question of his own. "Do you know that I fought with the Canadian Army during World War II?"

I nodded my head. I'd heard about this for the first time a couple of years before on Halloween night. As we arrived back at our house after trick-or-treating, the neighbors had set off a string of firecrackers. The unexpected banging and flashing made my father dive to the ground and claw the lawn with his hands. I didn't know what to do, but Mom rushed to his side and pulled him to his feet.

"John! It'll be all right. It'll be all right," she repeated over and over. Then she reminded him that World War II had ended fifteen years ago.

"Daddy suffers from shell shock," she told me later that night. "Sudden enemy fire killed many of the soldiers in his battalion. He and the others who survived learned to dive fast."

I'd never heard of shell shock before, but I understood that Daddy wouldn't ever get over his fear. Mom told me that I needed to be patient with him.

I watched my father take a sip from his water glass. It seemed that getting him

to talk would be like pedaling my heavy bike up North Vancouver's steep 29th Street hill. But I kept quiet and eventually he calmed down enough to begin his story.

"On May 5th, 1945, our division pitched camp west of Amsterdam." He reached for his glass and swallowed more water. "God, it felt good to clean up! We showered, shaved, washed our shirts and polished our boots. Then we stripped and cleaned our rifles. We had never stayed in one spot for long, and we felt anxious to receive our next orders. Finally at ten o'clock on the morning of May 8th word came down—in four hours we'd be crossing the Berlage Bridge and entering into the city."

His eyes got glassy and he tried to smile. Mom nodded and touched his arm.

"At the bridge we saw a huge crowd gathered on the banks of the Amstel River. Over the previous three days, other Allied battalions had entered the city. But those Dutch welcomed us as though we were the first wave of liberators. Their cheering sounded louder than the canon fire we were used to. It was overwhelming. I felt disoriented, but proud of my Canadian uniform and grateful to be alive."

Dad cocked his head. "The war had ended and I had made it. Sunlight shone down and women clambered up onto our convoy of trucks. They kissed us right on the mouth, and shy skinny kids giggled as they pressed flowers into our hands. I could spot only a few men in the crowd. They stood to one side, waving their caps and homemade Dutch flags. Tears shone on their gaunt cheeks. The Nazi occupation was over. For the first time since 1942, Amsterdam's people in hiding—known as *onderduikers*—could move about outdoors, make noise, and show themselves in public. Freedom flowed through the canals like electricity. Even though no one knew how or when normal life would resume, the practical Dutch had already begun clearing the debris from their stoops and streets."

"Daddy's family comes from the Netherlands," Mom reminded me.

I asked her if Gisèle and Wolfgang are relatives.

"Gisèle is, and when your Dad met her, he hoped that she would resolve some of his unanswered questions about his Dutch heritage."

"She sure as hell did that," Dad said. "But she posed new ones, too. The ashes you saw in the envelope are a reminder of our time together in Amsterdam. As if I could ever forget."

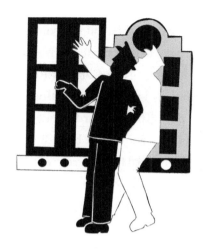

# CHAPTER TWO

# Liberation

*Amsterdam, The Netherlands: May 1945*

Dad eased me off his lap so we could follow Mom into the living room. He undid the top two buttons of his shirt, and then found a comfortable position on the couch. I sat down next to him and waited to hear the rest of his story about meeting Gisèle.

He explained that his division of the Corps of Royal Canadian Engineers had been in Amsterdam for a couple of weeks, and finally on May 20, he and his buddy Harry both received a day pass. They'd heard about the victory parties, and they wanted to join in as soon as they got off the base. But Dad figured he should first visit his relative, who supposedly lived in the center of town. Harry agreed to go with him and get the social call over with. Then they would hit the bars.

"After trudging past crumbling walls and shattered windows, we finally found the address we were looking for—Herengracht 401. From a distance, the house looked intact," my father said, "but once we got closer, we could see the cracks in the steps and chunks of missing brick. Decay leached out from the banks of the canal."

Dad told me the building was four stories high, but narrow. During damage-assessment missions, he'd been inside similar canal houses, and he knew that usually only one apartment or office fit on each floor. He figured the place had been handsome once—and maybe it would be again—but that particular morning, he and Harry felt uncomfortable being there.

I felt likewise imagining my forty-two-year-old father as a young soldier standing on the stoop of a derelict house.

He said he craned his neck upwards and saw a woman watching them from the third-floor window. She probably figured they'd been celebrating all night. Dad waved and she signaled for them to wait where they were.

She obviously recognized their Canadian uniforms because once she wrestled open the heavy door, she welcomed the two as her liberators. For sure she felt thrown off balance when the young man with embarrassed blue eyes and a lopsided smile bowed and faced her.

"Good morning. My father is Joseph van Waterschoot van der Gracht, and I am John. If you are Gisèle, we are first cousins."

The woman took a step back and appraised this unexpected visitor. *Family? A*

*relative in the Canadian Army,* she must have wondered.

Dad said she looked astonished, but not for a second did she seem to doubt his claim. She gave him and Harry a broad smile. "Come upstairs," she said.

The climb was steep and on the third-floor landing, a door stood ajar. She pushed it open further so the two soldiers could follow her inside.

"We took off our caps and entered the dimly lit apartment. Once our eyes adjusted, we saw that the woman had eased over to the corner of the main room. She stood behind three men."

Dad told me he would forever remember every detail of that scene. "It looked like the four of them would blow over in even a light wind. Their eyes seemed too bright and I could see a blue vein pulsing under the oldest man's temple. The clothes they wore hung off their shoulders, and I wondered when they'd last had soap and water for a bath."

The woman spread her arms wide. "I am indeed Gisèle, and I want you to meet my friends, Wolfgang Frommel, Buri Wongtschowski, and Claus Bock."

The trio struggled up from their chairs to shake the soldiers' hands. The one called Wolfgang prodded the two younger men into pushing a couple of battered chairs towards their guests.

Dad and Harry sat down, but they couldn't stop their eyes from jumping around the room. They felt sure the men must be *onderduikers*—people in hiding from the Nazis. It seemed like the cousin had been their protector during the occupation and from the looks of them, it had been rough.

Gisèle's place looked out over the Herengracht, the gentleman's canal, an impressive address. Yet the furnishings and appointments appeared as bleak as the emaciated bodies of their new acquaintances.

The man Gisèle introduced as Wolfgang said he was a professor. He tried to make conversation, but the other two were wary of speaking with the Canadian soldiers.

My father said that Gisèle tried to relieve the tension. "If you are my cousin," she said, "then we have stories to share. What could be better?"

She stitched together a few facts about her and Dad's respective fathers and divulged details that he had been too young to remember. "In another lifetime," she

said, "I briefly met your family in California."

My dad had no memory of Gisèle, but he recalled the time his older brother Lewis talked about her. "Gisèle must have been nine because I was only five or so," Lewis had said. "I suppose we'd been sent to play out in the front yard so that the adults could talk. She teased me and threatened to throw me into the irrigation ditch that ran beside the road."

When my father recounted his brother's story, Gisèle put her hands over her eyes and shook her head. "Is that the only memory your brother has of me?" she asked. She seemed mortified by her childish misbehavior.

Dad chuckled. "You were just kids. Actually, Lewis said he liked being held in your arms. He didn't care that you dangled him over the ditch."

Gisèle clapped her hands together and laughed, a full, robust sound, surprising to hear coming from such a frail body.

My dad said Gisèle's eyes held him immobilized until she lowered her gaze and broke her intense scrutiny. "Actually, you look like Uncle Jan," she said. "He was the middle brother, younger than my father and older than yours."

My father's friend, Harry, couldn't stop himself. "It's been hell, hasn't it? Do you have any food?"

Gisèle shook her head back and forth. "Not much," she replied.

Dad said he coughed to disguise the catch in his throat. He wanted to get out of there and find help. He stood up. "I'm glad we came and that I've met you," he told her. "But Harry and I have to get back to the base; we'll come again as soon as we can."

Harry followed my father's lead and got up to leave. Gisèle moved closer to say goodbye. "John, you're welcome here anytime," she said. "I want to hear all about my family in Canada."

*Will he bring us some food?* she no doubt wondered. Everyone said the Canadian soldiers were generous, but whether he or someone else provided their next meal, she knew their deprivation would soon end.

But would they be able to erase the pain of the Nazi occupation? She wanted her cousin to come back. With him around, maybe she could dull the ache.

Once the Canadians burst out into the fresh air, they scrambled along the broken

cobblestones bordering the canal. When they felt sure the people they'd just met could no longer see them, Harry spoke feverishly about the skeletal bodies and the condition of their surroundings. "None of them can weigh more than eighty pounds," he said.

Dad thought his fellow soldier's calculation might be a bit high. "I could have counted every rib through their ragged sweaters," he said.

My father and Harry had lost their desire to find a party and returned to the base. Of one mind, they entered the larder and stared at the stacks of canned stew, dried mutton, candles and kerosene.

"You know we'll catch bloody hell if we take anything," Harry warned John.

Dad shrugged, hauled a couple of refuse bins out from behind the makeshift sinks and began filling them with supplies. Harry shook his head with resignation and pitched in to help.

*After meeting Gisèle and her friends, what else can we do?* Dad asked himself.

The two hoisted the loads onto their shoulders. At the compound's gate, they greeted the hung-over sentinel. "We forgot to toss the garbage yesterday. Be a chum and let us through," Harry said.

Their fellow serviceman couldn't have cared less. His thoughts were on the girl he met at the dance he'd been to the night before. Barely glancing at the two privates, he waved his arm, "G'wan, get it out-a-here!" he said.

At the dump site, they transferred the provisions into their army-issue duffel bags, stuffed the bins behind a pile of rubble, and hurried back to Herengracht 401.

For the second time that day, Gisèle heard a voice calling to her from three floors below. The soldiers had returned!

"Come down and open the door," Dad said. "We've got something for you."

My father had enlisted in the army in 1939, right at the start of the European conflict. He was only nineteen years old. The senior officers tried to place the youngest soldiers in the food prep tent, the safest spot. Once the recruits gained experience, they got moved into infantry positions. But Dad had a talent for cooking and the whole battalion came to appreciate his skill so much that he worked in the kitchen for much of the war.

He had prepared meals under every imaginable condition, with enemy fire overhead, outside in the rain with no cover for the top of his portable stove, and in muddy fields at midnight after an eighteen-hour march.

But that evening, Daddy said he cooked for Gisèle "with reverence and with speed." He wished he had a different meat—mutton made him gag. He felt relieved that the onions, potatoes and turnips disguised the smell. Harry had slipped in some salt and dried peas. The rye loaves had gone stale, but the four people didn't notice. No longer accustomed to proper meals, they gulped fast and crammed in the next mouthful before the previous one had been properly swallowed.

Once every crumb had been consumed, my father and his friend said they had to leave. Their day passes would soon expire. Waving from the stoop, they promised to return just as soon as they could.

Gisèle rushed down the stairs. She wrapped her arms around Dad and Harry and her satisfied smile said it all. My father looked at his buddy, and he nodded affirmatively. To have brought food to these people had been the right thing. The two soldiers would accept whatever punishment the army decided to hand down for theft of government provisions.

Dad knew he wouldn't get permission to leave his post until the pilfering got sorted out, but he figured the supplies he and Harry delivered should be enough to hold the group over until he could take them more. The four people in the apartment at Herengracht 401 tried to cover up the extent of their desperation, but he knew if they didn't continue to get nourishment, their situation would grow even more dire. They had sores, racking coughs, and the sallow complexions he associated with scurvy.

The Dutch famine of 1944-45, known as the *Hongerwinter*, had already claimed thousands of lives. My father vowed that his cousin and her friends would not meet that fate.

He felt sure that Gisèle's clothing must have fit her at one time, but now, her serge dress hung in folds. She had cinched it at her waist with a piece of cord and over the top she wore a ratty cardigan. Again, it looked big enough to cover two women her size. Her socks had lost all their shape and drooped around her ankles. Her shoes looked like they would not hold together another week.

Buri, Claus and Wolfgang wore two shirts under pilled sweaters. Even though

spring had arrived, Dad could tell they felt cold. During his time in the apartment, they never removed any of their clothing.

"Do you think they sleep with all those clothes on?" Dad asked Harry.

"Probably," he answered. "It's hard to stay warm when you don't get enough food to keep your blood circulating."

The two soldiers received a summons to headquarters on May 30 and an angry officer asked them to explain the disappearance of the food. With heads held high, they gave an accounting of what had happened at Herengracht 401. They took full responsibility.

After hearing about all Gisèle had endured, the captain stood and walked over to his two enlisted men. He knew my father and Harry as honorable soldiers and understood how the scene at the apartment must have dismayed them. Dad said his commanding officer clapped him on the shoulder and smiled at Harry. He then turned back to his desk and tore up the papers piled there.

"My report will state that a marauding band robbed the dispensary twice," said the commander.

Dad said he and Harry were confused. "We just took one pack each, Sir," they corrected, "not two."

"Yes, but now I want you to take another. Load as much as you can fit into your rucksacks and go back to John's cousin's house." The captain held his arms out wide. "Give her everything as a small token of admiration from the Canadian forces."

As Harry and Dad were leaving the base with their bulging bags, another officer called my father back. "Take this too," he said as he stuffed two bottles of Canadian Club and a fistful of fat cigars into the pockets of Daddy's greatcoat. "I'm sure your cousin and her friends will appreciate some good booze and a smoke." He also gave my father two signed passes and added, "Don't worry about coming back until tomorrow."

"John, seems like the whole officers' mess knows about your cousin," Harry said. "I'm glad to be going back there with you."

When Dad and Harry arrived at Gisèle's home, she danced in circles. "Everyone on your feet! Help get all this upstairs. John, you've brought a whole shopful of supplies."

Blankets, detergent, bleach, rope, candles, kerosene, a couple of knives, bath

soap, tooth powder, a cut of fresh beef, milk, butter, eggs, cheese, ham, and dried mutton were unloaded. There wasn't another thing that Gisèle could have hoped for.

"This is so much. We'll share it with our neighbors. All through the occupation, they helped me find food for my friends."

Dad showed her the bottles of rye whiskey and the cigars. "Yes, invite your friends over. We'll celebrate!"

The Dutch had been starved and separated from their loved ones. The Nazi system of rule by terror went under the cover name of *Nacht und Nebel*—"Night and Fog." The secret police were empowered to seize anyone deemed a danger to the Third Reich's security.

Almost every citizen, young and old, had seen corpses in the streets. They had no idea how to shed their fear and pain or if they could even afford to.

Gisèle had largely forgotten how to be carefree. During the long war years, she had to suppress her sense of fun. If she wanted to survive she had to be focused— careful all the time—and the behavior had become part of her. The idea of frivolity threw her into a panic.

My father said he hugged her close. "But this is what you need," he said. "It's what we all need."

Once the second generous belt of rye entered the systems of the Herengracht 401 residents, their stoicism moved a measure away.

"We are all lucky to be alive tonight," Wolfgang said. He looked at Dad and pointed towards the shutters. "Last winter Gisèle made us take down all but three, and we burned them to cut the frost on the coldest nights. We piled our furniture in front of the open gaps, but that did no good. The wind snaked around the stack and it felt like an icebox in here. As for the poor tree outside, I wonder if it will ever grow new branches. We had to cut off so many to use as fuel."

Gisèle seemed lost in thought. "I cried every time we had to further butcher that beautiful living thing."

Wolfgang Frommel puffed contentedly. "I haven't smoked in so long. I will be grateful for this cigar until the end of my days."

*And that's when I understood. The ashes in the delft-blue envelope were from a cigar. Indeed Wolfgang never forgot.*

A thin teenager hummed an Amsterdam lament. Dad looked at his buddy, and they both leaped to their feet. They changed the tempo and sang some Allied soldiers' bar songs—"The Last Time I Saw Paris," "When the Lights Go On Again All Over the World," "Roll Out the Barrel," "In the Fuhrer's Face," and "G.I. Jive." No one else in the room knew the words, but they clapped and rocked their bodies from side to side.

"That's more like it," Harry said to Dad.

My father served a beef and barley stew to his new friends with the voracious appetites, and among them, every drop of whiskey disappeared. He said that once they had eaten their fill, the mood turned mellow, and it pleased him when Gisèle plunked down beside him on the sofa.

She moved close and looped her arm through his. "You probably know my family calls me Gisy. If you like, you can too." She sighed and patted her full stomach. "Thank you for this John."

"Gisy, is it true that you're an Austrian baroness?" he asked.

She laughed. "No, I'm not, but my mother Josephine is titled. Her father was Baron Hammer-Purgstall, and her mother was Gräfin Vetter von der Lilie. The Baron belonged to the Austrian diplomatic service and in the latter part of the 1800s, when the Emperor appointed him ambassador to the Netherlands, he moved with his family to The Hague. My mother and my father's sister, Mies, were schoolmates."

"So Aunt Mies introduced your parents to one another," Dad confirmed. "And you know my father, Joseph, don't you?"

Gisèle nodded and a lock of hair fell over one eye. "Of course. We called him Uncle Joop. He and my father, your Uncle Willem, both trained as geologists."

She pushed her hair back behind her ear. "I was just two when my dad accepted a position with Royal Dutch Shell in the United States of America, and he asked your father to join him. Uncle Joop met your mother in San Francisco and, unfortunately, she rather separated the two brothers."

"So I've heard, and I'm sorry she did that," Dad told Gisèle. "Mother was a suffragette. She takes pride in being seen as modern. Before her marriage, she warned my father that she would not tolerate a lot of travelling."

Gisèle interrupted her cousin. "My father said she couldn't pronounce our double-barreled name and insisted that the first half be lopped off."

"Yes, that's why I am a 'van der Gracht' and not a 'van Waterschoot van der Gracht' like you." Dad must have felt uncomfortable talking critically about his mother. He shook out a cigarette from his pack and offered it to Gisèle. She nodded and he lit one for each of them. He struggled to explain my grandmother's unpopular decision.

"Mom saw that while the two brothers searched for new oil finds in the remote corners of America, your mother had to make do on her own. Mine refused to accept that. Nonetheless I know Dad regrets that his adventures came to an end."

"You don't have to justify what she did or didn't do. Actually, I would like to meet her—I bet we're quite alike," Gisèle said. She looked down at her feet. "We all do what we have to do."

Dad knew that his cousin's last statement did not apply only to his mother. The alcohol had freed their tongues and pried loose personal secrets. He confessed how scared he'd been. Shaking his head, he said that some days he prayed to be wounded, just enough so that he'd get sent home to Canada. The noise of combat terrified him, and the meals he dished out rarely satisfied the hungry men of his division. He couldn't bear the misery he saw every day.

Gisèle looked into John's eyes. She told him about her own fear. To help the friends hiding in her house, she lived a covert life. Had it not been wartime, a young single woman cohabitating with three men would be questioned. Her eyes flashed a warning. She would make no apologies for her unconventional living arrangements.

Attempting to soothe her, Dad took her hand. "Like you said, we all do what we have to do." He made no judgments.

Gisèle pulled her hand away and crossed her arms over her chest. "I'm no saint—don't make the mistake of putting me on a pedestal." She looked angry. She'd not divulged this much of herself for so long, and once the words had been spoken, she immediately regretted them.

"This whiskey of yours has me blurting out more than I should," she said.

But Dad could not be shocked. He'd spent six years on the European front. In that time he'd met few people who'd been able to hang on to pre-war conventions. He took Gisèle's hand again and told her that she'd been brave and pragmatic. "If you hadn't been, I'd never have met you."

From the little Gisèle revealed, my father concluded that her particular situation had been even more perilous than most. Had it not been for her resourcefulness and obviously her valor, the group at Herengracht 401 would not have survived.

The explanation of the mysterious letter's origin and the story about the visit with Gisèle had exhausted my father. He slumped back and closed his eyes. His body seemed drained of all energy. He refused to share anything else.

I wanted to know more—much more—about Gisèle. I didn't understand everything my father had talked about and I wanted him to clear up my doubts. But my mother's eyes warned me to hold off. The way she arched her neck reminded me of a trumpeter swan protecting her wounded mate.

CHAPTER THREE

# Harry's Epilogue

*North Vancouver, Canada: November 1970*

When I discovered the Christmas card from Gisèle and Wolfgang, Dad hadn't been ready to make peace with his memories of World War II. Even twenty-five years after the end of the conflict, he still felt uncomfortable revisiting that time in his life. Many WWII veterans from both sides of the battlefield behaved the same way.

My friend Diane said that when she asked her German immigrant father about the war, he turned his woeful eyes on her. "Why stir up that hornets' nest?" he'd asked.

Like Dad, five of my Canadian uncles fought overseas and they shared the same reluctance to disclose their experiences. Today we recognize that many of the returning WWII servicemen suffered from post-traumatic stress disorder, but in the last half of the 1940s, in the '50s, and the '60s, the condition had not been given a name. The veterans were expected to buck up, return to civilian life, and forget what they had seen. Of course, they couldn't pull that off all the time.

The war haunted my dad. It had damaged him in ways he couldn't talk about. That's why he'd been so upset when I begged him to divulge the contents of the letter from Gisèle. I know he felt that a nine-year-old didn't have the maturity to handle her story, and he was right. Even the little bit he told me kept my imagination in a flux for years.

Sometimes I'd lie awake at night and wonder about her. She was forty years older than me and so "first cousin once removed" didn't seem an appropriate term for our relationship. Mom said I should think of her as my aunt, "Auntie Gisy," she suggested. But I didn't feel comfortable familiarizing her name, and I settled on "Aunt Gisèle".

At school, our class read about World War II and my imagination placed "Aunt Gisèle" in every scenario. I pictured her as a brave courier for the Resistance, as a forger creating flawless documents that would be used by desperate refugees, and as a munitions expert blowing up railway lines. Not until after the 25th anniversary of D-Day did I learn any more than what Daddy had first told me.

One Friday night during the fall of 1969, on impulse my father wandered into the Royal Canadian Legion Hall, not something we'd ever known him do. A cab brought him home at midnight, drunk. Another unprecedented occurrence.

From my bedroom, I could hear his slurred voice telling Mom over and over again that on next summer's family camping trip, he wanted to go to the interior of our province and drop in on his old army buddy, Harry.

I remembered that name! Harry was with Dad in Amsterdam. He too met Gisèle. I overheard my father say that when Harry returned to Canada at the end of the war, he used his saved-up army pay to purchase an apricot orchard.

And on a dusty August afternoon, twenty-four years after they had taken that food to Gisèle, our family called on Harry. I wondered if he would even recognize Dad.

My father stopped the car at the end of a long gravel driveway, and the foreman used a walkie-talkie to call his boss up at the main house. The transmission sounded full of static, but "I'll be a son-of-a-bitch!" came through loud and clear.

I watched a grinning Harry limp towards us, and my mouth fell open when he and Dad crumpled in each other's arms. My brothers and sisters stared wide-eyed at the sight of the two men, weeping and gasping.

Mom shepherded us away and for the next few hours we distracted ourselves picking apricots to take back to Vancouver. "Mr. Harry said we can have all we want. So eat your fill now and when we get home, I'll can the rest to have for dessert this winter," she said.

By 5:00 p.m. we'd finished gorging on fruit and had grown bored with chasing one another between the trees. Dad and Harry were nowhere in sight, and there was no Mrs. Harry to provide sandwiches. Mom packed us into the car and drove to the commercial strip of the closest town. There she surprised us with an early dinner at the local café. For a long while, we entertained ourselves spinning around on the counter stools, listening to top tunes from the jukebox, and feasting on burgers and fries.

Finally, at dusk after a lengthy wait beside the car, we saw our father coming up the rise, arm in arm with Harry.

Mom loaded him into the front passenger seat and with a firm look through the rearview mirror, she warned us all to stay quiet. Seeing our obviously inebriated dad, with the ever-present Players dangling from his lips, made me worry he'd light us all on fire. Harry insisted on giving Mom a goodbye kiss, which she cut off by leaping into the driver's side of the car. She signaled the foreman to pull his boss back, and then stepped hard on the gas pedal. "Wave goodbye to Mr. Harry!" she told us.

We did and never saw him again. According to the certificate from Vital Statistics, he died a few months later of a massive coronary.

"Dead from a trampled heart would have been closer to the truth," Dad said when he heard about his friend's passing.

From my place in the kitchen, I saw tears leaking from his eyes as he turned and reached for Mom. "Lots of guys like Harry couldn't lead a normal life after they came back," he told her. "I was lucky because I met you and we have the kids." My parents stood in the front hallway, holding each other tight, for a long, long time. I felt more confused than ever.

Harry had no next-of-kin, so the orchard employees sent his medals of honor to Dad. After opening the manila envelope, my father immediately tucked the contents into a desk drawer. "Thank God we went to see him last summer," he said.

A month or so after Daddy received Harry's belongings he started talking about marching in Vancouver's 25th anniversary Remembrance Day parade to be held on November 11, 1970.

He dug out his uniform from a trunk in the cold room and smiled when he saw that it still fit. The dry cleaner managed to purge the mildew, and Dad bought a new army-issue dress shirt and regulation boots. Mom sewed on his citations and insignia. As he stood before the full-length mirror in the front hallway, my sisters told him how handsome he looked. But I could tell he felt scared. No longer a boy soldier with a lopsided smile, I wondered if Gisèle would be able to identify him as the cousin she'd seen on her stoop in 1945.

Before leaving our house to join the rest of his division, Dad darted into the den and retrieved Harry's medals from where he'd stowed them. He wrapped the whole row in his white handkerchief and wiggled it into his pants pocket. He patted the slight bulge. "Let's go, buddy," he said.

None of us cried when Dad left, but once he disappeared down the street, my mother's tears came. I asked her why he hadn't ever marched in the parade before, and she said I should ask him that myself.

But after nine years with no further conversations about the war or Gisèle, I didn't want a scene. Mom hugged me, wiped her eyes with a Kleenex, and stroked my hair. "I feel like he wants you to ask," she said.

I'd waited a long time to hear those words and the following weekend I found my chance to corner Dad. The lumberyard had delivered a load of firewood onto our front lawn. My brothers were off with their friends, so I put on my rubber boots and a pair of gardening gloves to help my father lug and stack the full cord under the overhang of the back porch. The miserable job took a couple of hours and before going inside to get warm, Dad poked me in the ribs. "I can always count on you to pitch in and give your old pa a hand."

*Now!* I thought, and blurted out the questions I'd never had the nerve to ask. "Dad, tell me why you never went to the Remembrance Day ceremonies before now? What happened to you during World War II? Can you tell me more about Gisèle?"

I had broadsided my father, but I felt ready for whatever he'd tell me. In truth, I was a mature seventeen-year-old. I started looking after my younger siblings as soon as I was strong enough to keep them from squirming out of my arms. I knew how to cook dinner, clean the house, do laundry, and sew. But I didn't realize I was far too unworldly to understand what I'd be getting myself into when I begged Dad to tell me more about his cousin and the war.

## CHAPTER FOUR

# The Bread Line

*Amsterdam, the Netherlands: 1945*

My father wouldn't look at me. We clunked our boots against the doorjamb to loosen the mud, hung our wet coats on the pegs by the basement door, and shuffled into the house. "Do you want me to fix some coffee?" I asked.

Dad shook his head. He didn't even pull a cigarette out of the pack tucked inside his plaid shirt pocket. We sat rigidly facing each other in the two upholstered armchairs at the far end of the formal living room. I could smell chicken roasting in the oven—on Saturdays, Mom always made an extra effort with our evening meal. She knew all about Gisèle. I felt sure she did, but he'd kept his secrets from everyone else for a long time.

*Merry Melodies* cartoons were playing on the family room TV, so I knew my three sisters and youngest brother would be entertained for at least an hour. The three boys hadn't come back from their friends' house yet. Everyone except Dad and I had something to keep them busy. I looked at him; there was a lot I wanted to know.

He tucked a leg under himself and shifted his weight.

It appeared as though he'd rather be anywhere else than here with me, but finally he exhaled and asked if I remembered his story about the evening he cooked dinner at Gisèle's home.

I pulled my chair closer so I could touch his hand. "Of course I do, Dad. Isn't that why we're here now?"

He gave a nod and slid his hand out from under mine. "That we are," he began. "It had grown late by the time Gisèle's neighbors set off for their own homes, so Harry and I didn't even try returning to base. We bedded down on the floor with the other men at Herengracht 401—not too comfortable, but our battalion had slept in worse places.

"I can doze off anywhere, but after talking all evening with Gisèle, my mind would not settle down. I stared at the dark ceiling for hours after the house had gone quiet."

He hugged his arms around his torso. "It was the end of May and pleasant outside, but in that dank room I felt like I'd suffocate. No air circulated and it reeked of unwashed bodies."

I wrinkled my nose and Dad scowled at me. "It wasn't Gisèle's fault. What could she have done? They had no clean water and no soap."

With his hands, my father pantomimed tiptoeing, to describe the way he'd eased himself past the snoring form of his friend. When he reached the steep narrow stairway, he climbed to the top, and squeezed through a window with no glass that led to the flat roof. He stood in the middle of the space, tilted his head back, and breathed in air that tasted of the sea. On one side of the building, he said he remembered seeing a triple-arched bridge intersecting two canals. Looking in the other direction, he saw the moon reflecting off a dozen gabled roofs and the spires of a church.

The view relaxed him, and he hoped a smoke would calm him down still more. But as he cupped his hand around the lit match, he realized that Gisèle, Claus and Wolfgang had followed him up to the roof. Despite the moonlight, Dad found it difficult to read the expressions on the three faces in front of him.

He did not have to wait long to learn why they had joined him out in the night air. In his direct and abrupt way, Wolfgang asked Dad what he'd tell the Canadian family about meeting Gisèle.

Not sure what to say, my father swung his arm over the empty expanse, inviting the trio to sit down. Even though he'd spent just a short time at Herengracht 401, he could see that this household had secrets. But during war, didn't everyone? He hesitated to answer Wolfgang's question until he learned what more they wanted to tell him. Dad gestured towards the professor, and asked how he'd come to live at Gisèle's. Claus interrupted and answered the question.

"Lots of people spent time here. Some just stayed for a night, but Buri, Wolfgang, and I have lived with Gisèle for years. Up until now, we've depended totally on her. I am Jewish, so is Buri, and during the occupation we dreaded being arrested. I never went outside."

"I'm a German national, not Jewish," Wolfgang said. "Supposedly, I could move freely through the streets, but I too spent much of my time in the apartment. Gisèle sold paintings to get what food and supplies were available. She bartered clothing and personal belongings. People she knew sent us what they could. But towards the end of the war, no one had anything extra to share."

Both he and Claus told my father that over the past few months, Gisèle had not

been able to find much. Some days, tulip bulbs were all she could scavenge.

"Tulip bulbs?" my father asked. He'd heard about this but couldn't believe it.

"Oh yes, we've learned to eat anything," Claus said.

The tulip is an elegant bloom and much esteemed in the Netherlands. But at the end of 1944 and during the first months of '45—the period they called the *Hongerwinter*—the sustenance provided by the plant's bulbs cemented Dutch loyalty to this living symbol of their country.

People were forced to cower like dogs before a cruel master. To avoid capture, torture or imprisonment, Jews and other enemies of the Third Reich went into hiding.

"I moved into Gisèle's apartment in 1942. Because I am German, she knew my presence would not upset the overlords. Gisèle felt afraid, though, when I asked her to take in Buri and Claus. She only agreed because they had nowhere else to go," Wolfgang said. "And as food became more and more scarce, she had to join the crowds in the food lines and soup kitchens. All of her other sources had totally dried up. In the line-ups she faced inspection, and this past February she barely escaped being caught."

Dad told the professor that he didn't want to hear about it. He'd seen refugees in the food lines outside the army camp. He couldn't imagine his cousin as one of them.

I suppose that Gisèle recognized the distress on my father's face. He said she patted his hand with her own. Her touch comforted him, and he forced himself to continue listening to the story.

She told him about that day. "I'd been holding my place in line outside the bakery for a couple of hours. The wind off the North Sea had picked up and clawed its way underneath my coat. My knees throbbed from the cold."

"Why didn't you wear warmer clothes?" my father asked.

She shrugged her shoulders. "I don't have any. When I sold my things, I kept one coat, a scarf and a knit hat to cover my ears and forehead, but not much else. I never imagined how bitter this winter would be."

Claus continued with the next part of the story. "Gisèle said she turned to the neighbor behind her, 'We've been here for so long,' she whispered. 'When will this end?' She said the lady looked panicked. She took one hand from her pocket and brushed a finger across her lips."

"I then understood that if my words had been overheard, we would have been

yanked out of line. I felt bad about putting us both at risk," Gisèle said.

Wolfgang shook his head. "Your cousin is not known for her patience," he told my father. "She must have wanted to stamp her feet and yell in frustration."

Gisèle glared at the professor. "But I didn't. I heeded the good woman's warning and from that point on, I kept as still as the rest of the queue. I certainly couldn't afford to draw attention to myself and finally my turn came." She inhaled. "When I showed my ration card, I noticed the bakery employee's eyes shift away and a quickening passed over the features of the soldier. He snatched up the piece of paper, and gripping it in his gloved hand, he strutted over to where a senior officer leaned against the warm oven door. He clicked his heels and said, *Heil Hitler!*"

Dad told me that his cousin had narrowed her eyes. "That baker suspected I'd passed him a forgery. And I didn't have a hope unless he helped me. Glancing carefully around, he saw the two soldiers bent over my card. I'm sure he realized he'd be in trouble if he let me leave, but if I got arrested, everyone would be rounded up and questioned again and again."

"Some would have been unable to withstand the pressure. They'd tell their torturers all they knew," Claus said.

Gisèle wrung her hands. "Leaning slightly towards me, the baker told me to back up and get out of there," she said.

When he turned away again, my aunt knew that was her signal to move.

"My escape almost seemed rehearsed," she said. "As though we were actors in a play, the people in the queue opened a path to let me pass, and then huddled closer, shielding me from view. I kept going. If I was lucky, I'd still have a minute or two before the guards began searching for me."

But Gisèle could see no place to hide. The soldiers who set out after her were closing in. She could hear their harsh accents ripping through the foggy air. To become less recognizable, she tore off her coat and hat. Throwing them into a sunken stoop, she crossed over to the edge of the square.

Dad said he felt like he'd be sick.

"She had been cornered like a fox by hunting dogs," Wolfgang said. "So she moved to the back of the clearing and hunched her shoulders. Facing the wall, she feigned interest in a posted announcement."

"The thundering boots sounded ever closer," Gisèle said. "I wanted to bolt, but I couldn't move. My surroundings had grown darker and I seemed to be immobilized by a steady weight pushing on my back. I thought maybe fear had pinned me in place."

"Time must have moved in slow motion for her," Wolfgang said. "But finally the gruff voices faded and the restraint released. A pair of older men she faintly knew moved their tall frames away from her. 'Go home right now,' one of them told her. 'You'll freeze out here.'"

"*Dank U*," Gisèle said to the pair of men whose long coats had made her invisible to her pursuers. She hurried to retrieve the clothing she had discarded, but saw no sign of it.

"I hoped that whoever scooped up my rags was even colder than me," she said. "When I arrived back at Herengracht 401, my legs ached. I had chilblains, I suppose. Worse yet I had no food to share. When the door opened, five pairs of hungry eyes stared at me."

"Five?" Dad asked.

"Yes. At that time, five of us lived in Gisèle's apartment," Claus interjected. "Our friends, Simon and Torry, two more 'undesirables' needed temporary shelter, and Gisèle did not turn them away."

Wolfgang interrupted. "We had gone for too long with so little. You cannot understand what it is like to be hungry every day, month after month. Look at us!"

Gisèle spontaneously jumped up and wrapped her thin arms around my father again. "John, we are so grateful to you and Harry. The food you brought is like a miracle."

After she let go of Dad, he saw Wolfgang press the heels of his hands hard into his eyes. "I wrapped Gisèle in a blanket and tried to keep her like that until she stopped shaking. Her chattering teeth sounded like a woodpecker boring into a dry tree trunk. She wouldn't stay still. She shrugged away from me and tried to go back outside."

"We can't last one more day without something to eat," she said.

"Wolfgang wouldn't let her go out into the dark," Claus said. "He suggested that she go to see Mari in the morning. 'We'll have to ignore our hunger for one more night,' he told us."

Dad asked who Mari was and Gisèle softened her voice to explain.

"You know, John, intellectual life in Amsterdam did not completely halt during the war years," she said. "It continued with severe limitations right through until 1945. The Third Reich encouraged the arts that exemplified and glorified the Aryan culture. And, of course, they suppressed and blacklisted other artists for their so-called 'unacceptable' works."

She said she'd held her last two exhibitions in 1941. After April 1, 1942, only artists who were members of the *Kultuurkamer*—the Nazi's cultural chamber—could continue to work openly.

"I refused to join and I had to paint in secret," Gisèle said. "The sculptor Mari Andriessen and Adriaan Roland Holst—a poet we called Jani—had established their professional reputations well before the war. They were among the first invited to be members of the *Kultuurkamer*.

"Eventually, Jani had to capitulate. He was well-known and his refusal would not be forgiven. But on his application he wrote that he hoped he would not be accepted because he did not agree with the Third Reich policies. Mari never even applied to the organization and he had to stop sculpting. As it turned out, Jani did become a member of the *Kultuurkamer*, but had to go into hiding because of the critical comments he wrote about the occupying forces. Jani was a good friend of my family, but I could not be seen with him in public," she said. "Our meetings had to be completely clandestine."

"A number of painters, musicians, dancers and writers reluctantly became members so their families would not starve. Some rationalized that they were providing their countrymen with a small respite from the otherwise horrific situation," Wolfgang said. "And some outright collaborated with the Third Reich."

"It turned out that I couldn't see Mari. He'd gone underground. The most recent forged food coupons he gave out did not pass the careful Nazi inspection, and he feared they would be looking for him," Gisèle said.

Wolfgang resumed speaking. "We didn't get food that night, but we prayed someone would bring us something the next morning."

"We'd been watching through the window," Claus said, "and Gisèle ran downstairs to swing open the door as soon as our neighbor, Guido Teunissen, came into

view. We saw them talking and we caught the exchange of a parcel wrapped in brown paper.

"Gisèle hurried back upstairs and entered the apartment. She could barely keep us from grabbing the food from her arms—she held on tight and stood up straight.

"'Stop it! We are going to sit down like civilized people,' she told us. 'Get moving. Someone set the table.'"

"Gisèle divided the two loaves of stale dark bread, six cold sugar beets and four hard-boiled eggs with the fairness of King Solomon," Wolfgang said. "She had such a meager amount, and she told me later how she hoped it would be enough to nourish our spirits, as well as our bodies, for one more day." He shook his head. "We had reached our limit. We had no strength left."

I could picture the faces around Gisèle's table. It must have torn her up to watch the friends scraping every morsel off their plates. The young men needed at least four times the amount she had been able to provide. She told Dad they'd gone for so long without enough nourishment, and until his arrival with the food from the Canadian army, they'd lost all hope of ever feeling full again.

Sitting beside my father, I worried that he'd stop the story, he seemed so overcome with sadness and had closed his eyes. But I gave him time and finally he shifted in his chair.

"I'm sure Gisèle would have given her share to the others," he said. "But she knew if she didn't eat, she wouldn't be able to keep foraging. And if that happened, what would everyone have done?"

The Nazis had become experts at detecting small irregularities. Again and again, Gisèle said that feeding the people hiding in her apartment proved to be the most serious obstacle she faced during the occupation.

The famine impacted three-and-a-half-million people. By April 1945, an estimated 20,000 men, women, and children had succumbed to starvation in the Netherlands. Most of those who died lived in the cities where the effects of shrinking food supplies were the most severe.

"We felt desperate," Claus told Dad. "All able-bodied men had been picked up and forced into labor for the enemy. And just before the end of the war, the Nazi high command ordered the execution of the imprisoned Dutch citizens they suspected

were members of the underground resistance movement. The death toll and degree of suffering seemed to have no limit."

My father told Wolfgang, Claus, and Gisèle that he'd seen first-hand how the pressure from the Allied offense turned the retreating army into raging bulls. In retribution, they destroyed whatever they could, bogging down all manner of land transport. "On our march towards Amsterdam, we slogged past bombed bridges and broken dikes," he said. "Instead of fresh country air, we felt as though we were breathing burning oil fumes."

Part of the agricultural land had been swamped by flooding, and the pitiful harvest of 1944 filled Nazi silos and larders, not Dutch ones. In some parts of the Netherlands, all the livestock had been eaten or had died from disease. Gone were the hundreds of thousands of gallons of milk and thick cream.

Collectively, people hiding from the Nazis—Jews, intellectuals, members of the underground resistance, many religious leaders, Dutch men of draft age, Romani people, and homosexuals—were called *onderduikers*. The Dutch system of hiding them down in the cellars and up in the attics of their houses was used also in the countryside to protect airmen who had been shot down.

"I have friends who live on a farm," Gisèle told Dad. "More than once, they saw the telltale plume of smoke spiraling downward, and their children ran into the field to look for survivors. Working together, they would drag the injured man back to the house. Not even the smallest boy or girl ever told a soul. They learned to keep quiet."

Gisèle tried to maintain her activities in secret, but towards the end of the occupation, there were too many who knew about the hiding place at Herengracht 401. It had become just a matter of time.

"The awful war was ending, but the struggle was overwhelming," she said. "We were at the breaking point. We had endured so much, yet I knew if the occupation did not end soon, no doubt about it, we would be caught and probably die in a camp."

The tide irreversibly turned on April 29, 1945, when Canadian and English planes air-dropped more than 37,000 tons of food for the Dutch. Dad said they called the relief mission *Operation Manna*.

"The pilots who flew the planes told us that when the boxes hit the ground, people materialized from behind the dikes and from inside drainage ditches."

Dad added that he and the rest of the kitchen division made "soup" from vegetable peelings, mutton bones, and any of the soldiers' leftovers. He said that he considered using seawater to boil up the gruel, but particles of oil had contaminated it.

"People would line up waiting for their share; they were always grateful." His voice caught. "It broke my heart.

"I remember a ten-year-old girl. I saw her over and over again taking whatever she could scrounge to her family. The mother and father lay on the ground staring into space. They'd lost all hope. I couldn't imagine the horrors they'd seen," Dad said.

"Their daughter poured broth into their mouths. There were a couple of smaller kids too. What made that one girl different? The others could no longer function, but she kept fighting for their lives."

I wanted to answer that she must have been made of the same stuff as Gisèle, but I didn't dare interrupt his monologue.

"You might have read about the end of the war in your history books, but on May 2, when our battalion found out that Hitler had committed suicide on April 30 and Goebbels did likewise on May 1, 1945, we cheered and whooped like teenagers," Dad said. "'This war will end soon' we said to one another."

"On May 5, the news of victory spread along the rooftops and across the canals," Gisèle said.

"Right where we are sitting is where I first heard," Wolfgang said. "A courier told me that regiments of the Canadian army had assembled outside the city limits, and they were poised to march in. Little did I know that tonight I'd be sitting with one of those soldiers." He shook his head and smiled at Dad.

"Thank God you came," he said, "but on May 7th, we had heartbreaking setbacks."

Dad thought he knew what the professor meant. "Are you talking about the B-17 that crashed into the North Sea? It was the only casualty of the thousand-plus food drops. Eleven Commonwealth crew members perished and just two survived."

Wolfgang shook his head. "I'm sorry I didn't know about that." He continued, "The Nazis were furious with the Allied presence. So much so that they shot into the festive crowds in Dam Square. We knew some of the boys who were killed. Imagine, right at the end, to lose their lives like that."

"To stay alive, we had to relax the rules of peacetime. It was as simple as that," Gisèle said. "Now, it's over."

I hugged my dad. "I am so proud of you," I said.

But he shrugged out of my arms. "What I did is not the point."

He held me by the shoulders. "I feel grateful that I ended up in Amsterdam and that I could help my cousin. You are about to begin your adult life, and I hope you will be the same kind of woman as Gisèle—one with the courage to live as you must and make the decisions you know are right even when that seems like the hardest thing in the world."

**CHAPTER FIVE**

# Falling Down, Falling Apart

*The Netherlands: 1938-1942*

World War II felt way too close as Dad told his story about the night he spent on the rooftop with Gisèle and her friends.

"I think I've heard enough," I said.

My father shook his head. He leaned forward, patted my knee and passed me his handkerchief. "Sorry, you wanted me to open Pandora's Box and now I expect you to listen until the time comes to close it again."

His gravelly voice made it clear that I had no choice in this, so I blew my nose and straightened up. "You're right," I told him. "Keep going."

Dad said that around five in the morning, the birds began singing back and forth to one another. Gisèle seemed to enjoy listening to them, but then she stretched her neck and looked all around. "Do you smell that?" she asked. "It's yeast—someone is baking bread. If I am dreaming, I hope I never wake up. "

My father said his cousin could not stop talking about food.

"We never had enough for everyone," she said once again. "Had we imagined how long the occupation would last, we might have tried to stockpile some basic staples. All the signs pointed to war, but along with most of the European population, I hoped that Hitler would be stopped before he dominated the entire continent."

Wolfgang lit another cigar and puffed contentedly. Claus coughed from the smoke drifting over the rooftop. "I can't believe it's really over," he said.

Dad turned around to face the professor. "Why didn't the Germans stand up to Hitler? How did he manage to get elected? If you had stopped him, all this suffering could have been avoided."

The professor's eyes studied my father. He did not like explaining himself to anyone, but this Canadian soldier had arrived with food, other supplies and the cigars!

"In Germany, before this war began, we felt wary of Hitler and the National Socialists," he said. "But his policies had pulled our country out of the poverty and shame we'd endured since the signing of the Treaty of Versailles. That agreement required Germany and her allies to accept the responsibility for all the losses and damage during World War I. This demand became known as the 'War Guilt Clause'.

Germany had to disarm, make substantial territorial concessions and pay reparations."

Wolfgang said that at first, Hitler raised the German people's hopes. "Once the tyranny began, we learned to practice appeasement until it became second nature."

The professor had contacts in the Frankfurt Hitler Youth and he knew high-ranking Nazi officials in Berlin who helped him get employment.

"If you wanted a job in Germany, you had to know the right people," he said. "I worked as a radio broadcaster from 1933 to 1935, hosting a program called *Vom Schicksal des deutschen Geistes*—'The Fate of the German Spirit.' I wrote newspaper articles as well."

My dad said he sensed tension in the professor's voice and felt more confused than ever. "How could you do that? How could you work for the Nazis?" he asked.

Wolfgang's voice thundered back, "Can't you understand? If I had not cooperated, I would have starved. And if I'd managed to keep myself alive before the war, once it began I would have been rounded up and put on one of those trains that left the station full of people and came back hours later empty."

He glared at Dad, and Gisèle tried to calm him down.

Wolfgang Frommel exhaled and continued, "But the turning point came when my friend and fellow journalist, Sven Schacht, was arrested during one of the purges Hitler staged against his political challengers. Later, I learned that Sven died in Camp Mauthausen, and I suspected it wouldn't be long before I too got hauled away."

He closed his eyes. "I had to be ultra-careful because the local Gestapo unit knew everything about me. They were aware that I socialized with Jewish intellectuals and other 'undesirables'. Yet somehow I managed to hang on to my position at National Radio for a while longer, and I also taught at Greifswald University."

The professor told Dad that he made trips to Basel, Florence, and Paris hoping to find a place to work when the Nazis forced him to leave Germany.

In 1936, Wolfgang's best known publication, *Der Dritte Humanismus*—"The Third Humanism"—showed up on the blacklist and he fled to France.

But he couldn't make a living there, so in 1939 he relocated to the Netherlands. Thanks to the introduction from Jani, the artists' colony of Bergen became his circle.

"You have no idea what it was like for us," he said in a low rumbling voice.

Gisèle held up her arms to deflect her friend's anger and spoke to him in German.

Dad couldn't understand what she said, but the professor continued to seethe. She did her best to ignore him. She needed to help my father understand the thinking in Western Europe prior to the occupation.

"We waited, we prayed that the Third Reich's war machine would break down. Of course, that didn't happen," she said. "Just a few had the foresight to prepare for the inevitable, like the museum curators. Long before the swastika flew from the rooftops of our Dutch buildings, they made plans to hide the most valuable works of art. By the time we heard goose steps in our streets, the Rembrandts, Vermeers, and van Dycks had disappeared deep underground. I don't know if everything has stayed safe or not. I suppose we'll learn soon enough."

Gisèle looked like she would cry just thinking that the masterpieces might have been destroyed. It surprised Dad when she spat on the floor before continuing, as though ridding her mouth of a foul taste.

She particularly worried about Rembrandt's colossally proportioned master-piece, *The Night Watch*.

"Do you think they had to cut it into smaller pieces?" she asked. "I can only imagine how the damp and mud would damage the master's intricate brushstrokes. Or worse yet, maybe Göring got his hands on it. I heard he has amassed a huge art collection for his beloved Führer."

Gisèle sat hunched over for a few minutes, but then Dad said a measure of contentment crept back into her voice. "At least I am certain many of the smaller canvases are safe. Only days before the storm troopers marched into Dam Square, the Rijks Museum called on all citizens to come get the remaining art down from the walls and hide it. It was surreal to see people scurrying along the canals with their burlap-wrapped treasures."

She gave a half-hearted smile. "I also have a couple of my stained-glass win-dows safely hidden away. In 1942, I buried them deep in the garden of my studio at Leeuwen-Maasniel. I was afraid the Nazis would discover everything I had there because, you see, I refused to cooperate with them."

Dad said he sensed how exhausted she felt. She combed her fingers through her hair and her blue eyes pierced into him.

"John, you are asking why we didn't 'stand up' to the Nazis. I can only say that

we were unbelieving. The Dutch military was insufficient and unprepared for the rapid advance of the Third Reich's occupying forces." She spread her arms wide. "Nobody thought that this could possibly happen.

"In retrospect, I realize that the first alarm shrilled in 1940, the year that Hitler formally occupied our country. But most of us lulled ourselves into thinking that the Netherlands would get off lightly. After all, we had been neutral in World War I and our government believed the Nazis would respect our position during this conflict too," Gisèle said.

"What about your mother and father? How did they manage?" Dad wanted to know. He imagined that when he got back to Canada, his father would ask him about Willem and Josephine.

"Rather than wait for a conflict, my parents left their home before the Nazis arrived. Our town, Wijlre, lies close to the border and Father said he felt unsafe. He knew their large house would be confiscated to billet officers, and he couldn't bear to watch that happen. I pictured Mummy's garden and Daddy's study being trampled by jackboots, and I saw the sense behind his decision."

Gisèle said that on the day they left, just before closing the front door, her father ran the Dutch flag up the pole in the front yard.

"I am grateful he never saw it cut down, trampled, and replaced by the swastika," she said.

Dad remembered how Gisèle looked straight at him. "When my parents moved, and I saw the accelerated military mobilization along the Vaals-Maastricht highway, I had to accept that full-scale war with Germany would soon come." She lowered her eyes. "Of course, I had no idea it would be so cruel.

"Jani Roland-Holst, the poet I told you about, was extremely fond of my mother and father," Gisèle said, "and he warned them that the tensions would only get worse. He advised relocating to the province of North Holland. Thankfully, Mom and Dad took his advice and rented *Jachtduin*, a cottage in Bergen. Even though I knew the Nazi advance could not be stopped, I wanted life to be normal for them as long as possible. I went on ahead with their belongings and arranged the furniture in the rooms. I filled vases with fresh flowers and hung their paintings."

Her brow creased. "The stress of the relocation worsened my father's heart

problems. On the other hand, my mother had endured so many moves during her lifetime she had less difficulty accepting this latest one."

Gisèle said she had been waiting in the Bergen cottage's parlor when the hired car stopped outside in the street. She jumped from her chair and ran to usher her parents into their new home.

As she guided them through the rooms, both seemed pleased with their daughter's efforts. But they grew agitated when she told them she had to return to her studio. "For as long as I can, I need to continue working in Leeuwen-Maasniel," she said. "We need an income."

When Gisèle spent time with her parents, Josephine fussed over her daughter and tried to convince her to set up a workspace in one of the rooms of their rented house.

"Sunlight shines in from the northern side of the garden. Your mother is right; you could work here. You'd be safer with us," her father urged.

The artists' colony of Bergen welcomed Gisèle. She often met with nationally acclaimed painters and writers at *De Zonnebloem*. She soaked up the ambiance, painted, and tried to forget about the increasing threat of all-out war.

Jani Roland-Holst and Wolfgang Frommel had known each other since 1925. It was at Jani's home, Gisèle met the professor and they became friends.

She was largely self-taught and respected Wolfgang's formal education. However, in the first part of the twentieth century, it was not yet *de rigueur* to pursue university degrees, especially for women. The family's uncertain financial situation had put an end to the painting studies she'd begun in Paris. Since then, despite her high opinion of advanced studies, Gisèle had simply been too busy for the lecture hall.

In the morning light up on the roof of Herengracht 401, Gisèle looked striking. Dad said he felt glad to see his cousin relax and lose herself in fond memories. She glanced at Wolfgang and leaned over to pull on his sleeve.

"The professor and I quickly formed a friendship. Those were exhilarating times," she said with a smile. "Nearly every day, we sat together talking, didn't we?"

Wolfgang nodded and she continued her reminiscence. "You see, John, all of us were so terrified of the unknown. Can you understand why we chose to ignore what was happening?" Gisèle asked.

"Everyone felt more scared than you can imagine," Claus added.

At *De Zonnebloem*, Gisèle said she regularly observed Wolfgang hold court. One afternoon, from her vantage point behind an easel, she watched several talented painters and writers, such as Vincent Weyand, Chris Dekker, and Buri Wongtschowski, listen to Wolfgang lecture on the works of Stefan George, a German poet. The young men looked spellbound.

Gisèle felt drawn to Buri, who had been a teacher at the recently opened international boarding school established by a group of Quakers from England, Germany, the United States, and the Netherlands. She asked him to tell her why the founders built the institute.

"They envisioned themselves as defenders of democratic principles," he explained. "They decided that English would be the official language and excellent academic standards would be the pillar of their school."

"I doubt the National Socialists agreed to any such plan," Gisèle said.

"Of course not," Buri had curtly replied.

Dad said his cousin remembered stepping away from the painting she'd been working on and sitting down on a couch that was pushed against the wall. "What happened next?" she asked him.

Buri shrugged. "In 1934, the directors were left with few options, and the institute opened at *Castle Eerde* in the Netherlands, thirty kilometers from the German border."

"The teachers wanted the school based in Germany, but along with the students and their parents, they got used to the change. They had no other choice. Buri said that he started teaching there in 1938," Gisèle told Dad.

Later that same afternoon, Buri talked more about the school. He said they followed the tradition of the progressive German *Landerziehungsheim*—which means "an educational home in the countryside." By the latter half of the 1930s, the Quaker institute was the preference of students and teachers who had to leave Germany. The staff fluctuated between twenty and thirty, and about 120 pupils boarded there.

"It was a difficult time for us all. We never knew what was coming next," Buri said.

On May 10, 1940, the Dutch authorities forced Jani Roland-Holst and another author friend, Edgar du Perron, to evacuate their Bergen homes because the nearby airfield had been bombed. "My father stepped in," Gisèle said." 'Both of you will

come and stay with us,' he told Jani and Eddy."

"And, of course, we are expecting Bep and Alain too," Gisèle's mother added. Bep, Eddy's wife, wrote under the name of Elisabeth de Roos, and Alain was the couple's five-year-old son. At *Jachtduin*, it was crowded, but not more so than many other households. During those uncertain times, people seemed to feel safer living as part of a group.

Four days later on May 14, the Bergen residents were permitted to return to their homes. But had they known that the Nazis would evict them again in 1943 so they could establish the Atlantic Wall defense system, many would probably have looked for lodging in less strategic areas of the country.

Edgar du Perron had been unwell while at *Jachtduin*, and Jani Roland-Holst agreed to help Bep retrieve some documents from where they were stored.

"Eddy is too ill to keep up with Jani and me. We'll need to move quickly if we want to be back in two hours' time from Nesdijk; can you stay with him?" Bep asked Gisèle.

Although my aunt felt worried about her friend's condition, she nodded in agreement.

Gisèle could tell Eddy was in pain, yet his face looked gentle. He seemed to be in a reflective mood and asked her to reach under the bed for a box he had stored there. She passed it to him and he motioned for her to sit down next to him. Eddy then showed her correspondence and photographs that spanned his lifetime.

*His cherished memories are all here,* she thought, *stored in an old cardboard box.* He tired quickly, laid back, and closed his eyes.

Gisèle placed the box back under the bed and thought that she too should save her mementoes, letters, and pictures. But she hoped she'd have a better place to keep them.

When Bep and Jani returned, Gisèle met them at the door: *Eddy beweegt niet meer!*—"Eddy is not moving!"

Obviously, he had suffered a heart attack. Jani sped off on a bicycle to fetch the doctor, but help arrived too late.

After his death, Gisèle's parents insisted that Jani, Bep, and Alain stay on until they found a suitable place to live, but by May 20 they had moved away. Gisèle realized the time had come for her to do likewise. Even though she would worry about her parents, she knew that she needed to live in Amsterdam. Jani said he'd help her

search for an atelier where she could live and work.

"For many years, my father's family had lived at Herengracht 280. That house had been sold though and I wanted to set up my home on the same canal. We walked the full length of the waterway, but could find nothing available. Finally, through the branches of a leafy tree, I spied a half-hidden sign advertising an office for let," Gisèle said, her face brightening.

"It was this very building! I stood firm when Jani protested that it would not suit my needs."

Throwing her arms over her head, she drew oversize rectangles in the air. "Light streamed in through the windows. I knew it would be perfect for painting."

Dad figured that his cousin never 'made do,' she 'made better'. But he doubted that she would have rented the tiny third-floor flat with no services if she'd known that a group of refugees would soon be living with her.

A little less than a year after the Nazi army began setting up more bases in the Netherlands, the Quaker school celebrated its seventh anniversary. The commander-in-chief ordered the director not to accept new students for the next academic year.

In September 1941, seventeen Jewish children remained at Eerde. The New Order demanded they be separated from the gentile students and confined to *De Esch*, a section of the property set aside for them. A faculty member, Elisabeth Schmitt, was put in charge of the Jewish boarders.

My father tried to stand up. He said he'd heard enough, but Gisèle urged him to stay where he was. She said he needed to know the whole story, so that he could tell the family living in Canada what the war had done to their homeland and to the people living there.

The occupying forces cordoned off the area around Amsterdam's Jonas Daniël Meijer Square, and 425 Jewish men were assembled there. Their gentile neighbors looked on helplessly at the frightened faces. They'd heard their fellow citizens would be sent to Camp Westerbork. No one knew for sure what went on at the camps, but after a while, when no one returned, they feared the worst.

Gisèle told Dad that the Dutch Communist Party organized a strike they hoped would hinder the evacuation. Sympathizers risked their lives setting explosives in

the records department of a building that belonged to the City Hall. When the dynamite exploded, paperwork scattered all through the building, but the Nazis moved immediately to restore their orderly system. My father said his cousin shook with rage when she remembered how quickly the insurrection had been cruelly and completely put down. The deportation of Jews continued.

From their pulpits, clergy urged their congregations to hide anyone who came to their door.

"But really," Gisèle said, "in the beginning most people felt terrified even thinking about doing that. Anyone caught giving refuge met the same end as those they took in. Choices were hard."

Dad told me that after she'd said those words, she sighed. "But they were transporting Jews away from their homes like chickens in crates. How could I stand by and do nothing?"

Gisèle's parents were forced to make another move. But her concern for them resolved itself when Mr. and Mrs. Michiels van Kessenich of Roermond gave the couple refuge in their home. Their hospitality allowed my aunt the peace of mind she would need if she was to remain in Amsterdam helping her friends.

Dad said that before the conversation on the rooftop, he shared the opinion of his fellow Canadian soldiers. They had wondered why the Europeans let the Third Reich amass such power. Gisèle and her circle of friends helped my father to understand that witnessing the ever-escalating Nazi control must have been like watching a locomotive roll out of the station. At first the wheels move slowly and ponderously. But soon, the momentum and weight make the train unstoppable.

"The Netherlands completely surrendered when the Nazis bombed Rotterdam," Gisèle said. "We knew if we didn't give up the Luftwaffe would destroy Amsterdam too."

## CHAPTER SIX

# *Onderduikers*

*The Netherlands: 1942–1945*

Pink and lavender streaked the horizon. Daybreak would soon come, and Dad hadn't slept all night. "Let's get off this rooftop and go downstairs for coffee with lots of milk and sugar," he suggested.

Gisèle's face spread into a smile; she clapped her palms together and within seconds had jumped to her feet. She glared at Wolfgang and Claus. "Are you two going to sit here all morning when there is coffee waiting?" Not allowing time for a response, she headed for the window, and climbed back over the sill and into the house.

She skipped over to her makeshift one-by-two-meter kitchen/bathroom. She did not enjoy cooking, and for a long time she'd had no fuel and nothing to cook, so the most basic appointments suited her needs. Chipped cups, assorted plates and bits of cutlery lay along the single shelf. On the opposite wall, a scarred stone counter with a recessed sink had been installed. Angled into the far-right corner stood a cooking burner and a curtained commode squatted in the other. There was no shower and certainly no bathtub.

But my father knew how to improvise. He had already cooked two meals in the space, so brewing coffee presented no challenge. Gisèle rifled through the dirty dishes until she found her one pot and passed it to him.

Dad said he smiled and took it from her. "This will do nicely," he said. While he washed up the remains of the night before, the aroma of strong boiled coffee filled the apartment. Despite the pungent smell, the noise of rattling dishes, and a bucket of water sloshing down the toilet, Harry and Buri did not stir. Gisèle looked ready to wake them both.

"Let them sleep," my father said.

Gisèle nodded and led Dad, Claus, and Wolfgang down the three flights of steps. They all settled, coffee in hand, on the stoop of Herengracht 401.

"I first saw you right here," Gisèle reminded Dad. "It was such a short time ago, but it feels like we have always known each other."

"Well, I have always known 'about' you," he answered. "My father spoke often of his family 'in the old country,' and I'm glad that we've met." He looked around at the piles of rubble and damaged buildings. "I hope we'll do so again, but under better conditions."

Gisèle shook her head. "No, John, nothing could have been 'better' than this. You came here with your bags of food just when I needed you most."

My father knew that his division would soon be deployed to Belgium and hopefully they'd be returning to Canada before long. He thought about how dismayed his father would be to hear about the conditions in Amsterdam. And yet Dad had to admit he'd feel satisfied telling Joop that he'd done his best for their Dutch family.

For sure my grandfather would ask a lot of questions, and my dad wanted to be sure he had all the facts. He did not want to return to the topic of the occupation, but he needed clarification on a few points.

"You said that your apartment was designed to be an office, and I can see that making a home for yourself was relatively easy. But how did you imagine you could hide young men here? It is such a small space."

Gisèle let out a long sigh. "I keep telling you that we did what we had to. I didn't plan on anyone else living here. That came later.

"Some of our country's artists re-directed their talents to forgery, producing the false ration cards, travel documents, maps and counterfeit money needed by the Dutch Resistance. But I soon figured out that I would not be useful at that. I am not precise enough. Anything I tried to duplicate would not have passed inspection," Gisèle said.

She had considered working for the underground sabotage units. Specific details were needed so that explosives experts could set fires in German-controlled factories and ammunition depositories. On a regular basis, the saboteurs cut phone lines to the camps and damaged the railway tracks used to transport people there.

"I told her that would not have been a good job for her," Wolfgang said bluntly. "Her eyes are unforgettable, and a mundane appearance is what keeps those operatives safe."

*They need to purge all the pain,* my Dad concluded, and he marveled again at the strength contained within his cousin's tiny frame.

Gisèle said she had lived in Amsterdam for two years before Wolfgang asked to move into her home. They had no romantic interest in one another, but they were devoted friends. The professor had been quiet while Gisèle talked to Dad about finding and setting up her apartment, but at this point he once again joined the

conversation. "I realized the Nazi occupation would be more brutal than the Dutch could imagine."

In 1943 the Nazis evicted the population from the seaside towns and villages. The generals of the Third Reich feared that the Dutch living on the waterfront, in places like Bergen, would assist the Allies to gain a foothold on the continent. The shoreline became an Axis military stronghold. Many private houses were taken over and adapted for strategic defense purposes.

"Getting anyone out of the Netherlands had been difficult for years. Belgium had closed its borders earlier, and Germany's war machine patrolled the North Sea in U-boats."

Wolfgang felt increasingly anxious about the Jewish students at the Quaker boarding school. "For them, leaving the country is impossible and transportation to one of those camps is imminent," he'd told Gisèle. "They need help."

He recalled how nervous she had been. If they were caught, she too would be executed. "Look how cramped you and me are now," she had said, and then closed her eyes and went quiet.

"I didn't need to explain to her what would happen to those boys," Wolfgang said. "And although she felt fearful, she agreed to take them in."

Like many Dutch who hid enemies of the Third Reich, she knew she wouldn't do well as part of a web. She realized she would be better off working independently. The clandestine sanctuaries' success lay in what some called their disorganization.

Gisèle didn't consider herself a member of the formal Underground. And she did not think she was braver than anyone else. "I figured that many people in Amsterdam hid their friends just as I did, but I didn't know any other safe house locations. I didn't know any names and I hoped that no one outside my circle of artist friends knew about me."

Secrecy increased her chances for survival. And because she had no specific information, if she got caught she couldn't turn anyone in.

Wolfgang's facial expressions and his nervous gestures showed how much the memory of those days still bothered him. "There were still students at the Quaker school who needed to go into hiding, but twelve could not bring themselves to separate from one another. Instead, they left 'voluntarily by public transport' to Camp

Vught, and from there to Camp Westerbork."

Gisèle shook her head. "We found out that up until the day those boys were transported to Auschwitz, they sat together whenever they could and read the works of writers they had been introduced to at the school, like Goethe and Tolstoy."

Claus continued. "The first three were murdered at Auschwitz on September 24, 1942, and only last month, we learned that the final survivor of the group, Hermann Isaac, had perished during the liberation of the camp on January 21 of this year."

Dad said he'd heard of the systematic killing, but knowing the names and exact dates that friends of Gisèle, Wolfgang, and Claus had met their fate made the barbarism seem even more intense. My father wondered how this group of people would ever put the past behind them.

Gisèle saw that her cousin could not bear to hear much more, and she forced a smile to her lips. "But two Jewish teachers and five Jewish pupils agreed to take refuge. They all survived. Buri was one of the teachers and Claus, a pupil at *Castle Eerde*. They came to live here, and now they are part of my circle."

Buri first found shelter in September 1940 in the Limburg home of another artist, Charles Eyck. But in May 1942, when the Jewish population was ordered to wear the yellow Star of David, Buri knew he could no longer put his host at risk. Wolfgang went to see him at Charles' house and asked if he'd like to move into Gisèle's apartment in Amsterdam. In the bigger city, he'd be less visible.

He agreed to come, but getting him there required daring and subterfuge. Vincent Weyand, a half-Jewish poet, helped Wolfgang move Buri to Amsterdam. On the appointed day, the three met for the journey to Gisèle's house.

She continued the story of Buri's rescue. "When they came to a checkpoint, Wolfgang put on the official armband he had been issued during the compulsory military service for German nationals living in the Netherlands. He demanded to be allowed access to the train station. The young, inexperienced Nazi guard must have been intimidated by the professor's commanding manner, and permitted them to pass through the gate. But if they'd been asked for identity documents, the ruse would have been discovered and the three wouldn't ever have seen freedom again."

After the terrifying train trip on July 8, 1942, the trio collapsed with relief in Gisèle's living room. Wolfgang smiled when he remembered that she had welcomed

them like heroes—with red roses. Buri got settled in, and Vincent returned to his home. But as often as he could, he visited his friends at Herengracht 401. Wolfgang Frommel felt relieved that Buri was safe, or at least as 'safe' as possible. But he worried incessantly about one of the students. He glanced over at Claus and pointed his index finger. "This fellow was in an especially vulnerable position."

The professor explained that he'd met Claus Bock in the spring of 1941. Claus was just sixteen years old at the time.

And a few months after his perilous experience with Buri and Vincent, Wolfgang realized he needed to get Claus into hiding as well.

"If you aren't Dutch," my father asked Claus, "what were you doing in this country?"

"I came from Hamburg to the Netherlands on September 21, 1938, via Brussels, with my Czech father and German mother," Claus answered. "Germany was home; we had a profitable business. My parents figured our country would soon come to its senses, and they'd be able to return and carry on with their lives.

"As it turned out, we got to Belgium just before the signing of the Munich Pact. After that, no more Czech passport holders were allowed to enter the country." Dad said Claus locked his eyes on him. "We were extremely lucky."

My father let out a slow whistle.

"One of our family's business contacts in Brussels arranged for him and my mother to go to India allegedly as the firm's representatives for what they thought would be just one year."

"They still lived in denial," Wolfgang said. "Claus' father and mother felt it would be best not to interrupt their son's studies. His education was their priority."

"That is exactly what they thought," Gisèle confirmed. "Claus is brilliant and his parents decided that the Quaker boarding school would be ideal for him. After all, it had taken in many other German children. Josi Warburg, the school's house mother, had been a classmate of Claus' mother, and both his parents assumed he would be well taken care of."

Gisèle told my dad how the sixteen-year-old got away from the school and into hiding. "Once again, Vincent Weyand helped Wolfgang. He wrote a suicide note, supposedly from Claus, explaining that he preferred to take his own life rather than

suffer what he knew he'd soon be subjected to."

Vincent left one additional "clue" behind. He took a handkerchief that belonged to Claus and threw it into a brook near *Castle Eerde*. The current carried the fabric a short distance downstream where it got caught on a rocky outcrop. He knew the Nazis would see it there.

In August 1942 Claus was moved to the Dekker family home in Bergen.

"But when the Atlantic coast was evacuated in early 1943," Gisèle told Dad, "no one could live there anymore. My home was Claus' only alternative. He got to Amsterdam and became the fourth member of our circle."

The Gestapo had been suspicious of the "suicide," but they accepted it. Even Claus' parents had to be told their son was dead. Wolfgang and Gisèle could take no chances that the truth would come out.

Wolfgang, Buri and Claus lived full time with Gisèle until the liberation of Amsterdam. And for varying periods, she gave lodging to other *onderduikers*. Many came only once. They all swore they'd never tell a soul about the refuge at Herengracht 401, and Gisèle prayed they would be able to keep their promise.

Good friends of the group, Manuel and Peter Goldschmidt, "half-Jews," according to the Nazi classification of racial lineage, did not have as many difficulties as the children of two Jewish parents. For a time, the brothers also attended school at *Castle Eerde*. Their non-Jewish mother had arranged safe papers, and their gentile appearance made it possible for them to avoid going into total hiding. Manuel rented a room in a boarding house on Amsterdam's Singel, but he considered Herengracht 401 his home. Reinout van Rossum du Chattel and Chris Dekker came by often, as did Manuel's brother, Peter.

At nineteen, Gisèle had decided she would never have children. She did not want maternal feelings to interfere with her art. But to her circle of friends, the *onderduikers* who hid in her home, she was a mother in every important sense of the word.

CHAPTER SEVEN

# The Circle Widens

*The Netherlands: 1942–1945*

People who had no connection to Gisèle lived on the two lower floors of Herengracht 401. She occupied the third, and Guido Teunissen lived with his wife, Miep Benz, on the fourth.

In 1943, when Claus moved into Gisèle's home, she took a calculated risk and approached the couple upstairs. She felt reasonably sure that Guido and Miep held the same sympathies as she did, and yet, if she was wrong about them it would cost their lives.

Gisèle smiled broadly. "Not only did they promise to keep our secret," she told my Dad, "but they offered their own apartment as a sleeping place for our latest arrival. A good thing because we had no more room."

Guido, a skilled carpenter, created a hiding place for the *onderduikers* in the building's dumbwaiter, a chute that had once ferried items up and down between the floors of the building. He set a large wardrobe in front of the entrance and thanks to recessed hinges, even a small person could manage to swing out the massive piece of furniture and hurry inside.

During the raids, while the young men hid in there, sometimes for hours, they could not make any noise. They couldn't cough or sneeze. To do so would mean instant arrest not only for themselves, but also for Wolfgang and Gisèle.

Another example of Teunissen's resourcefulness could be seen in the main room of the apartment. He refitted an old player piano so that a person could lay inside completely concealed.

A table and an assortment of chairs, bookshelves and cabinets occupied the entire living area. The men also slept there. Blankets, such as they had, got rolled up and hidden away when not in use. Every trace of the unknown inhabitants had to be constantly obliterated. A few hairs in the sink or a carelessly tossed piece of clothing could lead to their discovery. All the friends constantly needed to be aware of the small traces of their existence that could lead to the demise of the entire household.

Throughout the day, those in hiding could usually move discretely about the flat. And despite the bleakness of their lives, they continued with their education. Wolfgang lectured about the philosophies of Goethe and Hölderlin. They studied

the poetry of Stefan George, analyzed literature, and let their minds wander to the splendor of the Renaissance, ancient Greece and other cultures. When Gisèle could get her hands on supplies, she taught drawing and painting. The work they produced was intricate, not by choice, but by necessity. Paper, along with everything else, had grown scarce. Each sheet had to be filled up completely to make it last.

Gisèle told Dad that she was always scared, but she'd survived other difficulties during her early years and those experiences had made her strong. Although the danger never abated during the occupation, she knew she had to act with resolve.

Wolfgang leaned forward and whispered in Dad's ear, "She is used to people treating her the way she commands."

Gisèle overheard the comment and laughed. "That's true," she said. "In most situations, I feel confident and people do as I ask." She playfully slapped Wolfgang's leg. "Except you!"

However, she could also behave subserviently. It required refined acumen to decide on the appropriate persona for each challenge she faced.

Because Wolfgang Frommel was German and not Jewish or Dutch, he could have led a different life, but he chose to remain secluded with Gisèle and the young men at Herengracht 401.

Dad thought that Gisèle could have used the able-bodied professor's help with collecting food, but it seemed he'd been reluctant to get involved in that activity. Had he been afraid? Or did he feel that as an intellectual, he was above such tasks? All Jewish and Dutch men between the ages of sixteen and forty-five feared their backs would be broken by the heavy work, long hours, and inadequate food. But German nationals like Wolfgang would not have been forced to join a work crew.

Wolfgang Frommel had a dominating personality, and it bothered Dad to see how Gisèle acquiesced to him. Although the men were living in Gisèle's home, the professor seemed to make the decisions and her allegiance to him as their leader rarely faltered.

As the occupation drew to a close, everyone's nerves were as tattered as the clothing they wore. It would have been effortless to slide into bickering. Gisèle said that every morning she'd say to herself: *Right now, this is how it is. We are still alive. We haven't been arrested and we haven't allowed our differences to get the better of us. I can manage one more day.*

"When I met them, Gisèle and her friends were as thin and brittle as the branches of a tree during wintertime," Dad said. "During the last months of the occupation, the group had reached the limit of their tolerance."

One dark afternoon, Gisèle went into the kitchen to divide the small loaf of bread she had. At first she thought her eyes were playing tricks on her. One of the men had the knife in his hands. He looked ready to cut off a large chunk of the loaf for himself.

"Put that down!" Gisèle said.

But instead of doing so, he pointed the blade at her.

She wanted to turn away from his snarling mouth and heaving rib cage, but she forced herself to meet his gaze. "If you take that for yourself, everyone else will go even hungrier today. Can you live with that?"

His lips started to quiver. Quickly, Gisèle spread her arms and stepped towards him. She took the knife from his hand and held his shaking body. He wept like a man who had lost all hope.

"I am sick of this place, of you, of everyone. I can't take this anymore," he said over and over again.

The confrontation over the bread upset Gisèle, but it had not terrified her as much as an incident that happened half a year before. One evening, as Gisèle, Wolfgang, Claus, Buri and two guests sat reading together in the apartment; they found themselves caught in a lightning raid. No warning came from the lookouts perched atop the roofs on the canal street. Gisèle heard the Nazi boots pounding up the stairs. "Quickly—dive!" she hissed at Buri.

He scurried into the upright piano and listened to the exchange taking place right next to him. The remaining five sat frozen at the large table, gripping their books.

"Your documents!" the *Grüne Polizei* commander demanded.

Wolfgang handed over a convincing array of legitimate passports and ration cards for himself and Gisèle. The other guests, Reinout van Rossum du Chattel and Manuel Goldschmidt were able to produce similar authentic-looking credentials. Claus Bock could only show an outdated Czech passport.

"He will come with us," the commandant said.

Wolfgang stood tall and looked directly into his countryman's eyes. "This you cannot do," he said.

The official seemed to waver. Something in his eyes made Gisèle think that he had grown disgusted with his own role in the unending horror. She could feel his inner conflict. Each second that passed seemed suspended in air, like a speck of dust in a sunbeam.

Finally with a decisive shout, he called to his men, *Hier ist nichts los*—"There is nothing wrong here." He turned to Wolfgang and gave a curt nod. "Be sure your friend gets better papers."

No one could breathe. As the German soldiers swung their powerful search beams away and retreated down the stairs, the commandant looked directly at Gisèle. She knew she had to help him save face in front of his men.

She jumped to her feet. "*Heil Hitler!*" she said, jabbing her right hand up into the air at an angle, fingers straight out, pointing forward—the Nazi salute. The officer did likewise, and then joined his men out in the street.

"The war was such a bloody, bloody waste," Dad said.

I waited for more, but he turned away, lit a cigarette, drew the smoke deeply into his lungs and closed his eyes. He had finished. He would tell me no more that night.

In fact, my father never again made more than a passing comment about his wartime experiences.

The two times he'd opened up had been eight years apart. I replayed his words over and over again in my mind. I still had unanswered questions. Why had he reacted with such alarm on the afternoon I asked him about the Christmas card from Gisèle? What long-ago battle trauma made him dive to the ground when he heard a sudden loud noise? Why did it hurt him so much to talk about the past?

Dad could have answered my questions. Certainly he had other stories too, but he carried them and his pain to the grave.

# PART II

# MISSY REMEMBERS

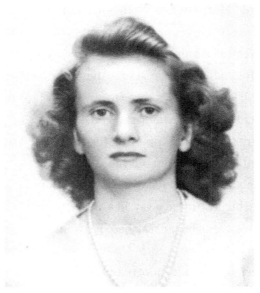

Maria (Missy) van der Gracht, 30 years old, 1952

# Essential Attitude

*Toronto, Canada: 1976*

In 1971 I accepted an assistant teaching position in Peru. I was about the same age Gisèle had been when she left home. My parents worried about my departure for unknown lands in much the same way as hers must have done.

I longed to see more of the world, and I jumped at the chance for my first adventure. On board the Vancouver-Lima flight, I felt like a long-distance swimmer ready to test new waters.

But instead of diving in gracefully, I felt that I had belly-flopped.

Ilo, the town I would call "home" for the next year, lay right in the middle of the Atacama Desert; I had never been in a place without trees.

To my Canadian eye, the buildings looked run-down, and the tar-paper shacks on the outskirts offended me in every possible way. The streets were rutted or unpaved; sanitation and services did not exist.

I realized that I was far too immature for the hard realities of southern Peru, and my digestive track was as distressed as the rest of me.

Early one mauve-colored morning, leaning against the schoolyard wall, I re-read my father's most recent letter. His words, written on flimsy airmail paper, urged me to remember Gisèle's resourcefulness and determination under far worse conditions.

*She certainly would not be wallowing,* I thought. *Not even the Nazi occupation of her country had beaten her down.*

I knew I had to jump clear of my fear, try the local food, make some friends, and learn Spanish. Once I opened my eyes and began to pay closer attention to everything around me, the culture shock lessened.

My Gisèle-inspired attitude made all the difference. Working with my students became more meaningful once I stopped feeling sorry for myself. Whenever I had time off, I snuggled into the window seat of a bus and set off to see different parts of the country. I have a crystal-clear memory of myself gazing over the top of the world at Machu Picchu. I remember thinking how Gisèle would have reveled in the ancient Inca city.

When I returned to Canada, my world continued to widen. I landed a job with an airline and traveled the world. Yet I never crossed paths with Aunt Gisèle. I tried

to on multiple occasions, but during those years she spent as much time away from her Amsterdam home as I did from mine in Vancouver.

I flew often to Toronto and while there, I liked to visit my father's sister, Maria, who our family called, Auntie Missy. At the time she lived in Rosedale, an elegant, older part of the city. Paintings by my grandfather, family photographs, and a couple of Gisèle's sketches hung on the apartment walls.

Looking at the portraits of Gisèle and Missy, I realized how much they looked alike—blonde and small-boned, with delicate facial features. Both were only daughters and had three brothers. The two women loved the arts, and neither of them had children. Growing up, they lived far apart; in the 1960s they met in person and became close friends.

Travel was as important to me as breathing, yet I never thought I would settle permanently anywhere but Canada. However, on a trip to southeastern Mexico, I met Jorge Rosado, the man I would marry, and I put down roots.

My parents and siblings had grown accustomed to my absences. They accepted my upcoming move to Mexico, but I also wanted my extended family's support. I flew to Toronto so I could share my news with Auntie Missy.

The night I arrived, an ice storm froze the leafless trees. The following morning, when I looked out through the frosty window pane, I saw the branches glittering like Swarovski crystal. I urged Auntie Missy to join me on a walk through the ravines. Because of the intense cold, I accepted the loan of a mink coat—the first and only time I've ever worn fur.

The air bit my lungs with every breath. After an hour, we'd both had enough and slogged our way home. *No more of this weather for me,* I vowed.

As soon as we stepped into Missy's entrance hall, she hurried to light the gas fireplace in the living room. "Hot coffee and whiskey is what we need," she said.

With numb hands, I absent-mindedly picked up and looked through the mail that had been pushed under the door while we were gone.

One piece stood out. In fact, I felt like someone had slammed me in the gut. The *déjà vu* washing over me was the strongest I'd ever known.

The envelope was not delft blue, but I recognized the handwriting and the return address. No mistake. The letter had come from Gisèle. On the front I read Missy's

name, but for sure, it had been delivered into my hands for a reason.

Auntie Missy walked back into the living room carrying a tray with two dainty cups of Johnnie Walker-laced espresso. "There now, this will take the chill off," she said.

I handed over the mail, and begged her to open the envelope from Gisèle. She set the coffee down on a small table, lowered herself onto the edge of the couch, and pried up the sealed flap. Inside was a photograph of two men, standing in a grove of trees.

On the back Gisèle had written: *For Meisje, It is wonderful to discover our Daddies together, so eternally young. Love, Gisy*

No letter came with the picture. "Why does she call you Meisje?" I wanted to know.

"That is my name's Dutch spelling. Missy is an Anglicized version."

"Will you tell me more about Gisèle?" I asked.

Auntie Missy said she didn't know where to begin; she asked if I knew what Gisèle looked like.

"From the few pictures I've seen of her as a young woman, I can tell she has small bones and a slight frame. Her skin, hair, and wide blue eyes make her seem fragile, but that long Dutch nose of hers changes everything," I said.

Missy agreed. "You're right. Her nose is disproportionate to the rest of her face, but she is proud of it. In fact she prefers to be photographed in profile so she can show it off. Can you imagine?"

After poking that little bit of fun at Gisèle's nose, Missy gave me a few hard facts. "Her parents, Willem van Waterschoot van der Gracht, a geologist from Amsterdam and Josephine Hammer-Purgstall, an Austrian aristocrat, first had sons—Arthur, Walter, and Ides. The three came into the world a number of years before Gisèle was born in The Hague on September 11, 1912."

I took a scalding sip from the demitasse that Missy placed in front of me. "It doesn't sound as though she had the background for what she faced during the Second World War," I said.

My aunt looked at me and shook her index finger back and forth.

"If you want to understand Gisèle, you'd better get over any preconceived ideas you have," Missy warned. "She's a complete original. I have never met anyone else like her."

"Keep going," I urged. "Tell me what you mean by that."

Missy poured more coffee into her cup, settled into the cushions, and looked me straight in the eyes. "I suppose you want to hear about what she did during the occupation of Amsterdam."

"Yes," I replied, with no hesitation. "Dad told me some stories, but it was difficult for him to relive those times."

"I thought as much," said my aunt, as she set her cup back on the table. "Those years were dramatic and traumatic, but they make up only one part of her life achievement."

To minimize her wartime experience made no sense to me. "I can't agree," I said. "After surviving that, everything before or later must have seemed insignificant. That's what Dad felt."

"He would have said something along those lines. After the war he never saw Gisèle again. But she and I have visited each other many times," Auntie Missy said. "We've talked a lot, and believe me, the stories about her life before and after WWII are as remarkable as those that took place during the occupation. To start with, there is her art. Her style is as unique as she is."

She pointed out Gisèle's sketch of leaves with faces falling into a swirling pool of water. "Through good times and bad, her creativity sustained her. She doesn't think in linear patterns and so circles fascinate her. She sees them everywhere and paints them all the time."

Missy stood up to take our empty cups into the kitchen. I hoped this didn't mean our conversation was over.

After waiting five minutes, I got up too. I decided to go see if she needed help with anything and at that very moment she returned carrying a cream-colored booklet. "I think you'll enjoy reading what's in here," she said.

I hugged Auntie Missy tight. I wanted her to know how eager I felt for more information about Gisèle. At last I'd found someone who seemed knowledgeable and willing to answer my questions.

When we sat down, she passed the small book into my hands.

"Where did you get this?" I asked her.

"Gisèle told me that during the war, family mementoes, including most of her

mother's letters, were stolen by looters. Gisèle wanted to have a written account of her parents' experiences and she asked Josephine to write everything down."

Auntie Missy leaned closer and put her hand on the cover. "Gisèle's mother spoke English, French, and German, as well as Dutch, and she could type.

"It seems that Josephine told her daughter she would write her story in English so that not just anyone would be able to understand it. Certainly she never imagined that you and I would be reading her words thirty years later. If she wanted to keep her information secret, she should have stuck to Dutch."

"You still haven't told me how it is that you have this diary," I reminded Missy.

She laughed. "No, I haven't. Several years ago, Gisèle and I sat in her Amsterdam studio, much like you and I are doing here today. She read me a few passages and I realized that I'd been told a different story about her mother. My mom said that Josephine was unhappy as a frontier wife. She went so far as to say that her brother-in-law took advantage of her sister-in-law's gentility. I never knew how tenacious and brave Josephine had been." Auntie Missy leaned over and tapped the cover. "This diary was a surprise for me."

I opened the book and read a long dedication written in Gisèle's hand.

*My mother,*
*born Josephine Hammer-Purgstall,*
*married to my father,*
*Willem van Waterschoot van der Gracht,*
*wrote this for me at my request.*
*Gisèle van Waterschoot van der Gracht*
*(who later married Arnold Jan d'Ailly, mayor of Amsterdam, 1946-1956)*
*Now I give my second copy to my cousin,*
*Maria v.Waterschoot van der Gracht*

When I took the book in my hands, I felt transported into the past.

## CHAPTER NINE

# Gisèle's Childhood

*The Netherlands, Austria and the USA: 1914-1928*

**M**issy studied the photograph of Willem and my grandfather.

"Whenever Gisèle spoke to me about her early years, I heard the voice of a lonely girl," Aunt Missy said. She smiled and held the picture up for me to see. "The brothers are a handsome pair, aren't they?"

I took the sepia-colored photograph from her and looked at it closely. "They are quite different from one another. Where was this taken?"

"There is nothing written on the back to tell us, but they both seem to be in their thirties," she said. "It could have been made anywhere. Maybe in the Netherlands shortly before they traveled to the USA?"

Missy said that because of World War I, Willem had all but lost his means of making a living. "His ability to secure his young family's future depended on the development of the oil industry. When the European borders closed up tight because of the Great War, he couldn't travel as needed. So, as I understand it, the two brothers accepted an offer from Royal Dutch Shell to supervise a comprehensive survey of the mid-continental oil fields in the United States."

My grandfather, also a seasoned geologist, had previously made expeditions through the Middle East, North Africa and Antarctica. He had not yet met my grandmother, Florence Ross, so for him the journey to America would be just another adventure.

However, Willem had a family, and they too would make the move to "the wild new continent." He must have worried that the changes would be hard on them.

Despite the war and the travel ban, Josephine's mother, Gräfin Gisella Maria Sophia Josephine Vetter von der Lilie, somehow made her way from Styria, in southern Austria, to Rotterdam, the principal Dutch port. She needed to say goodbye to her daughter, son in law, Gisèle and her brothers. On the dock, in the company of faithful friends and staff, she must have stood out in her dark damask dress. Those who passed by may have thought she was wearing mourning attire, which would have been a fitting assumption considering how she likely felt about the move.

Josephine's mother kept her composure and instructed her daughter not to stay too long in New York. "You need to have the courage to leave for your final destina-

tion as soon as possible," she insisted.

Missy said she had asked Gisèle how her Austrian grandmother became an authority on the "wildness" of Oklahoma, the state where the family would make their home.

"Gisèle laughed," Missy said. "Grandmummy had been given 'the inside information' by the American wife of Baron Gizkra, who had never been further west than Philadelphia."

Holding back their unspoken fears and unshed tears, Willem and Josephine herded their four children aboard the Nieuw Amsterdam and set sail for New York. Anxiety about the unknown must have made Josephine and Willem feel insecure, an unfamiliar sensation for the pair. They were born to privilege and never foresaw that a move to America would be part of their lives.

Gisèle said she couldn't remember anything about the voyage; she was not yet three years old. But her brothers often laughed about disembarking from the ship in New York. Their mother had held her head high while struggling to regain her land-legs. The boys gripped onto one another as they swerved and stumbled towards the car that would drive the family to the Hotel Belmont.

When Josephine saw a silver bowl of white roses sitting on top of the reception desk, she let go of her daughter's small hand and tip-toed toward the flowers for a closer look. After the tense sea crossing, she must have longed to smell freshness. But the blooms had no scent.

She turned up her nose. *Mijn afscheidsboeket van degelijke Hollandse bloemen ruiken nog steeds een beetje, deze zijn mooi, maar hebben geen ziel*—"My farewell bouquets of sturdy Dutch flowers still have traces of their perfume; these have beauty but no soul."

That small disappointment must have seemed like a dark portent of all that she and her family would face in the new country.

They would be living in Tulsa, where just fifteen years previously the "Indian Wars" had raged. To the European family, it seemed that the frontier town had yet to acquire even a thin veneer of civilized society.

The newcomers rented a large suite at the Tulsa Hotel. They did not intend to stay there for long. They felt anxious to find a house and turn it into a home. But

Gisèle's brother, Ides, contracted diphtheria and the family had to be quarantined. Josephine felt grateful that the doctor and the manager allowed them to stay at the hotel otherwise they'd have been sent to the "Pest House,"which to all sounded like a bleak and hopeless place.

No one else got sick, and once they received a clean bill of health the two older boys were enrolled at St. Mary's Jesuit College in Kansas. Walter attended school in Tulsa and lived at home with his mother and too-small-for-school Gisy. Josephine made every effort to provide a fitting environment for her family, but she felt daunted by the challenges of living in this small outpost of the Wild Wild West.

Missy looked sympathetic. "Can you imagine how strange the American frontier must have seemed? Gisèle once told me that during those years, she regularly saw Ponca tribesmen in their traditional dress right downtown. She was fascinated by the way their long hair and feathers streamed out behind as they galloped their pinto horses down the main street. She never forgot the designs painted on the flanks of those panting ponies." Auntie Missy wondered if maybe Gisèle's lifelong fascination with circles might have begun then.

Willem's work required him in the field, and he spent little time with his family. When he did, he enjoyed the continental home atmosphere that his wife did her best to establish.

Josephine caused quite a stir when the local Tulsa newspaper reported on her "aristocratic lineage." She downplayed the fuss and dedicated herself to her children. She spent vacations with them in the Adirondacks, where Gisèle and her brothers swam, went boating and hiked up Whiteface Mountain.

Within a short time, St. Louis, Missouri, became the company headquarters, so the family had to sell their home in Tulsa and move there. But Josephine didn't mind because in the bigger city all her children could attend local schools.

During the summers, they vacationed on Fishers Island in New York. Gisèle told me that she remembered falling off a jetty. Sputtering and flailing her skinny arms, she managed to reach a piling and hang on until Ides came to the rescue.

My aunt walked over to the fire and held up her hands. "It makes me sad that Willem and my father drifted apart. It seems my mother had a hand in that, but my brothers and I missed out. We had no close cousins, aunts or uncles."

In 1918, Willem's career seemed to be thriving, and it looked as though the family would prosper in the United States. No doubt Josephine would have preferred to live in Europe, but capitulated when their furniture, artwork and other household items arrived from the Netherlands and Austria. With her possessions around her, she created the home that felt right to her. The neighbors enjoyed the fragrance of the blooming vines she planted and they also took an interest in Walter's virtuoso piano performances spilling out through the open French doors into the garden. "That boy of yours will be a concert pianist one day," they predicted.

"I'm not sure why," Missy said, "but in 1922, Gisèle's father decided to leave Roxanna Petroleum, the American subsidiary of Royal Dutch Shell, and accepted a position with another American oil company. Prior to starting, he needed to take specialized courses in London."

Auntie Missy looked back and forth through the pages of the journal, and eventually found the one she wanted. She tapped her finger over a passage. "Here, Josephine writes that she had not been in Europe for seven years. Understandably, she eagerly accepted the invitation to go there with her husband."

Missy turned her eyes towards me. "As it turned out, being in London was providential. Just a few days into their stay, a telegram arrived from Austria. Josephine learned that her mother was dying. She hurried with Gisèle to Hainfeld, the family's ancestral estate in southern Austria."

Unfortunately, they didn't get there in time. Not having the chance to say goodbye to her mother might have broken a lesser woman, but Josephine remained supportive of her husband's career and his decision to work in America. Nonetheless, she insisted on an extended stay at Hainfeld. She needed to grieve, find her center again, and reestablish her position in her own birth family.

Missy said that for ten-year-old Gisèle, living in Austria must have been challenging in countless ways. Her mother's family expected her to fit into their provincial aristocratic ways, but since the age of three, Gisèle had lived in the United States.

"Could she speak German?" I asked

Missy shook her head. "No, she could not, and I'm sure she felt overwhelmed. Yet there were aspects of life at Hainfeld that must have piqued her curiosity. I can picture her careening through the high-ceilinged, melon-colored hallways and

teetering on top of lichen-covered, crumbling garden walls. I bet she loved hiding in a corner of the library, totally absorbed in musty books. She once told me that some of Sir Walter Scott's original manuscripts were part of the collection of rare volumes at Hainfeld."

Missy covered her shoulders with a shawl, moved closer, and kissed my cheek. "Gisèle seldom reveals all that she feels. The endings of her sentences, spoken or written, are often left dangling. This way nothing can ever be fully attributed to her. I have never been sure how she coped during the time she lived there, but certainly in later years she considered the experience to have been an exotic one."

I watched Auntie Missy closely. She seemed to be wondering how much to tell me.

"In 1922 when Gisèle went to Austria with her mother, she said her brothers, Arthur, Ides and Walter, were 'almost men' with concerns that had no relevance to her. She felt set apart from them," my aunt said. "The family home in Amsterdam had been sold. Gisèle's paternal grandfather had died and her grandmother had grown infirm. Gisèle's father seemed to have few ties left in Europe. Nonetheless, Josephine definitely had strong emotional attachments to Austria."

Missy looked pensive. "Gisèle and her mother had no real place or purpose on either continent. For nearly a decade they had followed Willem from one oil frontier town to the next, never establishing any deep commitments."

My aunt shook her head. "How different the Hainfeld manor house, with more than sixty rooms and a moat, must have seemed to ten-year-old Gisèle."

Hainfeld dates back to the fourteenth century. It was originally built as a defending fortress against invasion by the Huns. Hundreds of hectares of forest and fields surrounded the estate and a small river ran through the property.

Despite the family's pretensions, the amenities at Hainfeld were rustic. Indoor plumbing had not been installed, and Gisèle told Missy that she had to duck under "a row of bats" to reach "a wooden seat with a hole cut in the middle."

She also explained that she bathed in an enormous copper tub that the maids had dragged into her bedroom. They filled it from giant steaming kettles and the first time they motioned for her to get in, Gisèle wondered if they intended to cook her.

"None of that could have been easily understood by a girl who had only known American bathrooms and other conveniences," I said.

"Neither did the food appeal to young Gisèle," my aunt added. "She once told me they ate sauerkraut every day. But I guess her Uncle Stumpferl felt sorry for her, and he sometimes let his linen serviette fall to the floor so she could pretend to retrieve it for him. While bent over, she could spit the half-chewed pickled cabbage into the napkin without anyone being the wiser."

Uncle Stumpferl also introduced his niece to outdoor activities like skiing, hiking, tracking and feeding the snowbound deer. He showed her how to paint. Although her father would have been the first man she admired, the Austrian uncle was a person that she looked up to and learned from.

Missy believed that even if the comforts were lacking, the colors, textures and scents of the centuries-old maternal home first awakened Gisèle's muse. Through the dim light cast by low wattage bulbs or candlelight she saw art all around. She attended musical soirees and took part in the ceremonial serving of Turkish coffee. She felt cocooned by the warmth emanating from the ornate porcelain stoves. "Hainfeld definitely proved to be a confusing but captivating experience for Gisèle," my aunt said.

Clearly Missy wished she'd seen Hainfeld in its glory days. There was a salon where the family gathered to socialize. The spiraling smoke from cigars—and also from the hookah—made Gisèle think of the phantoms who supposedly haunted the hallways.

I snuggled back into the pillows on the couch and closed my eyes. Like Auntie Missy, I wished I could have seen Hainfeld as Gisèle depicted it in a sensorial poem she wrote many years later. She called her piece, "When I Was Ten."

Gisèle described her aunts in full-length dresses and exotic wigs, and the uncles twirling their long moustaches during tarot readings held on Sundays. What became of the courtly visitors who arrived in horse-drawn carriages? By the early 1920s, motorized transportation had become common in America, but at Hainfeld modernity had been kept at bay.

"I can see how all Gisèle saw at Hainfeld must have contributed to the surrealistic world she depicted later in her art," I said.

Auntie Missy agreed. "Gisèle absorbs everything and at some point uses it to create a fanciful world on canvas or in glass."

After our conversation, I asked what would happen to Hainfeld in the future.

Missy shrugged her shoulders and said that no one in the family had the kind of money needed to restore the estate to its former magnificence.

Mother and daughter returned to the United States when Gisèle was eleven and stayed there until after she turned sixteen. The period passed painfully for Gisèle. Josephine and Willem lived in a succession of new towns and when they deemed the schools inferior, they would send their daughter away to Catholic boarding school.

Because of the distance, during holiday periods Gisèle could not always go home, and she'd usually be invited to spend a long weekend with one of her classmates.

"I couldn't help but contrast the informal atmosphere in my American friends' houses with that of my reserved European family," Gisèle told Auntie Missy. "In those homes, the children talked back to their parents. And they got their way. I wished my father would wrestle on the floor with me like an American father. I wished my mother would cut off her thick French twist and bob her hair."

"Gisèle didn't have the daily guidance of her father," Missy said. "He always seemed to be absorbed in matters that did not involve small girls. She craved his approval. I believe that throughout her life, she searched for a man who would give her the stability her father never provided."

That sounded sad. I gave a silent prayer of thanks for my own dad, who'd been such a steady and loving influence in my life.

"Serious tragedy struck Gisèle's family in 1925," Auntie Missy said. "At the age of seventeen, during his freshman year at Princeton University, her brother Walter died of an accidental gunshot wound."

"Poor Gisèle," I said. "From an early age, she endured one difficulty after another."

Missy turned and put her hands on my shoulders. "We can't understand why sad events are part of our lives. But during their years in the United States, Gisèle and her mother developed resilience. Perhaps neither of them would have survived the war if they had not already learned how to adapt to what each day brought their way."

Once Gisèle's brother had been buried, Auntie Missy said the family rarely spoke about him. Walter had been the musical, introverted brother, and no one could bear to speculate about the circumstances surrounding his death.

Josephine remained committed to her husband and determined to support his career aspirations in the strange country they called home. After all, she could

mourn her son wherever she lived.

For a long time after Walter's death, neither Willem nor Josephine took much joy in life. Perhaps this state of melancholy is partly responsible for the fact that Willem's work did not pan out as he had hoped.

Numerous times, Josephine's brother had invited the family to return to Europe and live at Hainfeld. Finally in 1928, seeing this as their best option, Willem and Josephine agreed to pack up and return to the continent with Gisèle in tow. Ides and Arthur remained in the USA, so they could complete their degrees at Princeton.

To Gisèle, the low-rolling hills of southern Austria loomed as high as mountain peaks. How many of them would she need to scale in order to get away? With each day of drizzling rain, the walls and ceilings slid further into decay. She felt them circling her like a pack of coyotes around their prey. If she didn't leave, she would surely slump into the mire of the past—like everyone else who inhabited the place.

Perhaps in an effort to make the Austrian relatives conscious of his own identity, Willem decorated his family's suite of rooms in blue and white. But his daughter felt no sentimentality for the delft tiles along the baseboards or the Dutch lace that bordered the drapes. She had no memories of a home in the Netherlands. The place she knew best was the midwestern United States, and the bucolic fields of Hainfeld bore no resemblance at all to the wide empty plains and broad vistas she'd known there.

In her eyes, Hainfeld had only one merit—she had time to paint as much as she wanted. Her father shared her interest, but his penchant was for restoring the centuries-old family portraits that had succumbed to the same neglect as the other appointments of the manor. He set up his work space in the vacant conservatory.

Uncle Heinz's wife, Cleo, introduced Gisèle to *L'École ABC Paris, Course Dessin-Peinture*, a correspondence drawing course. The two of them liked to work in the sitting room close to the library. Regularly, they would send their completed assignments to Paris for critique. Another cousin painted in one of the empty first-floor rooms that got the morning sun. Gisèle felt surrounded by artists and she wanted to be one of them.

# The Artist's Circle Takes Shape

*France and the Netherlands: 1928–1938*

Auntie Missy said she once asked Gisèle how she had convinced her parents to support her dream of a career in art. Gisèle's blue eyes twinkled and she told her cousin that she'd waited for the perfect moment to enlist her father's help.

She explained that she had approached Willem just as he finished applying the final coat of varnish to his latest restoration project—the portrait of a nineteenth-century baron. He'd spent more than a month repairing the large oil.

He told Gisèle about the difficulty he had removing the damaged portrait from its frame. Once he'd completely freed the canvas and laid it down flat, he needed extra patience in the cleaning process—only the softest cloths and finest sable hair brushes could completely remove the dust and debris that had settled into every crevice and brushstroke.

He had to work carefully so as not to damage the pigments underneath. He used a fixative to adhere a fresh canvas onto the back of the portrait, and once he felt satisfied that it was completely dry, he put it back onto the stretcher bars.

What a challenge it had been to match the faded colors, but he felt pleased, especially with the facial features. This was the fifth portrait he had restored and by far his best work.

When Gisèle walked into her father's studio, she took note of his good mood. She felt certain this would be the best time to approach him with her plan.

She knew he disliked cleaning his brushes and she offered to help. He happily handed over the onerous task. "Doesn't the turpentine smell bother you?" he asked.

Gisèle smiled and said that the bottles of solvent, pots of glue and the wooden workbench gave off odors more pleasing to her than the scents of her mother's flowers and fine perfume.

When she was done, she stood next to Willem and studied the restoration of the ancestor whose likeness had been saved from oblivion. Normally, Gisèle didn't show much interest in her father's work, and he knew she didn't really care about it. He was not bothered by this; he believed that as she matured as an artist, she would learn the value of restoration. He wondered what his daughter wanted.

Gisèle did not keep him guessing for long and after no further preamble she

made the statement that would chart the course of her life.

"I am going to be an artist. I know that family responsibilities will interfere with my goal, so I am never going to marry and I won't have children. To get started, I need you to let me study painting in Paris." *Whew!*

Willem could see determination written all over her face. "You want to paint?" he asked. "Before you even take a brush into your hands, you must know how to draw. You have to master drawing if you want to be a good painter."

When Gisèle's mother heard the proposal, she worried that her daughter would find trouble fast. But Willem, who had similar artistic aspirations as a young man, told his wife they should support Gisèle's dreams. As she usually did, Josephine acquiesced and tried to show the same enthusiasm as her husband.

Several weeks later, mother and daughter traveled to the City of Lights. Josephine got Gisèle settled into respectable living quarters, but as soon as she returned to Hainfeld, she felt mired in doubt. She seriously questioned what she'd allowed—she knew that her Gisy could be imprudent and impulsive.

Obviously, Gisèle suffered none of Josephine's angst. She felt like she'd been sprung from jail. She couldn't believe her good fortune—*Paris!*

The 1920s are known as the Roaring Twenties. The decade began immediately after the horror of World War I and ended in economic crisis. Gisèle managed to slip in and taste that way of life just before it crashed, along with the stock market.

She drank in the effervescence of Paris as though it was champagne. Feminine emancipation had begun. Women insisted on following their aspirations and taking responsibility for their own destinies. For the first time, Gisèle felt free to live as she wanted.

The 1920s were also a defining time for culture. Literary surrealism attracted many writers. As far as music was concerned, jazz was "the cat's meow." A new aesthetic emerged that had a huge impact on painting, sculpture and design.

Gisèle enrolled at the *Académie de la Grande Chaumière*, a school founded in 1902 by Martha Stetller, a Swiss artist who did not follow the traditional composition rules of *L'Ecole des Beaux-Arts*. Happier than she'd ever been, the beautiful young art student had no trouble meeting the most prominent painters of the period.

"Once she showed me a photograph of herself with Henri Matisse," Missy said.

Over his six-decade career Matisse worked in all media, from portraits to sculpture to printmaking. Although he painted traditional nude figures, landscapes and interior views, he used brilliant color and exaggerated form in surprising ways, making him one of the most influential artists of the twentieth century.

"But I knew she also greatly admired Picasso," Auntie Missy said. "I asked if she had a picture taken with him too. She threw her head back and held up her arms in a defensive position. 'No—never,' she said. 'He is a wonderful painter, but an extremely naughty man.'"

I had to laugh at that. "I wonder if he made a pass at her?" I asked Missy. "He has a reputation of being a real ladies' man."

Missy looked down at her feet. "You never know. Gisèle had many friends and admirers, but she's kept her personal life private."

Although the economic crisis that began in 1929 put an end to the *joie de vivre*, the pattern had been set for Gisèle. In some ways, she continued to emulate the 1920s lifestyle as long as she lived.

Without the income from his stock investments, Willem needed to return to work. In Austria, he could have found employment—he spoke German—but the steady rise of the National Socialist Party in Germany concerned him deeply. When offered a position with the Dutch *Staatsmijnen*, a Dutch mining interest, he didn't hesitate. Once again, the family moved.

Gisèle could not stay in Paris without financial support, and she reluctantly followed her parents to Wijlre in the Netherlands. Josephine and Gisèle had both found what they wanted, but it didn't last.

Gisèle needed a mentor. In 1936 at the *Beaux-Arts* in Brussels, she first saw the work of Joep Nicolas, a well-respected painter and stained-glass artist from Limburg in the Netherlands. She had been impressed by three of his portraits: "Suzanne with Scissors," "D.H. Lawrence," and "Aldous Huxley." She knew she'd found the right person to introduce her to the Dutch art scene.

Gisèle learned that Joep Nicolas lived in Roermond, close to her family's home in Wijlre. Mutual acquaintances arranged a meeting, and she felt delighted when he suggested that she spend a few days at his family's residence.

The spacious studio set in a whimsical sculpture garden charmed Gisèle. She felt

awed and attracted by the extravagant dress and demeanor of the artist and his wife.

Because Joep Nicolas allowed Gisèle to see his work in progress, she dared to believe that he considered her a serious artist. He seemed pleased by the way she intuitively understood his secular and religious compositions. When he asked if she'd like to enlarge one of his sketches, she knew this would be the way to showcase her talent.

Gisèle often thought back to that life-changing event. Joep's presence overwhelmed her and so she waited until she could see no light under the doors of the family bedrooms. *You must first learn to draw,* her father had impressed on her. She thanked God she'd followed his advice.

She crept into the studio and found the sketch that Joep Nicolas wanted enlarged. She carefully traced the details onto a clean sheet of paper and drew a grid over the design.

She then laid large squares of brown paper on the studio floor and drew a second grid on a larger scale. She began copying the outline and details of the small-scale drawing onto the big grid; it was painstaking and backbreaking work. If her calculations were not exactly right, the enlargement would be useless. Gisèle worked through the night.

Not knowing about her nocturnal session, in the morning Joep wandered into his studio to find the exhausted Gisèle still tweaking the enlargement. The master stood back and viewed her work from every possible angle. He put his hands on his hips and smiled at her. "This is good," he said. She felt elated by his approval. Truly this moment marked the beginning of an artistically focused life for Gisèle in the Netherlands.

Within a short period of time, she became Joep Nicolas' premier assistant. She also developed close friendships with his Belgian-born wife, Suzanne, and with Claire and Sylvia, the couple's two daughters. At the time, Gisèle did not speak fluent Dutch; with Suzanne and Joep she spoke French, and on occasion they acted as translators for her.

"Gisèle's relationship with the Nicolas family could be called by no other name than 'complicated'," Missy said. "And that would be putting it mildly."

Joep and Suzanne were bohemian artists. Their appetites for life bordered on gluttonous, but they also had two young daughters. They approached their parental responsibilities in a somewhat unconventional way, but they seriously aimed to be

the best mother and father they could be to their girls.

"Enter Gisèle, who they called 'Ficelle,' a beautiful, exuberant female artist lusting for acclaim, acceptance and adventure—and the embers flamed," Missy said.

I could imagine that Gisèle turned their world upside down. From what I could understand, the two years in Paris had ripened her natural flair. When she met the Nicolas clan, she fully blossomed into a free-spirited muse for Joep, a mischievous best friend to his wife and a nonconformist mentor to the girls.

Many years later, Claire, the elder sister would write a memoir, *Fragments of Stained Glass,* in which she remembered how "Ficelle ate her chicken with jam and her ham with pineapple slices, and her voice was always on the verge of laughter. She listened to Liszt and danced to Haydn." Both girls found her eccentric personality "embarrassing, but irresistible."

In the days when Dutch women wore somber clothing and rode sturdy black bikes, Gisèle had a magenta and purple skirt with a matching cape and peaked hat. She would roar to town on a yellow racing bike thus attired, provoking stern looks and whispered accusations. And she loved it.

Joep Nicolas had many commissions to complete, so Gisèle regularly stayed at the family's spacious house. Until late at night, she could be found in the garden studio where the master stained-glass artist taught her the techniques of the craft.

She adored costume parties, charades, posing for portraits and sunbathing in the nude. She asked a lot of the Nicolas household help, and although they cursed behind her back, they did her bidding without question.

Gisèle had definite opinions about the Nazis. Once, on holiday with the Nicolas family in Saint-Tropez, they dined in the company of a handsome Dutchman at a harbor-side restaurant. The balmy air seemed to blow their conversation from one delightful topic to the next. All were charmed by the man until he jumped to his feet, raised his straight forearm into the air and called out, *Heil Hitler!*

Grabbing young Sylvia and Claire by the wrists, Gisèle hauled them away and sat brooding on the dock. She shook her head and her shoulder-length hair swung furiously from side to side.

"What a disgusting man," she repeated over and over.

The next day, Joep Nicolas started talking about moving. It seemed clear to him

that Germany would cause conflict in Europe again. Suzanne said she was terrified of living under Nazi occupation. She could not bear seeing her daughters suffer as she had during World War I in Belgium. Joep feared that if war broke out, he would have no commissions and did not know how his family would manage without a steady income. He begged Gisèle to accompany them to the United States.

"But I'm happy living here," she said. "I don't want to leave. Besides, they say that if war comes, it will last for several years and I cannot leave my parents. My brothers stayed in America when I returned to Europe. Mummy and Daddy have no one else."

It devastated Gisèle to lose Joep Nicolas, and she begged him to reconsider. She told Missy that at the time she felt as though her fledgling success would float away with him.

He took her face in his hands. "I have introduced you to a circle of the best artists, poets and writers in the Netherlands. Stay friendly with Jani Roland-Holst, Jacques Bloem and Jan Engelman. They like you and will help you to receive your own commissions," Joep said. "You need to have more confidence. For your career, this is best. My absence will force you to make your own way."

"Gisèle had brought both light and chaos into the Nicolas home, and I think her intensity was irreplaceable," my aunt said.

"I don't quite understand. She was friends with the whole family, but was she more than that to Joep?" I asked.

"Remember that I told you to suspend your conventional judgment if you want to understand Gisèle," Missy said. "She speaks and writes to everyone, even me, using the same intimate endearments as in her letters to Joep. And I assure you, nothing more is part of my friendship with her. I can't answer your question, but I know that Suzanne missed Gisèle more than anyone. When the family had settled in New York, Claire and Sylvia asked their mother why she looked so lonely. 'I miss Ficelle,' she replied, 'the best friend I ever had.'"

I shook my head and looked at Auntie Missy. "You said that understanding Gisèle is challenging. I am beginning to think that I will never fully grasp the complexity of her multi-faceted personality."

"Gisèle no doubt felt insecure without Joep Nicolas' patronage," Auntie Missy said. "But a short time later, she created the stained-glass windows for the church in

Oostrum, near Venray. Unfortunately, this example of her early glass artistry was obliterated by Allied bombardments in 1943."

"Allied bombardments?" I asked.

"Oh yes. During the campaign to destroy Nazi footholds, the Allied airmen bombed other countries, too, not just Germany," my aunt said.

Missy again put a reassuring arm around my waist and pulled me close. "Understanding Gisèle is like peeling an onion; you need to slice through many layers before you reach the core."

I laid my head on her shoulder and wiped away a tear. "And cutting into an onion often makes you cry, doesn't it?"

CHAPTER ELEVEN

# Josephine's Diary

*Toronto, Canada: 1976*

"Indeed, and the more rings you peel back, the sharper the onion stings," Missy said. "Gisèle's life had challenges from the time her family moved to the USA and the difficulties really never stopped."

Missy rose from the couch, smoothed down her slacks and straightened her sweater. "Are you hungry? Would you like to have dinner now?" she asked.

The sky had grown dark. My stomach would normally be growling by this time, but learning new facts about Gisèle's life had cut my appetite. I didn't feel like eating.

"If you'd rather continue reading Josephine's diary, the casserole will stay warm in the oven," Missy said as she left the room. "I'll be back in a little while."

Curled up on the couch, I read straight through to page thirty-six, where Josephine recorded the death of her husband in Roermond, 175 kilometers southeast of Amsterdam, two years before the war ended.

During wartime, traveling was not easy. Gisèle had to call in every favor owed her so that her friends Wolfgang Frommel and Jani Roland-Holst could join her in Roermond for her father's funeral.

Josephine mentions how honored she felt when Roland-Holst, heroic poet laureate of the Netherlands, offered to compose the text for her husband's memorial leaflet. Although her translation into English does not do Jani justice as a poet, it allowed me to understand more about Willem. It reads:

> *With much knowledge and simplicity of the heart, he was a great servant of society and a humble servant of God. His touching kindness was manly through his strong and bright spirit—and mild through his profound and equally bright faith.*

Because of the Nazi occupation, the Catholic Mass for Willem had to be low profile. Many friends, colleagues and admirers could not attend, but by one way or another, condolences and flowers from those in hiding arrived at her door.

Gisèle had adored her father and without her brothers nearby, she knew he would expect her to look out for her mother's welfare. But how could she do that?

She couldn't move to Roermond. And with the young men hiding at Herengracht 401, her mother could not possibly live with her in Amsterdam.

Gisèle stayed in Roermond after the funeral. But once a few days had passed, she took her mother's hands and kissed them. "I need to go back to Amsterdam. I have an important job there."

Josephine hugged her daughter tight. Mother and daughter felt sure that the less they knew about one another's activities, the safer they would both be. Torn between her family duty and her need to protect her friends, Gisèle returned to Herengracht 401, trusting that the good people in Roermond would look out for her mother.

Mr. and Mrs. Michiels van Kessenich did just that. They took the widow in and protected her during her first year of mourning. They kept Willem's memory alive by placing his framed portrait on a small drawing-room table. Josephine appreciated how Mrs. van Kessenich made sure that a vase of wildflowers always stood next to it.

But in November 1944, the family received evacuation orders and could not take the older woman over the rugged terrain to their country cottage.

However, they spoke with Judge Wim van Roosendaal who brought Josephine into the home he shared with his wife and children. He also stored her possessions in their cellar.

From the last weeks of November 1944 until the final month of the occupation in March 1945, the citizens of Roermond, like the rest of the Dutch in the not-yet-liberated part of the country, suffered systematic starvation. In her diary Josephine wrote:

> *Gisy and I could not communicate anymore. She devoted herself, with great energy and utter devotion, to the difficult and dangerous task of hiding and feeding a group of young men in her abode in Amsterdam, drawing at the light of a primitive oil lamp, selling these drawings for food, which became more and more scarce and expensive, a condition culminating in the Hongerwinter, which claimed so many victims.*
>
> *At the Roosendaal's house, I again had to be grateful for the perfect hospitality which they offered me, as well as several other friends, under the most difficult situation. During the winter of '44–'45, the winter of the siege of Roermond, they kept up an atmosphere of courage and coziness, almost*

*unbelievable when I recall the circumstances.*

*The first air raid took place on my birthday, October 6, 1944. We went into the cellar. ... I also recall a very heavy raid on November 11. All kinds of projectiles were flying over and coming down on Roermond.*

*In those months our host and hostess often went out with a hand-wagon to get wood and food from quite a distance outside of Roermond, more than once under heavy crossfire. They took exceptional care of their children and guests without a letdown in spirits.*

After reading the account of the *Hongerwinter* from Josephine's perspective, I had to stop for a few minutes. I felt humbled by her stoicism and acceptance. I set her diary down on the coffee table in front of me. Ten pages remained and I felt as though my great-aunt was sitting beside me, gently urging me to continue until the end.

When the final evacuation order was handed down, Judge van Roosendaal secured transportation for Josephine in the back of a rickety truck that had formerly been used to pick up and deliver flowers. Wrapped in her green travelling quilt, she bumped along to Brüggen, a small German settlement just over the Dutch border. Although the ride was far from comfortable, Josephine felt guilty watching those who had to walk through the snow with their children and a few essentials piled on top of sleds.

The entire group of refugees from Roermond was kept in Brüggen for several days. In her diary, I read about one of the bittersweet nights:

*On the first February of '45, a young priest brought us Holy Communion; an ironing board was our communion railing. We then learned the church was open and what we saw there would have inspired Gisy to do a painting. The Baroque nave was crowded with people—old and young—camping on straw and fixing their food. I remember the light of candles here and there in this picture never to be forgotten. In the night, one of the men started playing Limburg songs on his guitar and a great number of people sang these songs of their homeland beautifully.*

When Josephine once again received orders to continue on her way, a young man

from Roermond helped her pile into a cattle car with hundreds of other refugees, and he settled her into a corner. She tried to lift the spirits of those crammed in next to her by sharing her blanket and the little bit of food she had. As the train shuttled back across the German border into the Netherlands, she gave a quiet prayer of thanks. Although she never voiced her fear, she'd been worried that the whole group from Roermond would not leave Germany. She had been afraid they'd be taken to one of the camps they had heard whispers about.

On the next leg of the evacuation, Josephine felt blessed to secure a spot in the back of a mail wagon. She finally arrived at Beetsterzwaag in Friesland almost a week after the exodus from Roermond began.

I looked up to see Missy watching me. "Gisèle told me she felt sick with worry for her mother during the evacuation. For the third time since the occupation began, Josephine was driven from her home and forced to go elsewhere. It had been several months since the two had even spoken."

I pointed to the page that lay open. "From what it says here, Gisèle did not know if her mother had survived the relocation. Many of the elderly had not made it through the ordeal. Gisèle must have been feeling desperate to get in touch with Josephine."

But during the last months of the war, any kind of transportation was nearly impossible to come by. Civilians handed over whatever they were asked to pay for a ride in a utility van or delivery truck. They felt grateful to secure space on a vehicle traveling anywhere near the place they needed to go.

Gisèle felt relieved when she learned of a ride north. She could go and look for her mother. Arriving early at the spot where she was told to wait, she saw a burly fellow standing beside a truck. He looked like the driver. When she got close enough to ask, he didn't say a word but jerked his thumb towards the back. Gisèle's eyes went wide at being shown such disrespect, but she kept quiet and clambered in—immediately she realized the truck had no roof—the prospect of riding all night exposed to the freezing air seemed terrifying.

But even worse, she soon learned that in return for her passage, she'd have to care for a group of children.

Several women arrived and as gently as possible began passing the children up to Gisèle. As she caught them and sat them down in the bed of the truck, she realized how

frail they were. *Why did they have to go north on their own?* Even though she knew the probable reason, she had to ask, "Where are their parents?"

"These little ones have no family. We have learned that some food is to be had in Groningen," was the answer. These were orphans. They seemed so listless and weak—they didn't even react to what was happening. None of them had cold-weather clothing and their heads were covered only with paper.

Once underway, Gisèle said the wind blew as hard as a storm on the North Sea. Shivering uncontrollably, she tried to shield the children with her own body. But despite her efforts several gave up the struggle and died during that nightmare of a ride.

After reading that entry my eyes were stinging and I had to put the diary down. I couldn't imagine a more horrific situation. I looked at Auntie Missy. "How could conditions have deteriorated to this?"

"There was nothing else the Dutch hospital authorities could do," my aunt said quietly. "In Amsterdam, food and shelter for unclaimed children was scarce. No one had extra clothing or blankets to give them. During the *Hongerwinter*, in the northern and eastern parts of the country, food for the destitute could still be scrounged up. The idea of babies traveling in an open truck in below zero temperatures seemed abhorrent. But they all would starve to death if they remained in the city."

Shortly after daybreak the driver stopped in front of a church and ordered Gisèle to get out. He left her and the children huddled there. She felt near despair, but soon the townspeople appeared.

One of the young matrons took a small girl from Gisèle's arms. "I'll look after her," she said. "The others will also take one home." As the woman carried the child away, her clothing hung in folds from her chest and Gisèle noticed that her complexion had the sallowness of an asthmatic.

Gisèle couldn't get the image of the emaciated babies out of her mind. She stumbled through the rocky streets of the town and finally managed to find a way to Beetsterzwaag, where she hoped she'd find her mother.

During the journey with the refugee children, she herself developed pneumonia and was debilitated to the point that she passed out. She woke up in a hospital. In her dulled condition, she couldn't understand the nurses' unfamiliar Friesland dialect, and thought she had somehow ended up in England.

Although still delirious with fever, she did not lose sight of her goal and insisted on borrowing a bicycle to finish the journey and find her mother.

Gisèle wept with relief when she discovered Josephine safely lodged with Mrs. van Regteren Altena, a friend from Bergen who had moved in with relatives in the north. Although they had so little, the family gave Josephine their son's room. Mother and daughter were overjoyed to be reunited. With the host family's permission, Gisèle rearranged the furniture in the borrowed room to make Josephine as comfortable as she could.

The older woman stayed in the north for the final months of the war. She assured her daughter that God would keep them both safe and that the fighting soon would end. Of Gisèle's farewell, Josephine wrote, *Gisy returned to her hard life in Amsterdam, this time in a fish truck!*

Near the end of the occupation, Josephine received an encrypted message: "Paula's godchild is alright."

She told her hostess that her sister Paula had only two godchildren—the first being the son of a gamekeeper at Hainfeld, and the second, her own boy, Ides.

The woman hugged Josephine and encouraged her to believe that the caller must have been referring her son. But Josephine had seen too much suffering and disappointment. She did not dare get her hopes up.

"Such things only happen in books," she said.

A short time later, in April of 1945, the Canadian Army liberated the region. Josephine's diary account of that day describes her relief and the jubilation of the population:

*Friesland was liberated by the Canadians. My host and hostess went out to see the huge trucks passing through the village street while I stood at the window of the little house. It would be as difficult for me to describe the enthusiasm of the otherwise very reserved Friesian population as it would be to put my own feelings of gratefulness into words.*

During the euphoria, the caller from the Dutch Underground arrived at her

door. She looked past him into the garden and saw a tall figure. Of that moment, she wrote:

*It came like a flash to my mind that it might be my boy. It WAS ... I cannot describe my feelings ... I had no idea that he was in Europe, let alone the Netherlands.*

Gisèle's brother, Ides, had served with the U.S. Army in Europe and North Africa. By the time mother and son reunited, he had been promoted to the rank of colonel. Decorated by the United States government, he received Dutch recognition as well with the *Officierskruis van de Orde van Oranje-Nassau, met de zwaarden*, an honor that had also been bestowed on his father.

Ides had not seen his mother for more than a decade. Prior to joining the army, he had been at university and rarely had the opportunity to spend time with his parents. He had access to classified reports and knew all about the difficulties that women like his mother had endured. Later he said that when he glimpsed Josephine from the edge of the garden, the years melted away and he felt the same joy he'd known as a little boy. He felt relieved that she had been kept safe. Josephine told her son that his sister lived in Amsterdam and that she had *onderduikers* hiding in her home. Ides promised his mother that he would do what he could for Gisèle as soon as he could reach her. It proved to be some time before that happened—the hardest months of the war for Gisèle.

Having done his duty to both the land of his birth and that of his adopted country, Ides felt anxious to resume his architectural career in the United States. But his leave-taking did not happen as soon as he hoped. He took advantage of the time and saw his mother as often as he could.

Much of Josephine's furniture and many of her keepsakes had been stored at Hainfeld, and learning that the bulk of them had been carted off by Russian looters was yet another loss. She particularly mourned a favorite mirror that had been in the family for generations.

*And yet, I am better off than most*, she wrote.

With the freedom of movement afforded to a colonel in the American army, Ides

managed to travel in a jeep to Hainfeld and rescued some of his mother's remaining possessions. Several place settings of silver, a couple of Oriental rugs, a few paintings and other special treasures had remained safe because prior to the war Josephine's sister-in-law had packed them into wooden trunks and buried them deep in the fields.

Josephine told Ides that she longed to go back to the cozy house she had shared with her husband in Bergen, but when he looked into the possibility of taking his mother there, he found it occupied by another family.

And so on August 12, 1945, two years after her husband's death, Josephine moved into the *Louisa Pension* in Roermond. At first, she only had a single room, but later a suite became available. She decorated the walls with the remains of her once-great art collection. With time, Josephine stopped mourning the loss of material possessions. Her memories remained intact, and she felt grateful to finally have a safe place where she could live out her days.

"War changes our priorities and the perspective we have. Josephine and Gisèle seemed to be polar opposites," Auntie Missy said. "But they were of one heart. In Gisèle's paintings and stained-glass panels, I see the soul of a free-thinking, contemporary woman. She has a strong, decisive character and during the occupation, she learned to cherish relationships. She also realized how much she would sacrifice to protect them."

I watched Auntie Missy walk over to the collection of framed photographs hanging on the wall by her front window. She pointed to one that showed a young Josephine holding the infant Gisèle. She tapped the glass and looked at me. "I believe that Josephine's example began shaping her daughter's personality about the time this picture was taken."

## CHAPTER TWELVE

# Gisèle's Return to America

*New York and St. Louis: 1946*

Once the war ended, Gisèle needed to repair her damaged apartment. I could picture her peering through the casement that faced the Herengracht. Knowing how much she loved trees, I know she'd have been keeping a close watch on the elm in front of her building. During the *Hongerwinter*, she had chopped off so many branches to use for fuel, she no doubt worried that she had killed the tree.

She hoped that the next spring she'd see green velvet leaves unfurling from plump buds along the trunk. She ran her hand around the perimeter of the window.

*Nature will take care of her own,* she must have thought, *but replacing the shutters will require money for lumber and a carpenter.*

Auntie Missy said that over the years she and Gisèle had many conversations about the weeks right after the war ended.

"Looking back at Gisèle's experiences, I wonder how she survived," Auntie Missy said. "When I asked her that, she shrugged and said she kept putting one foot in front of the other and did whatever she had to do. But she admitted that when the occupation ended, she felt exhausted. She had little strength left."

"We Dutch appeared to be strong and capable," Gisèle said, "but inside, we were broken. Nonetheless, day after day, neighbors stood side by side sifting through the rubble, shoring up walls and disposing of debris. We had endured physical and psychological starvation for five long years; we hoped that full stomachs and habitable homes would help us get past the pain.

"But one morning, I was forced out of my lethargy," Gisèle said. "I came into the main room of my flat and on the scarred oak table I spied an envelope."

Missy explained that the letter had come from The Netherlands-American Foundation headquartered in New York. Gisèle sat down to read the single page. It had been written by the director of the organization. He wanted her to travel to the United States and give a series of talks about the conditions endured by artists in the Netherlands during the occupation.

Gisèle wondered what she could tell the people of such a country. How would she relate with the residents of New York, the world's most affluent urban centre? She told Missy that she imagined a place surging ever upward, day and night.

By contrast, in Amsterdam she and her friends still slogged along at ground level. The young men who hid in her home and, in fact, most of the people of Amsterdam, were hesitant to walk openly along the canals or sit on the benches next to their doorways. They still felt like they needed to hide. Avoiding discovery had been such a part of their lives. How difficult it must have been to shed the ingrained fear.

"Any loud noise or even the sound of running produced a jolt of panic straight to the gut," Gisèle said.

Anger and longing for retribution foamed through the Netherlands, but Gisèle realized that the Dutch were not alone. Other European nations had suffered equal or worse damage.

The Luftwaffe's *blitzkrieg* sustained a strategic campaign that caused the deaths of 20,000 Londoners. More than a million homes were damaged or flattened during an intense seventy-six day period of heavy bombing. But the English followed the example of their Royal Family and took to heart the words of their Prime Minister Winston Churchill: "We shall fight on the beaches, we shall fight on the landing grounds, we shall fight in the fields and in the streets, we shall fight in the hills; but we shall never surrender."

British tenacity changed the course of the war. From 1942-1945, the island nation provided a springboard from which the Allies could leap and fight back.

The Parisians also had been terrorized by the Third Reich. When news of the Allied landing on the north coast of France reached Hitler, he told the military commander of Paris, General Dietrich von Choltitz, to destroy the city. Bridges were mined and other actions taken to fully follow through with Hitler's order. However, the Parisians did not stand by and let this happen. They held off the Axis forces until the American and Free French battalions arrived.

I remember reading an account written by a French civilian who fought during the Paris siege:

*We staved off the Nazis for nine terrible days. All of us were sick and exhausted. I spied a muddy salon chair atop a heap of furniture blocking the entrance to our street. How out of place it looked and how sad. I pulled it towards me, plunked it down by the curb, sat, and closed my eyes. When I opened them*

*again, I saw a piece of paper falling from the sky. It fluttered to my feet so I picked it up. Unfolding the ragged page, I read a handwritten message in English: "Hold on—we're coming." I knew this had been dropped on our besieged city by an American airman flying recognizance runs. I lifted the plush chair back to the pinnacle. It had met a noble end—and if need be—so would I.*

When the French found the hiding place of the Third Reich's commander of Paris, he surrendered without resistance. General Charles de Gaulle entered the city in a triumphal procession on August 26, 1945. France was free, but thousands of citizens had died alongside the nation's soldiers.

The horror never seemed to stop. More than a year later, buried mines exploded around Dutch farmers hoeing their fields. Country borders were drawn and redrawn.

Much of the continent's wartime leadership had been removed from power, and trials for crimes against humanity ensued. The devastated population screamed for justice and traitorous collaborators were sent to prison and often executed.

Dutch families had suffered greatly, and now they had to rebuild their lives as best they could. American, Canadian, and other Commonwealth troops walked around like heroes in Western Europe. When Gisèle told a group of friends about her cousin John, who brought her food and provisions, one of the women spoke of her own experience with the Canadian Armed Forces.

"One afternoon in June, my eldest daughter and her friends saw several men in uniform walking past the schoolyard. The children knew that the Canadian Army had freed our city, so they waved and called out, *"Dank U, Dank U."* Despite the friendly grins on the strangers' faces, the children felt afraid when one of the soldiers separated from the group and walked over to where they were standing.

"The man in uniform held out chocolate. Our kids didn't even know what it was, but they devoured it. They giggled and tried to speak with the Canadian, but obviously he couldn't understand them. My daughter told her friends that I speak other languages. And bold as you can believe, she took the soldier's hand and brought him to our house."

"The whole neighborhood must have thought your daughter was awfully trusting," said one of the other women.

"Yes, they did, and I asked the man to forgive her impetuousness. He assured me no apologies were necessary. He told me that he had a girl just her age in a place called Winnipeg. I could see how much he missed his child and on impulse I told him he could visit us whenever he wanted. He returned often and always brought treats. When his division received orders to move on to Belgium, he came to say goodbye. It was late and time for my children to go to bed. 'Would you like to tuck my daughter in?' I asked. Watching that big man pull the covers around her made tears run from my eyes."

The Dutch were conscious of the sacrifice the foreign soldiers made. These men from across the sea fought with no guarantees they'd ever see their own families again.

"Before he left our house, the Canadian asked if I could sew. When I told him I knew the basics, he took off his long woolen coat."

"Maybe you can re-cut this and make something warm for the girls?" he said.

"And I did. I made thick jackets for all of them."

Knowing what Josephine had endured and with her own terrible memories of life under the oppressive Third Reich, Gisèle no doubt asked herself again and again how she would manage to cope with the painful questions she'd be asked by the New Yorkers, people who had not experienced the *Hongerwinter* and who lived in a city where the war never physically touched them.

But she needed to be pragmatic. She assessed her options and then accepted the speaking engagement. She had debts and whether she felt strong enough or not, the offer from America would put her back on the path to financial solvency.

She prepared for her lecture series by interviewing the artists and Dutch Resistance members she knew. She combined their tales into an insightful allegory. She added particularly poignant stories that she'd heard during her conversations with the sculptor Mari Andriessen.

Like Gisèle, throughout the occupation Mari hid "undesirables" in his flat. He had been a key member of the underground resistance movement, providing false documents and ration cards to people like Gisèle. After the war, the Dutch government decorated him and commissioned a monument to Amsterdam's Dutch Resistance members who participated in the strike that was organized by the Communist Party in February 1941. He called his signature piece *De Dokwerker*—"The Dockworker".

Gisèle also spoke to Simon Carmiggelt. When the Netherlands was occupied,

he refused to work on propaganda pieces for the Nazi regime and resigned from his position at the daily newspaper *Het Volk*. In secret, he put his writing, layout and publishing skills to good use at *Het Parool*, one of the Dutch underground newspapers that circulated during the occupation.

A long sigh escaped from Gisèle's lips. How ironic that the looming First World War had been the catalyst for her family's move to America in 1915, and now, thirty years later, the Second World War's aftermath would cause her to revisit some of the same cities she'd seen as a child.

Although very much her father's daughter in terms of temperament, interests and determination, it was the admiration and love she had for her mother that shaped many of her future decisions. Moving to America had not been easy for Josephine, but her brave example impressed on Gisèle the importance of accepting and adapting to whatever life brought her way.

Arriving in New York aboard the Holland America Line, Gisèle joyfully reunited with Joep and Suzanne Nicolas.

"Living here agrees with you both. You look just the same as when I saw you off at the dock five years ago," Gisèle exclaimed.

But her friends did not chime in with reciprocal compliments. Suzanne put her hands up over her mouth. "Oh, my dear, I heard that you had a terrible time," she said.

Gisèle evaded their concerns. "There's too much I cannot talk about just yet," she said, "but I have to put it behind me and being here with you is a good way to start."

The house in Long Island had a different atmosphere than Suzanne and Joep's Dutch homes. Looking around, it seemed difficult to believe that her friends actually lived here. Suzanne said she missed the sloped thatch roof of their cottage in Groet. In the Roermond studio, the light shining through the large window cast a patina that modern American glass could never duplicate.

"We are making plans to return home," Joep told his former assistant. "I have been asked to restore as many church windows as I possibly can. I hope you will have time to help me."

"You know I will," Gisèle replied. "But first I have these lectures to give. Quite frankly, the prospect terrifies me."

Four years prior to the Nazi occupation, formal cultural and trade agree-

ments between the Netherlands and the United States had been signed. The treaty proved beneficial for both countries and in 1938 the concept for Holland House was conceived. The culture and trade center had big-name supporters, including Ambassador of the Netherlands to the United Nations, Jonkheer Henrik Maurits van Haersma de With and American industrialist, Nelson Rockefeller, who praised "new and friendly ties" between the two nations.

As soon as the Dutch had regained control of their country, The Netherlands-American Foundation looked for ways to help re-establish the economy of their partner nation.

Holland House leased a wing of a four-story building in the south block of Rockefeller Center. As one of their post-war efforts to support the Dutch cultural community, the organization extended the invitation to Gisèle. Tickets to attend her series of lectures, "Art Underground," soon sold out. This surprised and scared her. Again she asked herself, *What do these people expect me to say?*

Like my Canadian father and uncles, American veterans meant to spare their loved ones pain, but in reality, not speaking of their war experiences made their return more difficult and awkward. Wives felt anxious to help their husbands and neighbors wanted to befriend newcomers who had fled the old continent to begin their lives over again in America. New Yorkers had lived a world away from the fighting, and the opportunity to hear a first-hand account was welcome, if somewhat sobering.

My aunt's presentation and the exhibition of drawings at Schaeffer Galleries received remarkable reviews in magazines and newspapers. When she read an article in *Time* magazine, she could not believe how the Americans reacted to her story. Many years would pass before she understood the impression her bravery made on everyone who heard her personal account of the occupation.

The Dutch Ambassador to the United States, Dr. Alexander Loudon, inaugurated a second event for Gisèle at the Waldorf Astoria, attended by Dr. Eelco van Kleffens, the Netherlands' UN Security Council Delegate, and other illustrious guests.

Gisèle still wondered why so many came to hear her speak, but by this point she had learned to take advantage of her current prominence. She invited the audience to visit the exposition of drawings by three of the young men who spent time in her home: Simon van Keulen, Peter Goldschmidt and Haro op 't Veld.

During the years that I visited Gisèle at Herengracht 401, I saw a number of the drawings that had been exhibited in New York. She never allowed them to be sold. To her, they were mementoes of the time she spent with "The Friends" hiding at Herengracht 401.

Gisèle did sell her own work, though. She learned how to hold the crowd's attention by alternating objective opinion and impassioned rhetoric. Her slight frame had a weighty impact on the usually hard-to-impress New Yorkers. She also drew a large crowd when she spoke at the University Club in St. Louis, Missouri.

Indeed, a timely opportunity was handed to Gisèle. Her immediate economic problems had been resolved. When she sailed back to the Netherlands, she brought forty cases of art supplies and an equally large shipment of clothing to share with her wide circle of colleagues and friends. It had all been donated by American philanthropists, painters and everyday citizens who heard her speak.

# PART III

# FRIENDS ARE THE FAMILY WE CHOOSE

Joep Nicolas, Gisèle's mentor and friend.
(Photograph courtesy of the Nicolas family)

**CHAPTER THIRTEEN**

# Like a Phoenix

# CIRCLES

Years are divided into seasons and so are relationships. During different periods of our lives, most of us feel close to certain members of our extended families, and at other times we are in touch with different ones.

Gisèle faithfully kept up her correspondence with my father. Until he died in 1982, he received several letters from her each year along with pictures of herself, her husband, and her art. He showed them to us. Most of my brothers and sisters did not care for her interpretive style, but my sister Barbara and I were fascinated with her use of color and the subjects she chose to include in her artwork.

What I know of Gisèle's life, before and during World War II, comes from my birth family. The stories about her from the late 1940s until the start of the second millennium have been shared with me by her circle of friends—the family she chose.

By the time Gisèle turned 35, she had lived through more high drama and danger than most people do in a lifetime, and she had experienced great loss. Her grandparents, father, youngest brother and a score of friends had already passed. Her mother, two more brothers and other relatives lived far from Amsterdam.

"I had to rely on myself," Gisèle said. "But I like having people around. I don't enjoy solitude, except when I choose to be alone."

"But she rarely wanted that," one of her intimate friends told me. "Gisèle collects shells, sticks, stones, and feathers, and she collects people too. She calls us 'The Friends'—we are the family she has chosen."

In May 1947, the day before the second anniversary of Liberation Day, Gisèle watched good-natured revelers sailing along the canal. Lively music played and she could smell *bitterballen*—a fried ragout snack that vendors carried in baskets covered with immaculate white cloths.

She had decided to go downstairs to get a couple of them, but before she headed for the door, sudden excitement on the water made her eyes swing towards the canal.

She saw a young man standing up in the bow of a flat-bottomed dinghy, dangling a morsel of food over the expectant lips of his pretty companion. As she raised her body to bite the treat, he playfully snatched it away and gobbled it down. The girl laughed and lunged towards him. It looked as though their antics would capsize the

small craft. Gisèle held her hands over her eyes as the two teetered to the left. She heard the women in another boat gasp. But the sturdy little tub somehow stayed afloat, and the couple continued on their way.

*Didn't that little scene perfectly illustrate life after the occupation?* Gisèle thought. *The politicians promise that our lives will get better, but they cannot begin to provide us with what we need, and so we wobble along as best we can.*

After World War II ended, resources were needed to pay for new infrastructure, such as undersea telephone cables between the Netherlands and Britain. The Dutch felt proud seeing their nation rise like a phoenix. But rationing continued, and their homes still looked damaged and dreary.

Economic recovery was further hindered by the battle for independence in the Dutch Southeast Asian colony. Merchants from the Netherlands did not want to lose their investments, and the government could ill afford to forfeit the revenue from taxes and licensing.

Opinion was divided. The breakup of the Dutch kingdom caused opposing points of view at every level. Indeed, the world had changed and it was a challenge to keep the nation's moral compass pointed towards true north.

Gisèle ran her hand along the handsome new shutters. She knew she'd been fortunate. With the money she earned from her speaking tour in America, she was able to start rebuilding Herengracht 401.

She sat down on her sagging settee and thought how she also would like to purchase some antique furniture that she saw for sale in one of Amsterdam's better shops.

*All in good time,* she rationalized, *all in good time.*

Wolfgang walked into the room and settled down beside her. He told her about a just-released book, *The Diary of Anne Frank*. One reviewer called it, "an important reminder of our recent past."

"Why would I want to read that?" Gisèle asked. "I don't need any prompts to bring those memories to the surface."

She knew that danger still lurked no deeper than the dark waters of the canal. Politicians and world leaders continued to antagonize one another.

*Hadn't they learned? Hadn't there been enough suffering?* she asked herself.

Gisèle told Wolfgang that she had spoken with her cousin. Although the Austrian

monarchy was abolished in 1919, many still considered Maria a Countess. "From what she tells me, the Russian troops ransacked the rooms of her manor house and Hainfeld as well. They carted off all they could," Gisèle said. "But she had buried the family silver protected in strong crates deep underground."

"She sure has spunk," Wolfgang said, and when he heard the next part of Maria's story, his eyes popped wide.

Gisèle's cousin explained that in the confusing months after the bombing, the Allied prisoners of war were released from the camps and left to trudge their way home. Gaunt from hunger, and without warm clothing or sturdy boots, they urged one another onward.

"We had little food for ourselves, but when the soldiers passed our place, Mama always found something to give them," Maria said. "She could tell which men were too injured to survive the homeward march, and she'd insist they stay on to recuperate. One day, an Australian pilot arrived in terrible condition from burns he suffered when shot down by Axis antiaircraft guns."

Maria told Gisèle that a Russian refugee girl, who had come to live on their estate a year earlier, nursed the soldier back to health. "He fell in love with her. One thing led to another and she became pregnant," Maria said. "When the British troops marched through the area, the colonel had no knowledge of the romance and he insisted on taking the stabilized airman with them. I helped Mama look after the girl when her time came, and a short while later, the English officer returned."

"A pleasure to see you again," he said as he shook Mama's hand. "I'm looking for a Russian refugee, a woman with a baby.'"

"Mama wanted to protect the young mother and her child," Maria said.

"'Oh heavens!'" my mother replied, shaking her head. 'There is no such person on these premises.' She straightened her skirt and smiled at the officer.

"The army man studied her with frankness. 'I need to find the woman who nursed the Australian fighter pilot here on your estate. He has made arrangements for both her and her son—their son—to join him in Australia.'

"Mama made her eyes go wide and she rapped on her head with her knuckles. 'Oh I can be so forgetful, but I remember now. When I think about it, maybe there is such a person here.'

"And after a tearful farewell, off went the mother and her baby. As far as I know, all are happy, and living in Australia," Maria said.

Growing concern about Russia's political agenda preoccupied Western politicians. During the course of the recently ended six-year conflict, eastern Poland, Latvia, Estonia, Lithuania, part of Finland and northern Moldavia had been annexed. Other neighboring nations, including the rest of Poland, East Germany, Czechoslovakia, Romania, Yugoslavia, Bulgaria, and Albania would soon become Soviet satellite states.

The Kremlin made no secret of its intention to fully destroy Germany's capacity to wage another war by returning it to a pastoral state with no heavy industry. In a counter move, the United States announced an assistance program open to all European countries wanting to participate, including Germany—the Marshall Plan.

"The war has barely ended and already countries seem hellbent on destroying one another," Gisèle said, shaking her head. "I want no part of this lunacy."

Gisèle, Wolfgang, Claus, and Buri acknowledged that their experiences from 1942 to 1945 would always be their yardstick for the intensity of love and fear. But they had to put the Nazi occupation into the past. They needed to look forward.

"Now my home should be a haven for artists. I hope we are never again forced to hide in here," Gisèle said.

As expected, after the liberation of the Netherlands, the core group at Herengracht 401 splintered. Claus and Buri had been secreted away for so long they felt insecure about leaving the apartment, but finally Buri agreed to accompany Wolfgang to the home of the professor's friend Jannie, who had four young children.

Buri spent the entire visit slumped against a door frame. He only spoke with Jannie and her little ones when absolutely necessary. She understood his impenetrability and did not make any demands on him. Over the next months, Buri returned to her home from time to time and eventually he relaxed. She was patient and in 1948 they married. When their daughter Renate was born, to support his wife and five children, Buri, the former artist and teacher, accepted work offered to him in an Amstelveen factory.

Claus needed to visit his parents in India, but he no doubt felt conflicted about the trip; after all, he had not seen them since the late 1930s. I imagine they must

have been jubilant but stunned to learn their only child had not committed suicide. To know that he survived the Nazi occupation and Jewish persecution thanks to a Dutch woman they'd never met must have seemed like a miracle.

I never got the opportunity to speak to Claus about the reunion with his mother and father. I have no way of knowing what transpired, but he did not remain in India for long. He traveled to Manchester to begin his undergraduate degree, and afterwards to Basel to prepare his thesis in Germanic Studies. He obtained his doctorate in 1955, and from 1958 until 1964 he worked as a lecturer at the University of London. He later became a researcher at the same institution and finally a tenured professor in Germanic Studies from 1969 to 1984.

Wolfgang stayed on at Herengracht 401, but because of his nationality, the Dutch watched him and his friend, the painter Max Beckmann, with suspicion.

Prior to the start of WWII, Max Beckmann had achieved success in Germany as a painter. Like Wolfgang, he was forced to leave his home because he refused to be part of the Third Reich psychosis. Gisèle wished her own countrymen would remember that not all Germans had supported Hitler.

During the occupation of Amsterdam, Gisèle, and Wolfgang regularly visited Beckmann and his wife Quappi Kaulbach. Max also called on them at Herengracht 401. Gisèle spoke with me about the first time he saw her work.

"Max and Quappi had been at my home all afternoon. But the light of the day was fading before I got up the nerve to ask if Max would look at my paintings. He agreed and had me hold up canvas after canvas," she said. "After barely glancing at any of them, he'd yell out, 'Next! Next! Next!' I felt mortified until Quappi interrupted, 'Don't worry, dear. Max always does this. He scans everything first and makes a more detailed critique later on.'" Max Beckmann smiled and nodded. Gisèle said she relaxed after that.

Beckmann had chosen Wolfgang Frommel to be the model for at least one of the canvases, painted during wartime. In 1945, he made drawings of both Wolfgang and Gisèle. Some art critics say that the volume of Max Beckmann masterpieces is rivaled only by Rembrandt and Picasso. Max also enjoyed reading philosophical theories about the search for self, and he contributed to several literary journals. There is wide speculation that Gisèle was the muse for one of his best-known essays, "Letter to a Woman Painter."

In 1947, with help from Gisèle and her contacts at the American Embassy, Max Beckmann and his wife immigrated to the United States. They settled in St. Louis, and after spending two years there, they moved to New York City in 1949. Sadly, just twelve months later, while walking near Central Park, Max Beckmann dropped dead of a heart attack.

Back in the 1950s, Gisèle's paintings did not bring a high price. She would not become well known outside her immediate circle for decades. She needed a steady income and gratefully accepted the work her brother, Ides, offered.

Before entering the army, he had trained as an architect, and when the war ended, the American government commissioned him to oversee the restoration of their embassies and other government missions in Europe.

Ides told his sister that he needed someone to redesign the interiors. He recognized that her European taste, coupled with her understanding of the North American penchant for practicality, made her the ideal person for the job. "Because you have no formal accreditation as a designer, we need to avoid accusations that you have the job because you are my sister," he said.

"I know how we can take care of that," Gisèle told him. "I'll work under the name of van Waterschoot, and you can use the second half of our long name, van der Gracht. No one will suspect a thing."

Gisèle revamped embassies in Stockholm, Oslo, Copenhagen, Brussels, Luxembourg, and Paris. She received her pay in dollars, and soon had saved enough to cancel her debts. With that accomplished, she announced her intention to return to her easel and her stained-glass window making.

"Don't quit," Ides begged her. "I have other commissions lined up." But she stood firm and in the end, he wished his sister well. He understood that creating art meant everything to Gisèle.

Many of her friends say that the portraits she painted in the late 1940s and early 1950s are her finest work. It is quite easy to see that the Dutch expressionists and Max Beckmann had a strong influence on her work of this period.

Gisèle also did a number of self-portraits. Perhaps, like van Gogh, she discovered more about herself by capturing her likeness on canvas.

She drew the female form, yet many of her best-known portraits are of males.

Jaap Gardenier and Simon van Keulen were two of the youths who posed for her, but not all her subjects were young and virile. While walking along the street one day, Gisèle met Willem Belleman—a bewhiskered older gentleman. Intrigued by his weathered face, she invited him to her studio and made several sketches. Later, she painted him in oil.

In Gisèle's home, impromptu intellectual discussions, poetry readings and dinner parties happened regularly. Herengracht 401 became a favorite gathering place for artists, writers and other creative personalities.

Buri and Gisèle had been close during the time he hid in her apartment, but after she made her trip to the United States, he stayed away. To build a new life with Jannie and the children, it seemed as though he needed to cut himself off from the people he knew during the occupation. This was not uncommon—many survivors behaved the same way.

In 1952 the Quaker school rehired Buri, and he quit the factory job. He taught Art and German. According to Marianne Stern, a lifelong friend, he enjoyed his students, and was well-liked by the school staff. It appears that once his teaching career resumed, Buri was able to leave behind the intensity of his youth and the fearful war years.

Gisèle gained a respected reputation for the restoration of stained-glass windows and accepted orders to make new ones. In 1950, the Abbess of the Begijnhof Chapel in downtown Amsterdam commissioned an important study in glass.

Entering the courtyard of the grounds, with its tiny houses and postage-stamp sized gardens, Gisèle said she felt as though she had entered an oasis of peace.

"The origins of the Beguines lie in the twelfth century, and I want the windows to tell our story," the abbess told Gisèle. "We are unmarried women who care for the elderly and live a religious life, but we don't make monastic vows."

The reflection, prayer and silence central to the life of these women inspired Gisèle, and she undertook the project with great energy. Instead of individuals in rigid poses, she rendered a lively procession of holy men and women. She used full, rich colors, not somber tones, and breathed life into the principal figures by depicting the faces of friends and family. In the final scene, she included herself speaking with the abbess and another sister.

The collection of windows at the *Begijnhof* is recognized as a premier example of post-WWII painted-glass artistry. Until the end of her life, Gisèle enjoyed visiting the chapel to admire her masterwork.

Perhaps the silence at the *Begijnhof* made Gisèle eager to accept more social invitations than usual. Little did she know at the time, but during the period she worked on the windows, she crossed paths with two people who would be important to her throughout her life.

The first, a seemingly unremarkable meeting, occurred when Gisèle, Wolfgang, and other friends attended a concert at the Quaker school in the eastern part of the Netherlands. Joke Haverkorn van Rijsewijk, one of the senior students in the performance, remembers being impressed by Gisèle's flair.

"I felt too shy to speak with her, but I knew I'd never forget her laugh. She captured the attention of everyone in the room," Joke said. "Afterwards, I wished I had introduced myself and hoped I'd get another chance to meet her."

The second unexpected encounter happened at the British Council. Normally, Gisèle disliked formal evenings, but she had a particularly beautiful creation made by her seamstress who could uncannily copy the latest Paris designs. Since she wanted a chance to wear the new dress, she accepted the invitation to dinner.

She had no inkling that the evening would open the portal to a new life. Many of Amsterdam's socially prominent citizens attended, and Gisèle found herself speaking with the *Burgemeester*, Mayor Arnold d'Ailly.

In 1946 Queen Wilhelmina fully supported d'Ailly's appointment to the position. Thanks to his banking background, the city's influential businessmen trusted him, and because of his ability to relate to everyday citizens, they too respected him. The overwhelming task of re-building Amsterdam after WWII fell to d'Ailly, and he did not shirk it. He often walked along the canals and streets, stopping here and there to speak with the repair crews or listen to stories war widows told him.

Friends of Gisèle's who knew Arnold said that on the surface everything seemed perfect in his world, but privately, he felt unhappy and alone. His marriage had lost its relevance, and he wallowed in self-doubt. Meeting Gisèle was like being struck by lightning, and he immediately knew that she would be the love of his life. After flirting all evening, she coyly accepted his offer of a ride home and their romance began.

Arnold lived with his family at Herengracht 502, not too far from Gisèle's home at 401.

Although they tried to be discreet, the two were in love and could not stay away from one another. Gisèle had been raised as a strict Catholic and Arnold's family was from traditional Protestant stock. The post-war Dutch did not accept extramarital relationships under any circumstances, and divorce was equally shameful.

When Wolfgang Frommel learned of Gisèle and Arnold's affair, he used all his influence to get the mayor out of her life. He and d'Ailly instantly mistrusted one another. They both wanted Gisèle's full attention for themselves.

Three years later, when Gisèle completed the Begijnhof windows, her mother made a rare foray into Amsterdam to see them. She took her time studying each panel and praised Gisèle's work. She smiled at her daughter and said how it touched her to see the face of her late-husband Willem portrayed as one of the bishops. But the true agenda for her trip from Roermond to Amsterdam came when mother and daughter went back to Herengracht 401. They sat down in the parlor and Josephine begged Gisèle to stop her affair with Arnold d'Ailly.

"He is a married man," she said. "You cannot dishonor yourself, your Catholic faith or our family by continuing this relationship."

Wolfgang's disapproval and her mother's condemnation wounded Gisèle, but did not sway her. She continued seeing Arnold.

The years of unending stress had become too much. She felt uninspired in her work, and realized that she could not possibly meet the demands everyone heaped on her. *I need to get away*, she thought, *to a place where nature will restore my dead creativity.*

She stuffed a few essentials and some painting materials into a backpack and set off for Italy. There she lived in the cottage of an archaeologist in Paestum, south of Naples.

Under a dome of bluer-than-blue sky, mesmerized by the gentle waters of the Gulf of Salerno, Gisèle spent her days drawing the broken statues and Doric columns of the ruined Roman city. Her attention to minute detail and the use of allegory was likely established during that retreat-like trip. Afterwards, the juxtaposition of natural beauty, myth and classical form became a reoccurring theme in her painting. And Gisèle seemed more determined than ever to live according to her own terms.

With a renewed spirit, she returned to Amsterdam. Rounding the corner, she saw her building with fresh eyes. She felt welcomed and protected.

How fitting, she mused. During the war, the code name for Herengracht 401 had been *Castrum Peregrini*—"The Fortress of the Pilgrim."

"If anyone came to our door and whispered that password, we let them in," Gisèle said. "Yes, it was dangerous for those of us already in the house, but how could we turn them away?"

She shook off her pack, left it in the entranceway, and greeted Wolfgang. He had been reading by the window in the living room, but closed his book when he saw Gisèle watching him. "Did you have a wonderful time?" he asked.

Gisèle urged him to move to the couch and sit down with her. She placed her hand on top of his. "Yes, I did. My mind and spirit feel scrubbed clean, and I am sure of one unchangeable fact. After all that you, Buri, Claus, and I went through, we are a family," Gisèle said. "No matter who else comes into my life, this cannot ever be negated. This place will always be your home."

Wolfgang Frommel took her at her word and, in fact, never left. Herengracht 401 was his home until he died in 1986.

When the two met in Bergen, he represented adventure. There was nothing Gisèle craved more than that, except perhaps a strong leader to follow. And Wolfgang had that quality as well.

Interesting, intellectual people came into her life through him. Gisèle and Wolfgang spoke German together, which she liked, because Dutch was not her most fluent language.

Throughout the war years, Gisèle believed that she, Buri and Claus were safer with Wolfgang in the house. She had faith in him, and on several occasions, he lived up to that trust. However, he relied on her to provide the food and assume risks that he refused to take.

Some of Gisèle's friends have suggested that he represented a father figure to her, and for this reason she accepted his authority. Others have gone so far as to use the term *Svengali* when describing the way he dominated and manipulated Gisèle's person and her creativity.

Like many artists, she felt insecure about her work. She craved Wolfgang's approval, but he doled that out in minute doses. In fact, Gisèle's art was not to his taste, and he used to tell her that. Her constant attempts to live up to his expectations

possibly explains why she agreed to the next idea he presented.

In Germany, Wolfgang had been involved in publishing. He told Gisèle that forming a literary society would be the ideal way to keep "The Friends" circle intact. Also, if the group published a magazine, it would help to re-establish the cultural eminence and heritage of Germany, particularly, the poetry of Stefan George.

She agreed to help, and he decided on *Castrum Peregrini* as the name for both the foundation and the magazine. Chris Dekker, a close friend with some means, paid most of the start-up costs.

In 1951, Wolfgang published the first issue that featured the poetry of his personal idol, Stefan George. He also included pieces that Buri had written during the occupation.

The magazine never had a large following and, in fact, only select readers were invited to subscribe. In this respect the magazine stayed true to the secretive side of *Castrum Peregrini*'s past.

*Castrum Peregrini* provided an intellectual haven for writers, painters and photographers. Wolfgang's contacts made it an international publication that won prizes for design and content. Gisèle was happy she had agreed to support the project, and proud to be associated with such a high quality and worthwhile activity.

By 1956, Joke Haverkorn van Rijsewijk, the student from the Quaker school who admired Gisèle's style, had become a weaver. She felt ready to go to Herengracht 401 and speak with Gisèle.

She showed samples of her work and felt flattered when the established artist praised her skill. Gisèle liked motivating young talent. She and Joke sat puffing on Gauloises until the room filled with blue-tinged smoke. They shared amusing stories, and Gisèle revealed that her wardrobe included pieces by the exclusive designer Dick Holthaus. She confessed that she traded her paintings for the clothes.

*Aha! That explains how you always look so stylish,* the younger woman probably thought.

Darkness fell and their conversation deepened. Gisèle talked about the war. She showed Joke how Buri hid in the refitted piano during the *razzia*—the raid. She also spoke of the time she rode on the back of her neighbor's bicycle to Camp Amersfoort

to see her friend Simon van Keulen, who had been picked up and imprisoned there.

"I bribed one of the Nazi jail keepers with cigarettes and brandy in order to gain entrance into the area where Simon was held," she said. "I nearly passed out when I saw what repeated torture had done to him."

Obviously, Simon had grown too weak to be of any use to his captors. In German, Gisèle asked the drunken guard what would happen to her friend, and she learned that his name was on a list of prisoners to be shipped out by train. She would never see him again unless he escaped.

"You are going to die if you don't get away. You might not make it, but that will be better than letting them kill you," Gisèle told Simon.

The young man agreed, and he found a way to throw himself off the train. His captors must have shot at him, but missed their target, and Simon dragged himself back to Herengracht 401.

I cannot imagine the euphoria the *Castrum Peregrini* circle felt when he appeared. Gisèle said it was like seeing *Lazarus* rise from the dead.

"But he could not get past his ordeal," she remembered. "He never recovered, in mind or body."

She finished her story about Simon by telling Joke that he might have been a fine artist and how she cherished the memories of the two of them, drawing by candlelight when he visited Herengracht 401 during the occupation.

Joke felt humbled by Gisèle's past and by her modesty.

"I thought she was incredibly heroic, and I was not alone," Joke said. "Gisèle inspired admiration in everyone she met."

The young woman did not have any money, a studio, or employees. However, Gisèle found a way to surmount these obstacles and they set up a weavers' studio called *De Uil*—"The Owl." Gisèle designed, Joke and other women wove, and together they created some of the most highly acclaimed Dutch tapestries of the period.

*De Uil* won major contracts. Unique weavings made on the studio's looms decorated the Holland America Line cruise ships, the headquarters of Shell Oil, and the offices of other international companies based in the Netherlands.

During this period, Gisèle and Joke strengthened the friendship that would weather the test of time. It seems Joke was the best female friend that Gisèle ever

had. The two women understood and respected each other—warts and all. I believe Joke provided a counterbalance to the over-exuberance Gisèle sometimes could not control. In turn, Gisèle introduced Joke to *her* world.

The orders piled up in the studio. As well, Ides repeatedly asked Gisèle to return to her job as a decorator. She was still seeing Arnold d'Ailly, and he came down hard against any additional work. He already had enough competition for Gisèle's time from *Castrum Peregrini* and *De Uil*.

When he asked if all her activities and interests didn't make her tired, she shot back, "I don't have time to be tired!"

Arnold wanted Gisèle to take him more seriously. He told her that he planned to divorce his wife. He knew that Queen Juliana and her mother, Wilhelmina, would ostracize him, but he didn't care. He wanted to be free so he could marry Gisèle.

She told me that when Arnold informed the monarch of his decision, "the Queen was not amused" and would never again acknowledge d'Ailly in public. She promoted Dutch values and culture, didn't understand his feelings and didn't want to.

Gisèle felt guilty that he had given up so much. She adored Arnold, but she would not agree to marry him until her mother died. She said she could not become his wife and hurt Josephine. "My mother has been through so much disappointment in her lifetime," the devoted daughter said. "I cannot inflict more." She wanted Josephine's last years to be serene. "We need to be as discreet as we can and have patience. Mama lives 175 kilometers away, so it isn't so hard, is it?" she asked.

When Arnold d'Ailly left his position as mayor, he returned to the banking world. In January 1957 he was appointed director of the National Commercial Bank NV in Amsterdam.

Those who knew Gisèle in the 1950s felt inspired by the world she created at Herengracht 401. Everyone who lived or stayed there, even for an evening, was infused with Gisèle's vivaciousness.

Marianne Stern, a Classics major, had lived away from the Netherlands during the war years. She too became a great friend to Gisèle—they enjoyed exchanging tales about the American cities they'd both lived in.

Marianne and Joke were, in a way, Gisèle's protégées. For a time they lived on

Beulingstraat, a small street around the corner from Herengracht 401. During those years, Amsterdam was dreary; people shuffled around in long dark coats, but Gisèle's world was light and happy.

"At Herengracht 401, artists and travelers from many countries came by all the time and I learned about the world from listening to their conversations," Marianne said.

Joep Nicolas had returned to the Netherlands, and Gisèle worked with him on the repair of Delft's *Oude Kerk*—the Old Church windows. This did not sit well with Arnold because she spent many nights away from home. He knew that she and the Nicolas family meant a great deal to one another, but he wanted to be Gisèle's priority. D'Ailly resented sharing Gisèle with Joep, his wife, the two daughters, or anyone else.

The windows that Joep Nicolas restored in Delft are said to represent the pinnacle of his long career. He put all his expertise into the restoration, and Gisèle assured him the panels would be his monument. It must have been a pleasure for her to assist her mentor and friend with his legacy project.

When Josephine died in 1955, Arnold did not insist on an immediate wedding. He knew it would be best to bide his time. Gisèle had loved her mother deeply and even though she did not share Josephine's traditional values, she respected them. Her late father also held an important place in her heart. She had his remains disinterred from Roermond, and she laid him to rest beside her mother in Beverwijk. The cemetery was not far from Amsterdam. She would be able to visit the graves of both her parents as often as she wished.

Willem and Josephine had given their daughter an identity. They made her feel that she had a singular place in the world. They supported her creativity and mostly turned a blind eye to the behavior they didn't approve of. They had loved her, and she grieved for them.

However, by 1958 Arnold felt he had waited long enough. He insisted that Gisèle drop her work with Joep Nicolas and that their wedding be planned as soon as possible. He had divorced his wife, renounced his position as mayor, and waited until Josephine's death and funeral had passed. When he saw that the estate had been settled, he told Gisèle the time had come.

She accepted that marriage to Arnold was the logical next step. But before she became

his wife, with the money she inherited she bought the entire Herengracht 401 building.

The tenants on the first two floors refused to leave, but eventually she evicted them. She had clear title and possession of her pilgrims' nest and she was ready for the next stage of her life to begin.

Now she could marry Arnold. The date was set—July 29, 1959.

To avoid prying eyes, Gisèle and Arnold married in Cornwall, England, at the home of Josephine, Gisèle's niece. The couple had know one another nearly a decade before becoming man and wife. Gisèle had sworn she would never tie herself down with a husband or children, but marrying Arnold and continuing to support her *Castrum Peregrini* family is how she had ended up. Life certainly was not following the master plan she set for herself at nineteen.

Maybe it would turn out even better?

CHAPTER FOURTEEN

# Life with Arnold

*All over the world: 1959–1968*

Gisèle strolled slowly back from the bakery swinging a brown paper bag filled with fresh *saucijzenbroodjes*—sausage rolls. Still warm, she figured the savory pastries should satisfy the breakfast requirement established by the men of her household.

She loved every creative thing except cooking.

She set three places. Her mother's aqua-and-white Austrian china matched well with the rustic wood table. A branch of blossoms in a clear glass jar added just the right touch.

Arnold hugged her from behind and nuzzled her neck. "This is pretty," he said. "Let's eat before Wolfgang wakes up."

Gisèle closed her eyes and sighed.

"Perhaps now that you and Arnold are married, Wolfgang should find another place to live," a friend had suggested. But Gisèle stood firm. She knew the two men did not get along, but they kept out of one another's way. She had learned to ignore the snarky comments they made from time to time.

"Yes, darling, sit here beside me," she said, pointing to her right. She looked closely at her husband. Although Arnold was older than she, he was handsome and gallant. This morning he'd already shaved and combed his thick white hair into place. She knew he did not feel completely comfortable in the apartment at Herengracht 401. He disliked that other people were always around. But Arnold had stubbornly staked out his own territory and set up an office on one side of the living room. To Gisèle's delight, in the corner he planted a cactus-and-succulent garden complete with salamanders.

"This evening I'm going to meet friends, and we plan to see the show at a new gallery. Will you come?"

"Why don't you stay home with me?" Arnold asked. "We have waited so long to be together."

Gisèle didn't like the way the conversation was going. She folded her napkin and placed it on the table beside her plate. She had not finished her breakfast, but she pushed her chair back and stood up. "When you fell in love with me, I lived my life

this way. Why should things change now? You don't want me to become a boring housewife, do you?"

Not giving him a chance to argue, she walked calmly away. Arnold shrugged his shoulders. He would need to think up a new strategy.

A couple of afternoons later, they sat on the roof watching the sun slide down behind the steeple and peaked roof of the Krijtberg Church. Gisèle pointed out the way the colors melded into one another.

"I need to remember that fusion of yellow-orange-red into pink-violet-blue so I can use it in a piece I want to start soon," she said.

Arnold's secure finances had made it possible for her to stop painting what other people wanted. Soon after their wedding, he suggested she give up working on commissions and create only what brought her pleasure.

"Your imagination should be your only limitation," he said, adding, "We both know that your imagination has no limit, so, Gisèle, you are free."

She loved that freedom, yet she did not feel at ease with some of the other restrictions Arnold wanted to put on her. She liked going out, but if she didn't let him know her plans, it disturbed him. And to say that he and Wolfgang did not get along would be a gross understatement. Wolfgang no doubt feared that Arnold would convince Gisèle to turn him out. After all, her husband told everyone that her old friend had overstayed his welcome.

Arnold could not understand the bond. In fact, no one could. Gisèle had promised Wolfgang, Buri and Claus that they would always have a home at Herengracht 401, and she would keep that promise. True, Buri had married and she missed him; nonetheless, she wished him happiness with Jannie and their brood. Claus was involved in his studies and she barely saw him. She could live with that too. He had such a prodigious intellect, and she felt proud of his career. But Wolfgang would never marry, and would never again be a university student. *Castrum Peregrini* was his entire focus. The foundation was part of Herengracht 401 and so was he.

She smiled at her husband and moved into his arms. Sooner or later, Arnold would have to accept her way of life and respect the promises she had made to her circle of friends.

Gisèle closed her eyes so Arnold wouldn't see the worry she felt. She knew he loved her, but she also wondered if he sometimes regretted their marriage. He'd always been a welcome guest at Amsterdam's best dinner parties. Men found him easy to talk to and women felt flattered by his courtly compliments. Gisèle had tried to be a part of that world, but as the second wife, she did not receive a warm welcome or the respect his first wife had enjoyed.

No doubt about it, Arnold and Gisèle received few invitations. A certain drop in number would have been normal, but as the requests dwindled to just a few each month, Arnold must have realized that because of her, he'd been cast out of Dutch society. Did that not bother him?

When Gisèle asked, he shook his handsome head back and forth. "I knew that my life would swing 180 degrees when I married you, and I felt ready to pay whatever price came with that," he said. "Now I am even more willing. You are the person I love."

He knew about her difficult past.

Arnold felt Gisèle had been through a lot, and he resolved to change that.

Part of Arnold's consulting job with the bank involved travelling to countries that had applied for economic aid. He would assess their eligibility and make recommendations. Gisèle's eagerness to see the world fit in perfectly with this aspect of his work. When they were away from Amsterdam, she was all his. There was no Wolfgang Frommel or *Castrum Peregrini*. He did not have to fake interest when he came home and found that a dozen artists and writers had invaded his living room.

Turkey was one of Gisèle's favorite countries. One hot, humid night the two of them dined on the terrace of their Istanbul hotel and watched the pelicans soar high in the sky. They would circle lazily for a long time and then suddenly plummet into the ocean.

"It's amazing how they fold their wings into the dive," Arnold said. "The fish don't even see them coming."

"Look at their satisfied smiles as they wolf down their dinner," Gisèle said.

"How wonderful it is to be here together," he added, opening his arms.

With a contented sigh, Gisèle snuggled into her husband's embrace.

Back in Amsterdam, she turned secretive. "Don't you dare go into my studio

until I say you can," she warned Arnold. He wondered what she was up to, but she didn't keep him in suspense for long.

"I have a surprise," she said. "I'll show you tonight."

All day long Arnold braced himself. He had learned that Gisèle could just as easily produce a "wonderful surprise" or one he would not be keen on. With some apprehension, he opened the door at 7 p.m.

Draped in scarves like the veils of a harem dancer, his wife threw herself into his arms, and then led him to the dining area. Arnold shook his head—at almost fifty years of age—she still liked to dress up. He didn't mind that she could not cook—the dishes of dates, olives, and hummus she had artfully set on a crimson table cloth tasted exotic and exciting. The newly hung painting on the other side of the table transported Arnold back to the Turkish terrace. Gisèle's pelicans took his breath away.

She stepped back and observed her husband. "Do you remember?" she asked. "I thought if I hung the birds here, we could look at them, and in our minds travel to Turkey every time we sit down to eat."

Even eons after Gisèle painted those pelicans, her eyes would turn bright when she looked at them. They captured a moment and feeling she wanted to hang on to. She displayed hundreds more memories on all the walls of her house. When she ran out of space, she stacked them in the corridors and on windowsills. From time to time, she wrote poetry and prose, but it is her paintings of people and places, of rooms and gardens, of events and gatherings that best tell the story of her long, rich life.

Although Arnold didn't enjoy a lot of people coming to Herengracht 401, he put up with the daily onslaught, and he had to admit that some of the women were charming—like Ineke Schierenberg.

Ineke told me she first saw Gisèle when she was fourteen. "My father took me to an exhibition of local artists and she was the best—no doubt about that."

When I visited Ineke at her home in 2009, the memories of that long-ago first impression made her face glow. "When I turned eighteen, my friend Sylvia Nicolas introduced me to Gisèle. I told her about my dream of learning to paint in Amsterdam. I gathered up all my courage and asked if she might have a way to accommodate me. Gisèle nodded, and then agreed to give me a room in exchange for cooking duties."

Ineke wrung her hands and looked up at the ceiling. "Cooking? I didn't know how to cook. In my home, we had a servant who did that. But I didn't tell Gisèle I knew even less about what to do with pots and pans than she did. This was my chance to become a member of her circle, and I did not intend to miss out. I told her that I needed to go get my things and that I'd return on Monday."

When Ineke arrived at her family's home, she gave her mother a quick kiss, and then ran off. "I need to learn my way around a kitchen—this weekend. Can we start now?" she asked the startled help.

The cook told her to roll up her sleeves.

Ineke slapped her palms on her thighs and laughed at the memory. "Gisèle did not expect any complicated culinary productions, and thank god I am a fast learner. She did insist on a superbly set table, though, and I could manage that." She winked at me. "I have a few more talents, as well, so I fit in at Herengracht 401."

Gisèle liked surrounding herself with lovely young people like Ineke.

"My family was staid and I craved adventure," Ineke said. "Watching Gisèle prepare the backdrops for an opera to be produced by Rex Harrower was one of my first experiences at Herengracht 401. Gisèle was so dramatic, and I couldn't have been more impressed."

"With her long blonde hair, bright blue eyes and her height, Ineke looked like a film star," said another of the women who often went to Herengracht 401. "I would have been jealous of her, Gisèle too, but Ineke's personality drew us all under her spell."

Ineke gave a long slow smile and hugged her arms around her waist. "Yes, we were happy together," said Gisèle's cook who couldn't cook. "I learned composition, painting, and interior design from her. We both love beautiful things and original ideas."

In 1960 Arnold resigned from his position at the bank and fully retired.

He and Gisèle spent more time than ever traveling to exotic locales, and they came in contact with even more interesting people than at Herengracht 401.

One day in Athens, they had gone shopping and Gisèle bought a frog figurine. The store clerk wrapped her purchase and then put it into a bag. Gisèle liked to tease Arnold, and she carried on as though a live creature was held captive inside.

Putting her mouth up to the top of the bag she asked, "Are you alright in there? Is there enough air? Can you breathe?"

By chance, Margot Fontaine and Rudolf Nureyev were browsing through the same shop. Intrigued by the way Gisèle caressed and spoke into the bag, Rudolph focused his attention on her. "I don't mean to intrude, but what have you got in there?" he asked.

Gisèle knew she had been approached by the most famous dancer in the world, but she did not show any recognition. "*Oh-oh-oh*, I have a beautiful frog in here." She smiled at him and held out the bag so that he could admire it.

"Open it up and let me see!" Margot demanded. She looked as excited as a child.

Gisèle winked at her, and showed the pair her "pet." Even though the frog was obviously not alive, she continued to speak as though it was. "You should see how high he leaps!"

The two couples left the shop and drifted towards a sidewalk table. They settled down to have lunch together. Gisèle never ate much and Margot only picked at her food. Both women seemed to feel that their spontaneous afternoon was more interesting than the rice with mint and skewers of lamb. Before they got set to go their separate ways, Rudolf invited their new friends to be his guests at a performance he and Margot would give at the Acropolis in three days.

"We can't. I'm sorry, the boat we need to catch sets sail tomorrow," Arnold said.

"No matter," Margot replied. "Can you come and watch us rehearse tonight?"

Several hours later, Gisèle and Arnold sat alone in the ancient theatre watching the world's premier ballet duo perform for them alone.

Sultry night air, soft lighting, and the briny smell of the sea awakened all of Gisèle's senses. "The stage is like a canvas," she said, "and watching Rudolf and Margot, I feel as though an invisible artist is using them just as I use my paint brushes."

Arnold rarely allowed himself to get caught up in his wife's fantasies, but as he watched the flawless pirouettes, plies and arabesques, he asked, "Gisèle, are they perhaps moved by the Divine?"

Overwhelmed by her husband's soulful words and by the exquisite presentation, Gisèle rushed to the stage. "Margot, you are without peer. And those leaps, Rudolf, I have never seen anything more powerful."

Rudolf Nureyev laughed out loud. "My dear Gisèle, please tell me something. Will you now admit that I can jump higher than that frog of yours?"

Gisèle spoke often about Hainfeld, and the times she'd visited her Austrian family's estate. Shortly after their marriage, she took Arnold there. All of her eccentric relatives were curious to meet the man who managed to marry the cousin who said she would never wed.

Arnold was intrigued with the colorful Countess Marianne May Torok von Szendro. Actually, she had been born in Philadelphia in 1877. Her mother and Gisèle's grandmother were sisters.

Countess Marianne's life got off to a scandalous start when her parents divorced, and she returned with her mother to the family's Wassen Castle, south of Graz, Austria. At twelve, Marianne allegedly wrote articles for journals and played the piano at an intermediate orchestra level.

Soon afterwards she moved into her own apartment in Graz, and her brother introduced her to his schoolmate, Abbas Hilmi Pasha, the son of Khedive Tewfik Pasha of Egypt. He was enchanted by her, and before her twentieth birthday, the young countess married the Egyptian prince. She changed her name to Djavidan Hanum and lived in his harem as the second wife.

For some time, as the favorite, she traveled the world with him. They stayed in elite hotels and Djavidan cultivated friendships with wealthy, titled guests.

When tensions in the Middle East boiled over, Djavidan's husband helped her escape from Egypt and return to Europe. She kept her adopted Arabic name, and in 1930 she wrote a memoir called—very appropriately—*Harem.*

The book enjoyed some success, but Djavidan, much like Gisèle, needed constant metamorphosis. At different times, she made her living as a pianist, a translator, a manufacturer of cosmetics, and a stage actress.

I have heard that Djavidan actually competed with Marlene Dietrich for the coveted lead in the cinema classic *The Blue Angel,* and that she was incensed when the younger German actress won the role. Although I could not confirm this story, it sounds like something she would have done.

By the time Gisèle met Djavidan, she was elderly. And yet, when she heard about Gisèle's art, she decided to become a painter. Her work actually sold well. However, that brief career provided her with the final money she would earn. In 1968 she fell ill and died penniless in the city of Graz.

Arnold said that Djavidan's lack of discipline and consistency had orchestrated her constant failure. Gisèle had to agree. "It is important for an artist to feel free, to travel and embrace original ideas. But one needs a secure home base." Herengracht 401 gave her the stability she needed, and her husband reinforced it.

The end of anything is always a bit sad. Marianne and Joke both said that when Gisèle began spending long periods of time away from home, the magic left with her.

"Don't be like that. My muse needs to move around," Gisèle said. "I thrive in new places. But pay attention, for I am always in the wings, waiting to stir things up again. You need to keep your eyes and ears open!"

Everyone should have listened up, because that statement proved to be prophetic.

Arnold often heard Gisèle tell stories about the invigorating artistic retreat she made to Italy in 1953. He knew that she longed to return there. In the early 1960s, to please her, Arnold arranged a trip to the land of Michelangelo.

The soaring towers built between the tenth and fourteenth centuries fascinated Gisèle. During this period, ruthless nobles controlled powerful city-states throughout Italy. The towers allowed them to defend their domains. Access could be gained by underground passages, or bridges that connected with the upper stories of their palaces. The towers represented the family's power and influence—the higher the tower, the more influential the clan.

Gisèle and Arnold wanted to purchase one of the towers, and she felt disappointed when this proved to be impossible. But I think Arnold must have been relieved to be spared the steep climb up and down. He had not felt completely well for some time, but he never mentioned his aches and pains to his younger wife. He needed her to believe he could keep up with the breakneck pace she kept.

Travel stopped for a short period when Gisèle and Arnold learned that Joke had become engaged to a nephew of Wolfgang Frommel. All the friends geared up to celebrate in grand style. Arnold felt honored when the couple asked him to officiate at the ceremony. On Joke's wedding day, Gisèle stood up for the bride.

"Who else would I possibly have wanted?" Joke asked. "She was my dearest friend, my teacher, my business partner." And later, when Joke gave birth to her first daughter, she named her Helena Gisèle.

In 1965 Gisèle and Arnold visited the Greek island of Paros. She wanted to see the place where Phidias found the marble for his sculptures. During their quest, quite by accident, they came upon an abandoned monastery that the local farmers and fishermen called *Agios Ioannis*.

Gisèle felt drawn by its proportions and elegance. She went closer and traced her hands along the bleached stucco. She walked barefoot over the cracked mosaic floors and climbed up on the roof to get a closer look at the goats grazing there.

"I feel like I belong here," she said to Arnold. "Can we buy this place?"

Arnold took his wife's hand, and they made their way to the village. In the darkened church they found a trio of long-bearded orthodox priests in flowing black robes. Gisèle kept silent as Arnold inquired about buying *Agios Ioannis*.

Three heads wagged in unison. "It is not possible," one of the clergy members told the couple. "The house of God is not for sale." Gisèle's face fell, but brightened again when Arnold offered to restore the building—even though he would not own it—on the condition that he and Gisèle could live there for several months each year.

This seemed an agreeable arrangement all round and work began immediately. Masons rebuilt walls, replaced roofs and leveled the floors. Arnold shooed the goats away. The sanctuary did not have electricity or running water, but sea baths and candlelight suited Arnold and Gisèle.

"Here you have just one responsibility," Arnold told his wife. "You must paint every single day."

On Paros, Gisèle's fascination with circles deepened. She transformed fish bones, feathers, rocks, shells and bits of driftwood into works of art. She had never felt more alive. One evening as they watched the sun set, she hugged her husband and laid her head on his shoulder. "Thank you, Arnold, for bringing me here," she said.

Gisèle and Arnold only had two years together on Paros. Actually, his health had been in decline since 1962, but he'd kept that fact from his wife. When his condition became too critical to stay a secret any longer, he returned to Amsterdam. Gisèle, of course, went with him.

Arnold's illness advanced relentlessly. Gisèle took him for blood transfusions to *Prinsengrachtziekenhuis*. Stella Admiraal, one of the nurses, became a close friend of the couple. D'Ailly knew that when he died, Gisèle would have difficulties accepting

the loss. He made her promise that she'd return to Greece and keep painting. He knew her art would save her, but he could not bear to think about her going through the grieving period alone. He asked Stella to accompany his wife when the time came.

On November 24, 1967, Stella helped Gisèle hold Arnold in her arms as he passed away.

Gisèle buried her husband at the cemetery of the De Stompe Toren Church in the section she had purchased for her *Castrum Peregrini* family. She wanted all those she loved to rest eternally, side by side. During his lifetime, d'Ailly made no secret of his antagonism for *Castrum Peregrini*'s director. I wonder how he felt at the prospect of spending eternity next to him?

Stella did go with Gisèle to Paros. No doubt the recovery period was fraught with sorrow, but also with joy. One day at a time, *Agios Ioannis*, the sun and the sea healed Gisèle. And with the muses and Stella rallying around her, the passion came back. She captured her moods and memories in swirling circles. The collages she made from bits of wood, shell, and bone, as well as the mosaics she pieced together from broken tile, took on mythical themes.

On Paros Gisèle felt free and uninhibited, and with Stella providing capable and caring attention, she felt safe. If Gisèle needed to talk, Stella would sit and listen. When she preferred silence, her nurse respected that.

No doubt Stella enjoyed both Gisèle's company and life on the exotic Greek isle. During their time together, the two women bonded for life. And several years later, when Stella gave birth to a daughter, she named the child, Gisèle—just as Joke had done.

Gisèle did not seem like the motherly type; nonetheless, it seems as though both women thought of Gisèle as their "spiritual mother."

After Stella returned to the Netherlands, for about fourteen more years, Gisèle lived part-time in Paros. She continued to paint every day and grew so attached to her work that she did not want to sell it. She accumulated canvases of all sizes and styles. Art critics praised her talent, but some opined that she rushed too much at the end of her projects. These reviewers felt she should take more time on each piece and correct any imprecision. She ignored their critique. Once she had expressed her idea, she brought out another fresh canvas.

Gisèle did not think most galleries were a good fit for her paintings and she

rejected offers from all over the world to do shows. Unfortunately, she never exhibited in the one place she wanted to—*Het Stedelijk Museum*—Amsterdam's Museum of Modern Art.

Because her financial position did not oblige her to accept commissions, after 1960 she agreed to very few. Only select people had the opportunity to see, let alone purchase her paintings. I am certain that had she been a more conventional artist, one who wanted the world to see her work, she would have become famous. Fortunately, though, she did give her work to friends and family. I treasure the whimsical watercolor she gave me, a self-portrait painted in 1966.

## CHAPTER FIFTEEN

# After Arnold

CIRCLES

*Amsterdam and Paros: 1968–1982*

During their marriage, Arnold repeatedly tried to distance his wife from the past and the people who tied her to Herengracht 401.

Arnold could never fully understand the steadfast loyalty she showered on those who had hidden with her during the occupation.

When her husband died, Gisèle was fifty-five years old. All her life, the need to feel connected to others had strongly influenced her decisions and actions. She'd fully expected to live a long time with Arnold d'Ailly, and when that didn't happen, insecurity and sadness were hard to keep at bay. She turned to her old friends.

Without many subscribers, the *Castrum Peregrini* magazine must have been financially challenged. Gisèle wanted to re-establish and strengthen the ties with her friends and she offered increased support to the foundation. Now that she no longer had her husband at her side, Wolfgang Frommel, Claus Bock and Manuel Goldschmidt came back fully into her life. She was confident they would always look out for one another; she felt secure and protected.

Productive years with many issues of the magazine and the publication of critically acclaimed books ensued. *Castrum Peregrini* had a solid reputation in the literary circles of German-speaking Europe. Gisèle felt proud of her role in the success of the foundation and magazine.

From 1968 until 1982, Gisèle continued to spend time in her two homes. She loved the restored monastery on Paros as much as her traditional canal house on the Herengracht. Both places were full of history, and she felt blessed to have two refuges where she could live and work.

The primitive amenities on Paros never bothered Gisèle. She rarely worried about practical matters like electricity and running water. She and I talked about this during my visit with her in 2009. When she told me about bathing on Paros, her eyes looked as mischievous as those of a wayward teenager.

I could tell she was playing with me, teasing me a little bit.

"I took saltwater baths most days. I would simply strip off my clothes, run down the beach and plunge into the sea." When she laughed, her nose crinkled. "I suppose I was a bit naughty."

I could well imagine that the conservative Greek islanders did not approve of the naked, late middle-aged woman washing up in the surf. But I didn't react to her attempt to shock me.

She continued, "Occasionally I collected enough rainwater for a tub full of fresh water. After it had warmed in the sun all morning, I added an infusion of cucumber and fresh mint. *Ah-ah-ah*, those baths felt like heaven."

Still on the topic of water, Gisèle explained that during dry spells, a young boy from a nearby farm would strap two clay jugs of well water to the back of his donkey and deliver them to her. Candles provided light at night. Giorgios and Marouso, a farm couple who lived nearby, looked after the cooking and the upkeep of her simple home. She considered her lifestyle to be ascetic, in keeping with where she chose to live.

On the lower floor of the monastery the sun reflected off the walls of the court-yard, and diffused light flowed into her studio. This created the perfect conditions for painting because there is no glare. Pure and undistorted illumination allows the painter to discern exact color and form.

The sea and the ruins of centuries-old structures stirred her imagination. She continued to comb the beach, looking for dried bones, shells, feathers, sea glass and driftwood. In these oddly shaped pieces her artist's eye recognized figures of fanciful animals, people and sea monsters.

Her imagination startled me. Once I watched her hold a small, rough stone in her hand. She pointed out a horse, a man bent over and another wearing a hat. After looking closely at the textured creases of the rock, I managed to distinguish what she saw immediately. Gisèle had an astounding ability of observation, the hallmark of all great artists.

She liked geometric and abstract forms, but most of all, Gisèle prized circles. She saw them everywhere, and she repeatedly painted them. In the town of Parikia, Greece, she discovered a wall composed of ancient marble cylinders piled up one on top of the other. The diverse grains of the stone drums and the way they were angled on top of one another fascinated her so much that she made close to thirty paintings of the many combinations of the wall's different sized casks. To Gisèle, circles represented the passing of time, a recurring theme in her art.

Gisèle usually traveled to Paros in April, and the cold would send her packing

by November. With no way to heat the old monastery, she could not remain there through the winter.

She would spend time at Herengracht 401 during those months, or visit friends and family in other parts of the Netherlands, in Austria, England and the United States. Sadly, she never made a trip to western Canada where my family lived.

Her brother Arthur married a woman named Esther. Gisèle felt close to the couple and she regularly traveled to the Adirondacks in New York to visit them and their three children, Josephine, Judy, and Buff. Buff died in a car accident while still young. When that tragic event occurred, Gisèle must have been reminded of her brother's death nearly fifty years before. When Arthur passed away in 1982, Gisèle remained close to her nieces and their children.

Some years when Gisèle returned to Amsterdam from Paros, she brought paintings with her. Collectors wanted to purchase her canvases, but on the few occasions when she considered selling, her terms had to be met one hundred percent. She would not compromise, and refused to conform to what the gallery owners, museum directors and art critics wanted her to do. She demanded absolute artistic control and would not display her work next to that of other artists. There would be no collective shows for her.

During the most productive years of her painting career, she did allow a few German and Dutch galleries to feature her art. Among these were: The M.L. de Boer Gallery in Amsterdam, the Singer Museum in Laren and the Galerie Utermann in Dortmund. She accepted a commission to paint a portrait of her father for the Geological Survey Office of the Netherlands, located in Haarlem. Some of the offices and the painting have since been moved to Utrecht, where I believe the larger-than-life-sized oil can be seen.

Gisèle often reflected on the different periods of her life—on all she'd seen and done—but she talked most about the years of the Nazi occupation of her country. And inevitably when she did, her face looked puzzled. Even after multiple decades, she couldn't figure out how the world became embroiled in such horror.

"While mired in the dark days of World War II, we wondered if we'd survive. Desperation paralyzed me sometimes. But it ended, and many years later, I was able to be with Manuel and Wolfgang in a place filled with light. That was fantastic—fantastic!"

Gisèle described how the two men enjoyed exploring the ruins on Paros, even though Wolfgang used a cane. They seemed awed by the turquoise Aegean, so different from the Netherland's tumultuous North Sea.

The Irish poet Desmond O'Grady met Gisèle on Paros. During the academic year he lectured at Cairo University, and then spent time in Greece during the summers. He was among the friends who brought out Gisèle's wild side. They hosted parties that lasted for days. Such behavior scandalized the local population. They expected foreigners to observe their conservative social customs.

Gisèle understood this, but sometimes she could not resist the sensual allure of Paros. She explained to her friends on the island that she believed life should involve more than strict religious observance.

"God wants us to be joyful when we can. I have seen enough bleakness in my lifetime. Here I revel in the wonders that He has bestowed on your lovely island," she said.

Gisèle made rugged beauty fashionable, and the local people began to see Paros through her eyes. However, the artful, playful viewpoint she encouraged worked against her best interests. As had already happened on other Greek islands, tourism developers set their sights on Paros. In 1982 Gisèle's time at "her" monastery ran out.

A businessman from the town of Naoussa, not far from Gisèle's beloved *Agios Ioannis*, noticed that it was not occupied all year round. He lobbied the local priests to support him in a plan to operate the property for profit. He told them this had been done successfully with former sanctuaries on other Greek islands. But to get started, they needed to get rid of Gisèle.

A plot was concocted, and she was accused of pilfering antique objects, a serious crime in Greece. The police arrived at her home, arrested her, and locked her up in a jail on the neighboring island of Syros. She spent one night there. The following morning the magistrate tried to mend the situation, but he entered the battle too late. When Gisèle arrived back on Paros, she found her home had been taken over.

Gisèle did not waste time wallowing. "St. John the Baptist, the patron saint of *Agios Ioannis*, had determined that I needed to move on," she said.

Reminiscences of the past twenty years swirled around Gisèle like ghosts:

Finding *Agios Ioannis* with Arnold had been like a rebirth. Together they had set up housekeeping in the primitive surroundings. She felt grateful for the surge of creativity she experienced in that quiet place.

The freedom from conventional entrapments kept her young. But with the arrival of the tourism development team, the life she knew was dug up and ploughed under. "They wanted to bury me and my memories," she said. The eviction occurred in 1982 when Gisèle turned seventy.

When I spoke with one of my aunt's friends about the time she spent in Greece, she smiled and looked thoughtful. "Gisèle recognized the beauty of Paros long before anyone else. In a way, she was a sort of 'tourism pioneer'. But those who remember the love she showered on *Agios Ioannis* call her 'a saint'."

# CHAPTER SIXTEEN

# New Circles

*Amsterdam, The Netherlands: 1982–1998*

Gisèle told me that when she left Paros, she felt like a lost bird. She had her apartment on Herengracht, but she did not want to go there. She couldn't face all the well-meaning friends who would come calling and make attempts to cheer her up.

"I want to lick my wounds," Gisèle told Claus.

"Why don't you come to England for a while?" he suggested. "I am teaching in London. Your niece, Josephine, and her family are in Cornwall. You'd have company, but not too much."

She had always enjoyed England, so convincing herself to travel there was not a hard sell. "After all, I had little choice," she said. "I had to leave *Agios Ioannis*." She shook her head and held up her arms in a resigned gesture. "So, I summoned the same energy I have always managed to find when faced with a challenge, and I took the next step."

Gisèle rented a small studio in Hampstead, an easy commute to central London's cultural attractions. She found herself in as different a setting from Paros as she could have imagined. "On the Greek island, my neighbors had been local fishermen and farmers," Gisèle said. "And in Hampstead, I was surrounded by millionaires."

Changes and challenges were once again part of Gisèle's life. But Hampstead, with its liberal arts associations, had much to offer her. When she discovered Hampstead Heath, a rolling expanse of parkland, she knew she had found a fitting place to walk away the distress of her personal diaspora.

Within the stucco walls of her studio on Paros, Gisèle had painted large-format oils that harmonized with the sun-drenched climate. In her English cottage, she turned to smaller-sized watercolors.

At first in Hampstead, Gisèle felt that her world had shrunk, but before long, she realized that the English enclave was actually like a womb. Here she could stabilize and restore her spirit for the next incarnation.

My father's youngest brother, William (Bill) van der Gracht, also lived close by. His company had posted him temporarily to London and he told me about the days he spent exploring the countryside with Gisèle. "She acted outlandishly," he said. "She had such a sense of fun and never tired of surprising people she met. She did

not know the meaning of the word embarrassment."

"Life is so short," she told him. "We need to live each day as though it was our last and who knows—it could well be."

The death of her mother's sister, Paula, in Austria precipitated Gisèle's next move. Along with her brothers, Arthur and Ides, she inherited her aunt's estate. Following the funeral and mourning period, Hantberg Castle, Paula's property, was sold. Gisèle knew the time had come to resume her residency in her homeland. "I felt as though I should go back to the Netherlands, so that my life could end where it began," she said.

*Another full circle*, I thought.

A friend of Gisèle's told me about her return to Herengracht 401. "It was a nightmare. Gisèle figured she could waltz back in and resume her role as 'Lady of the Manor'. But the men at Herengracht 401 had set the rhythm of their days. They did not appreciate Gisèle's mothering," she said

But it seems that didn't faze Gisèle. She tended to see the world as she wanted to, and when she sensed it had tilted in a direction she didn't like, she would take steps to right it again.

The Beulingstraat 8-10 house that butted up against the side of her property at Herengracht 401 came on the market. And thanks to the money from the sale of Aunt Paula's estate, Gisèle had the funds to buy it. She figured with the additional room, her household would be more comfortable and any disaccord would be taken care of. She wasted no time second guessing, and she used part of the inheritance money to purchase and renovate the property.

After the sale had gone through, Gisèle hired architect Jowa Imre Kis-Jovak to draw the designs that would unify her two buildings. Jowa had studied interior design in his homeland, the former Yugoslavia. He later took additional architectural and 3-D training at the Gerrit Rietveld Academy in Amsterdam. Well respected for his ability to create inspiring spaces from unusual sources, his talents must have been tested to the limit by Gisèle and her ideas. An acquaintance succinctly noted that Jowa found a way to incorporate Gisèle's priorities and finish the project "without bloodshed."

Substantial structural changes gave the *Castrum Peregrini* family more living space. Individual apartments were made for Wolfgang, Claus, Manuel and, of course, Gisèle. She furnished hers with unusual pieces and her favorite canvases. Portraits

of her parents and Arnold d'Ailly had prominent places.

On the top floor, Jowa created a studio for her. She wanted "a piece of Paros in Amsterdam," and that is just what he delivered. Banks of large windows allowed light to fill the space, and the white walls replicated those of her atelier in Greece. Soon the new windowsills and every other flat space overflowed with her treasures: paintings, sculpture, stained glass, centuries-old family mementoes, feathers, stones, twisted branches and bleached bones.

Gisèle had no way of knowing that she would paint in this studio until her ninetieth birthday, twenty years hence, and that she'd continue living at Herengracht 401 an additional decade after that.

Circles, continuity and the passage of time fascinated her. Many of her paintings—and her decisions—from 1982 until 2003 reflect these themes.

Gisèle grew worried when Wolfgang's health failed during the first half of the 1980s. He seemed preoccupied, not with his death, but with the future of the literary foundation he started after the war. *Castrum Peregrini* had absorbed his life's energy and he needed assurances of its continuation.

There are many theories to explain Gisèle's next move. But no one can ever know for certain why she felt compelled to take her subsequent step.

Against her brothers' advice and that of many friends, in 1982 Gisèle signed her property over to *Castrum Peregrini*. The foundation became the sole owner of her artwork and her holdings. This act solidified the continuation of Wolfgang's legacy.

I believe she wanted her oldest friend to leave this world peacefully, and maybe she had concerns about her own advancing age. Did she wonder what would happen to her if she didn't take steps to ensure that she'd be well taken care of in the future?

And despite the concerns that her family and friends continued to harbor over the years, the arrangement ultimately suited Gisèle. Her endowment had a caveat: the directors of *Castrum Peregrini* had the obligation and duty to care for their benefactress in her home until the day she died.

Barbara van der Gracht first visited with Gisèle in 1983. She says our aunt had one additional wish. She told my sister and her husband, Craig, that she wanted the van Waterschoot van der Gracht memorabilia to remain in the family. My aunt said she was the "current steward" of the heirlooms that had been passed down through

the generations, and that upon her death, they should be distributed among the various branches of the family. My Uncle Bill said she'd told him likewise. How I wish she had legally recorded her bequest because, unfortunately, the photographs, medals, citations, the teacup painted by my great-grandmother, silver, china, the Apostle dolls, hand-printed prayer books, diaries, letters and much more seem to be lost to us now.

In the 1980s, Gisèle's art continued to be her main focus. A group of men were her daily companions. They all played pivotal, but hugely different roles in her life.

Michael Defuster, a Belgian-born architect, got to know Gisèle at a New Year's Eve party at her home in 1983.

"We liked each other very much. There was great chemistry between us," he said about their first meeting.

In 1984 Claus went into early retirement and returned permanently to Amsterdam. The following year, *Castrum Peregrini* published his account of the time he spent in hiding, *Untergetaucht unter Freunden—Hiding with Friends*. Claus also carried out other activities for the foundation and the publishing house.

Throughout Wolfgang's illness, Buri came often to Herengracht 401. He had retired from the Quaker school, yet he continued to be a respected teacher. He took on the responsibility of nursing his mentor.

Wolfgang Frommel died in 1986. He and Gisèle had known each another for more than forty years, and although their relationship had its high and low points, they had shared much during their lives. She buried him in the Spaarnwoude cemetary in the same section where her husband lay. In death, Wolfgang Frommel and Arnold d'Ailly ended up about eight markers away from one another. Another circle had closed.

Manuel Goldschmidt succeeded Wolfgang as the director of *Castrum Peregrini*, and Claus became co-publisher of the literary review. Gisèle couldn't complain. Claus and Manuel were attentive to her, but they had lives separate from hers. They were not lavish. In fact, they were austere in their dress and manner. But Gisèle sometimes felt left out, and she wondered if the people she loved most might be more interested in her resources and furthering their goals, than in her, as a human being and artist.

For Claus and Manuel, life continued to be shaped by their experiences between 1942 and 1945. Gisèle could understand their predicament because during that time,

their existence had been intense on every level.

Even forty years later, these men still needed to be with one another. They were like-minded friends. Although Gisèle had shared the years of the Nazi occupation, and she never forgot the fear of hiding, she had moved on with her life.

*Sadly, these men seem stuck,* Gisèle thought.

In the summer of 1986, Professor Alexander von Bormann, of the University of Amsterdam, received a call from Gisèle. She asked him if he knew of a student who could help with her correspondence and with organizing her archives. The professor immediately recommended Leo van Santen, a recently graduated German language and literature major.

Leo called her to set up an appointment, and laughs when he remembers how she said, "You'll recognize me by my nose."

"At our first meeting, Gisèle was dressed in black and was very animated," Leo said. "She showed me her archive, and I could see immediately that it was in a terrible state—in fact, it was in total chaos—yet I could also recognize the wonder of it."

Leo has called Gisèle's collection of papers, documents, letters, drawings and memorabilia, "a microcosm of the twentieth century."

He immediately liked Gisèle. He felt her spirit and her determination to live on her own terms were admirable.

Gisèle had been raised as a strict Roman Catholic, and even though she'd been haphazard about attending Mass for a number of years, once she moved back to the Netherlands, Holy Mass once again became part of her ritual. Gisèle went several times a week to *De Krijtberg* on Singel—the next canal over from Herengracht.

Generations of the van Waterschoot van der Gracht family had been baptized, married, and eventually rode to the cemetery from there. Naturally, when she resumed regular attendance, she chose the place she knew. Each time she went, she headed directly for the family pew on the left hand side of the main nave.

If anyone had settled in there before she arrived, she informed them, quite firmly, that she needed to sit there. Not many argued with her.

During the seventeenth century, Catholics were persecuted in the Netherlands. *De Krijtberg* was one of several hidden houses of prayer. Because Catholics had to gather in secret, the churches had code names. In English, *krijtberg* means chalk

mountain; the church received this name because the patron and owner of the house was a merchant with business dealings near the white chalk cliffs of Dover.

The current neo-Gothic structure, St. Franciscus Xaverius Church, was erected between 1880 and 1883. It was built on the lot of the previous medieval building, which explains why it is so narrow. The church is famous in Amsterdam for its collection of stained glass. Actually, two of the windows were made by Gisèle.

She found great solace in her religion. During the last decades of her life, she felt forced to accept many situations she would not have chosen. She said that going to Mass placed her in a state of grace—which she found helpful when making decisions or overcoming hurt.

No doubt Gisèle turned to her faith in the early 1990s when she found out that Manuel Goldschmidt used money he received from an inheritance to buy a home of his own in Bacharach, Germany. The old circle of friends always promised they would pool their money and live together. Gisèle had already donated the bulk of her worldly possessions to *Castrum Peregrini*—there was no turning back on that. But perhaps when the others were not as forthcoming, she regretted some of her past generosity.

In 1998 Manuel appointed Michael Defuster to be his successor as the director of *Castrum Peregrini*. Gisèle agreed with the decision.

Once she'd met Michael, he became an increasingly important person in her life. She liked the idea of having him at the helm of the foundation. A longtime friend advised her that she should insist on professional people from the publishing field to manage *Castrum Peregrini*. However, Michael Defuster seemed willing to give up his architectural career to take over the directorship of the literary foundation and that is what occurred.

# Recognition

*Amsterdam, the Netherlands: 1992–2011*

Gisèle's background shaped her sense of place in the world. Her parents lived by the principles of *noblesse oblige*. They believed that with wealth, power and prestige come responsibilities. The van Waterschoot van der Gracht family of the Netherlands and the Hammer-Purgstall family in Austria took duty seriously.

"Leaving Europe and moving frequently from one American oil-frontier town to the next had not been easy on my mother," Gisèle said, "and the loneliness during my years at boarding school was hard to bear. But Mummy and I knew what was expected of us—and we did what we had to do."

Gisèle also put loyalty and duty first during the war years. She could summon strength and resilience when she needed it.

"And when she didn't?" I asked.

"Then she became an absolute diva," her friends all told me. "When she did not have to rise above danger or privation, she expected everyone to do her bidding. She took center stage; nothing less would do."

Such a complex personality provokes curiosity and commands respect. As the media learned about her exceptional accomplishments and talent, she received numerous requests for interviews.

Once she turned ninety and stopped painting, she allowed more access to writers and journalists. She meticulously wrote down her appointments in black leather-covered agendas. Actually, she had ten years' worth of these books stacked on her desk. She consulted them when she needed to check back on events and people she had forgotten about. Those who did not know about this efficient coping mechanism were amazed at how she could remember so many dates and happenings.

"And could she ever tell a story," her friends told me. "She had such an animated face. She liked to make her eyes go wide and jump around like a rabbit. She imitated owls, frogs and sea birds. Not only was she a great artist, she was a first-rate actress."

Between the ages of ninety and ninety-eight, Gisèle gave many interviews to local and international press. They fell all over themselves in her presence, and I confess that on my various visits, so did I.

Sometimes when I saw her sitting on her divan, she seemed old and frail, but

when she realized that I was watching her, joy would bubble out. On her ninety-fifth birthday, my husband and I gave her a Mexican piñata shaped like a donkey. She pranced around her studio with it, like a ten-year-old. "This is the best present I've ever had!" she cried.

Admiration for her accomplishments not only came from individuals and the media. In the last two decades of her life, three countries recognized Gisèle for her accomplishments and heroism.

The first came in 1992. The *Bundesverdienstkreuz* is an award given by Germany to people of great valor. In fact, it is the only federal cross of merit issued by Germany.

Initially, Gisèle came to the attention of the German government for the protection she gave to German-Jewish refugees during the Second World War. Then, the selection committee learned how she had supported Wolfgang Frommel when he started *Castrum Peregrini*. The foundation and literary magazine promoted German literature and culture in the Netherlands when not many organizations were doing so.

Gisèle said the world needed to make the distinction between the Germans who wanted peace and prosperity, and those who had been Nazis. She spoke German and admired the culture.

"Why would I not help out when I could?" she asked.

The second citation bestowed on Gisèle was *Righteous Among Nations*, an honor from Israel.

Jonkheer Walther van der Does de Willebois is related, paternally, to Gisèle and me. When she received her honorable title, he and his wife, Kaisu, attended the ceremony.

To receive the designation *Righteous Among Nations*, the candidate must be nominated by a nonrelative, who completes the application, available at every Israeli embassy. Joke Haverkorn van Rijsewijk put forth Gisèle's name. Claus and Buri wrote the two testimonials that are part of every investigation process. After thorough research, the worthy candidates are invited to the annual *Yad Vashem* awards ceremony.

The honorable mention is the highest tribute a non-Jewish person can be given by Israel.

Most of the time, Gisèle enjoyed being the center of attention, but when she learned she was to receive the Israeli award, she said she felt unworthy.

"She told me that she didn't deserve to be described as a hero. I don't understand why she couldn't see how extraordinary she was—getting food and other supplies for everyone in her house—how could she believe that the honors she received were unmerited?" asked Walther.

As she always did, Gisèle explained her actions during the occupation by saying, "I was only looking out for my friends. Everyone did the same."

But they did not. Even if they'd have liked to help, many Europeans were too scared to do so. They feared that if they were discovered with *onderduikers* in their cellar or attic, their own children and elderly parents would be shipped off to a camp. What Gisèle did was indeed extraordinary.

Walther straightened up, smoothed the front of his jacket and looked at me. The emotion in his voice and eyes was unmistakable. He certainly believed that his cousin deserved to be named *Righteous Among Nations*.

"She kept those young men with her until the end of the occupation," Walther said. "And if that is not heroic, I don't know what is."

I share my cousin's assessment. I too am proud of her and the other 5,351 Dutch citizens who have been recognized by Israel for their selflessness on behalf of the Jewish people. Many of them received their awards posthumously.

Gisèle's third honor, *Ridder in de Orde van Oranje-Nassau*—Knight of the Order of Orange-Nassau—pleased her immensely. Both her father and brother, Ides, had been recipients of a similar distinction, presented to Dutch citizens who deserve appreciation and recognition from society for special service to the country.

The foundation of the Order of Orange-Nassau dates back to April 4, 1892, when the Queen Regent Emma of the Netherlands created it, acting on behalf of her underage daughter, Queen Wilhelmina. Gisèle received her award from the Mayor of Amsterdam on January 29, 2011. She was ninety-eight years old.

"I will have to come back here in a year and a half," the mayor told her. "You will have your one-hundredth birthday, and I look forward to attending your party!"

# PART IV

# GISÈLE'S LEGACY

Gisèle d'Ailly van Waterschoot van der Gracht at
95 years of age, Amsterdam, 2007

### CHAPTER EIGHTEEN

# Visits with Gisèle

# CIRCLES

Since my father's death in 1982, I'd corresponded with Gisèle by mail. I knew much about her life, but I'd never heard her voice or seen her in person. My sister Barbara met our aunt a couple of times, and when I turned fifty in 2003, she declared it time for us to go together to Amsterdam.

I immediately agreed to the trip. And in September of that year, after a thirteen-hour night flight, we North American van der Gracht girls arrived in the land of our ancestors. We checked into a hotel that proved to be much more funky than advertised online. The reception clerk assigned us a room that overlooked a leafy lane and the two narrow beds looked comfortable enough. We would be fine. However, we felt too excited to even attempt sleep. Instead we set off to explore the city. Gisèle didn't expect us to arrive at her home until 4:00 p.m.; for three hours, we walked over stone bridges, alongside canals and through throngs of bicycles. *Ah-ah-ah, we are really in the Netherlands,* I thought when we passed an old-style windmill.

We ended up on Leidseplein, a plaza full of cafes and restaurants. After a cheese plate and a couple glasses of wine, we again checked our watches—finally, the time had come for me to meet Gisèle.

As we rounded the corner onto the Herengracht, I saw an elderly woman shouldering open a heavy wooden door. It slammed behind her and she paused on the high stoop. Gripping the iron railing, her eyes swung in our direction, and when she spied the two of us, we heard a whoop. "The daughters of cousin John, my tall, strong Canadian liberator!" Barb and I hurried over and she wrapped us in her arms.

"I am so happy you are here. Come in, come in!" she said.

After offering us something to drink and hearing our assurances that we didn't need a thing, she spoke with Barb and me about our father.

"I don't know what we would have done if he hadn't come to us that day," she said. "Food was starting to become available, but it was all confused. I didn't know where to line up and the boys were too scared to go outside for more than five minutes. You have to understand, they had been in hiding for three years."

Gisèle went quiet for a minute and gave us time to digest her words.

Three years—neither of us could imagine that. When she talked about Dad, I

wondered why she described him as "tall and strong." My father was five-foot-six—a slight man. Later I asked Barb if she thought our aunt could have confused the memory of Dad with some other soldier.

"No, I don't think so," she answered. "I imagine that if I was starving and someone brought me food, he would seem like the biggest person I'd ever seen."

We loved listening to Gisèle's stories. "Our father died young," I told our aunt, "He was only sixty-one—I was twenty-eight and Barb, twenty-one. As adults, we didn't have many years with him."

Gisèle shook her head. "Such a good man," she said. "And he sat right there— where you are sitting." She sighed at the memory, then stood up and asked if we wanted to see the rest of her apartment. Barb and I rushed to follow her quick steps.

"Of course, it is very different now." She took a deep breath. "Come over here."

Paintings and family portraits covered the walls. I felt drawn to a silver-framed sepia photograph. The formal poses of women in long skirts and men in three-piece suits transported me back in time. "I remember a photograph like that sitting on my Granddad's desk," I told Gisèle.

"They are his family." She named everyone. "You know they lived close by here at Herengracht 280."

I had never been in such whimsical surroundings. My aunt made our heritage come alive.

She smiled. "Now that you know your way, I hope you'll come and visit me often."

"Watch this!" she said as she waved her arm towards five painted panels set into the wall. She picked up a remote control from a small table top and aimed it at the panels. With each click, they rotated and we saw she had painted different figures on both sides of each one. When they turned, the composition changed and we found ourselves looking at a completely different scene. I had never seen that done before.

She walked over to the area where she stored her brushes and pencils. "During the occupation when there was a raid, my friends hid over here."

Barb and I opened the cupboard and stared. I raised my hand and stroked the wall's surface. I wondered how my aunt's eclectic home could have been the setting of so much fear.

"Let's go out on the rooftop to have a look over the city," Gisèle said.

"How?" I asked. I could see no door.

"Climb up over here," she said, lifting her leg over the casement of a thigh-high window. She straddled the ledge, and then lowered herself to the other side. "This is not the small roof of the old Herengracht building, and I don't have the same view I had in 1945. This roof actually covers what used to be two houses that I joined together."

Pointing to a corner she said, "But over there your father and I spent a whole night talking."

I remembered Dad's stories, and I said I wished he could be here with us.

Aunt Gisèle patted my arm reassuringly. "Oh he's here," she said. Then she tapped my chest with her index finger. "He is right in there."

I swallowed hard.

We reversed our steps back into her living room, and she extended her arms out towards the windows overlooking the canal. "So, what do you want to do while you're in Amsterdam?" Aunt Gisèle asked next.

"We want to see the galleries, of course," I started to say, but she cut me off.

"Perfect. We'll go tomorrow. I love the Rijksmuseum."

The collection at the Rijks' features some of the Netherlands' most famous works of art, including paintings by Vermeer, Frans Hals, and Rembrandt. As a girl, I took an art history class and saw slides of the Dutch masters' paintings. The next day at the museum Gisèle said I would see the *Nachtwacht*—"the Night Watch."

When she sat Barb and me down on the bench facing the colossal-sized masterpiece, I felt like I was back in class. For an hour, she explained the precision of Rembrandt's brush strokes, his use of color, the composition of the scene and the importance of the personages' positions. I saw that most of all she loved the light.

A group of students came in to see "the Night Watch" and they too settled down to hear what Gisèle had to say.

"Who is she?" one of them asked me. I felt honored to be able to say, "She is my aunt." Gisèle smiled at them and made a little bow.

I could fill up a whole book of empty pages with the details of unusual places that Barb and I visited, and the experiences we had during those ten days in Amsterdam. But what stands out more than anything is Gisèle herself. I had never met anyone like her. Well into her tenth decade, she exuded the passion of a young girl.

Returning home to Mexico, my husband said he wanted to meet her too. We had not traveled much together and we both felt it was time to change that. "Let's go to Europe for six weeks next summer," Jorge said, "starting in Amsterdam."

I had no trouble finding Herengracht 401. Just like the previous year, Gisèle stood waiting on her stoop, and she greeted me as though I'd last seen her the day before. Then she stood back and looked Jorge up and down. She waved her finger back and forth and winked at me. "Oh, now I can see why you went to live in Mexico!"

Entering into her studio, I watched delight and awe spread over Jorge's face—he gawked at her first-edition books, ancient nautical maps and, of course, the art. "I had no idea," he whispered. "Your aunt's home is like a museum."

"I have so much more to show you," she said, "but we'll have time for that later on. It is such a gorgeous day; let's go for a walk."

"She doesn't use a cane?" asked Jorge as he watched her bound down the stairs and into the street. She teetered on the edge of the sidewalk and looked up at the broad-leafed elm.

"Oh God, don't let her hear you say that," I cautioned. "She doesn't accept any concession to her age."

She led us to a plaza near the casino, where an exposition of experimental photography had been set up. Her eyes darted from one photo to the next. "Look at how the light bounces all the way off this print and onto the one beside it," she observed.

When the photographer came closer, she grabbed his arm and asked how he thought up his ideas. At first he looked taken aback, but she ignored that—she expected a detailed answer—now!

He shrugged his shoulders in resignation. I watched her eyes as they moved from one photograph to the next.

"I look for the out-of-place detail in any scene—a lost shoe, a wilted rose, a discarded newspaper. I frame my shot so that these look to be the correctly-placed objects, and what would normally seem to be dead center is actually off-kilter."

Gisèle's eyes had gone wide. "I like that. Come and see me some time," she said. I wrote her name and address in his notebook.

Recognition dawned. Many people in the Dutch art world knew Gisèle by reputation. "I will definitely come to visit," he assured her. "Can I do anything else for you?"

"No, we're off to my grandfather's office," she announced.

Jorge and I were puzzled. "I don't know what she means," I told him. But we followed along for quite a few blocks until she stopped in front of a wooden structure near Central Station. The circular building looked old and weathered. We saw a restaurant on the lower floor, but Gisèle walked right past the tables to a perilous-looking stairway in the far corner. She ignored the NO ENTRY sign, pulled the chain aside, and started climbing. "Come on," she said.

We nervously followed and once we arrived at the top, it didn't take long for the manager to appear.

"You can't be up here," he said. His eyes looked fiery.

"Sir, this is where my grandfather had his office. For generations, my ancestors worked right where we are standing" Gisèle said. She paced all around the perimeter, and looked out a dusty window. "I used to play up here."

The man seemed intrigued, but rules needed to be enforced. "I'm sorry, but you'll have to come back down; this floor isn't safe."

Gisèle smiled in a displeased way, but agreed to leave.

We spent several hours visiting more of Amsterdam's main attractions, including the Red Light district. The ladies in the windows were somewhat surprised when the ninety-three-year-old Gisèle smiled broadly and waved at them as she passed by.

At 4:00 p.m., Jorge and I stood with Gisèle on a different stoop—Herengracht 280, the former van Waterschoot van der Gracht home.

The façade's stone exterior needed polishing—obviously, no one had lived there for many years. "It is for sale," she said. "Do you have 6,000,000 euros to spare?"

We laughed, but I could see she wished the property would return into family hands.

"We should get you home," I said. "You must be tired."

Her eyes looked like two blue light sabers as they pierced into mine.

"I don't have time to be tired," she snapped.

If looks could kill I'd have been be a goner. Certainly I would never again presume to gauge her stamina. I felt shaken by her vehemence, but then she grinned, and I could see I was forgiven.

"I'm sorry," she said, "but I don't like acting my age."

Gisèle thoroughly beguiled my husband, and in 2007 she would celebrate her ninety-fifth birthday. "Let's go see your aunt again," he suggested.

She let us know that she wanted to spend her actual birthday in quiet reflection. She planned to go to the graves of her parents and her husband.

"But I'd like to spend time with you a couple of days before," she said.

We packed some Mexican fiesta favors and off we flew.

Four hours after landing at Schiphol, Jorge and I crossed over the bridge with three arches and once again stood in front of Herengracht 401. My aunt welcomed us with her usual enthusiasm and whispered that she had a surprise inside.

As soon as we entered, two handsome middle-aged men jumped up from their chairs and shook our hands.

"Jan Stam and Henk Hoedemaker," said the taller of the two.

"How did you two and my aunt find one another?" I asked.

Jan said they watched a TV documentary about Gisèle's life, and he wrote a note to congratulate her. She responded, and that was it until he had the idea of buying a painting for Henk's upcoming birthday. When he rang the bell at Herengracht 401, Gisèle herself let him in. She said she had no paintings she could part with. However, she did have a large volume of her art that she agreed to sell.

Jan had no cash on him, and he told her he would come back for the book.

"You have an honest face, take it now and bring me the money later," she said.

The next day, he returned with euros and flowers. She invited him to visit her again. "And so began our friendship. Getting to know Gisèle has opened up a new world for Henk and me," Jan said. "Through her, we've learned about people and places we'd never heard of before."

They in turn provided my aunt with faithful companionship.

Gisèle held out her arms and invited us to sit down. "You will all like one another very much. These boys have something exciting to show you."

Sixty-year-old Jan smiled at being called a boy, and passed me a bag emblazoned with the name of a used book store. Inside, wrapped in tissue paper, I found, as expected, a book. But not just any book. This one had been written by my grandfather in 1910. "This is for you," Jan said.

My grandfather wrote in Dutch, so of course, Jorge and I couldn't read the

text, but Granddad's sketches and photographs brought the book to life. "What an amazing present," I told our new friends.

As my aunt said would happen, Jorge and I greatly enjoyed Henk and Jan's company. In fact, they made plans to come and see us in Mexico the following spring.

"I wish I could join you," Gisèle said, "but I do not travel anymore."

At ninety-five that was understandable, but how I wished we'd met her earlier in her life—and ours.

On our final day in Amsterdam, Jorge and I dined with Gisèle and Claus. He had been a central part of her life for sixty years, and she clucked over him as though he was still the young boy who took refuge with her. Claus allowed her "mothering," and talked about the days he spent in hiding. When I asked how he found the fortitude to survive, he said that the lessons Wolfgang and Gisèle gave him and the others kept their sanity intact. He said that during those dark days, he repeated like a mantra: *As long as we write poems, nothing will happen to us.* Claus Victor Bock died peacefully on January 5, 2008, in his apartment at Herengracht 401 four months after we had shared dinner with him.

As we'd hoped, Henk and Jan visited us in Mexico. By chance, my Dutch friend Hanneke, who lives in Vancouver, and her Canadian husband, Burke Corbet, were also staying in Merida at the time. The Dutch guests were happy to find out that they had ties to the same town—Bussum. During the week we spent together, we talked a lot about Gisèle's remarkable life, her art, and wartime experiences.

"I would love to write about her one day," I confided.

"Why are you so intrigued by her?" Hanneke asked.

I couldn't come up with an immediate reply, and the conversation turned to other topics. Sleep did not come easily that night. Trying to find the words to answer my friend's question had my thoughts running round and round—just like Gisèle's circles.

When I walked into the kitchen the next morning, I found Hanneke pouring a cup of coffee. She sensed I had something to say, and we sat down at my blue-and-white tiled table.

"Last night you asked why I want to write Gisèle's story. Obviously, I admire her, but when I try to describe her, I run into one proverbial wall after another because she changes all the time." I took a sip of coffee and continued.

"She is as mesmerizing as fire and her warmth looks inviting. Yet if anyone dares come too close, when she's not in the mood, she scorches them."

"She sounds like a diva," Hanneke said.

"I wouldn't call her that. My aunt can be exceedingly kind, but at other times she seems unaware that anyone else has feelings. She doesn't seek fame, but she enjoys the company of renowned people. When injustice raises her consciousness, she acts with purpose, and at other times she avoids unpleasantness to such a degree that it doubles back and bites her in the butt!"

I tried to sum up my thoughts. "Putting a label on her is futile—she'll just tear it off."

My friend nodded. "In the Netherlands older people are often eccentric, but your aunt sounds like one-of-a-kind. Hearing your stories about her over these past few days has brought back my own memories of the occupation."

Hanneke and I had known each other since the 1970s, but we'd never spoken about this before.

"Our house was close to the train station in Bussum. My mother sometimes sent us there with baskets of windfall apples she had collected around town. 'Let's see how many you can throw into the train's boxcars', she said. "She tried to make us think we were playing a game, but I now know those cars were full of people on their way to the camps."

Hanneke seemed indecisive. I didn't know if she wanted to say more or not. She stretched out the time by getting up to bring us both another coffee. Now it was my turn to stay quiet until she felt ready to continue.

"Before the war, Mr. and Mrs. Jonas had a famous floral shop in our town. People came from all over the country to buy cut flowers. As a Jewish man, Mr. Jonas knew that he and his family would be forced into hiding. One day, they simply disappeared. We later found out that the town's priest had hid them up in the bell tower for the duration of the occupation. Both parents and their five children survived, and once liberated, Mrs. Jonas wrote a book called *Eighteen Hundred Days*. Can you imagine?"

My friend looked shaken. "Are you alright?" I asked.

"I'm OK. I don't think about World War II very often, but all that happened is never far away. Anyone who lived through the years of the Nazi occupation in the

Netherlands feels just as I do. And from the way you have spoken about your dad, I can see that not only the Dutch bear scars." She gripped my hand so hard it hurt. "Just like the florist from my town wrote about her time in hiding, you need to tell the story of your dad and his cousin," Hanneke said. "If you want, I can help you."

I didn't trust myself to speak just then, but I felt more compelled than ever to write about Gisèle, her ties to my father, and, by extension, to me and my siblings.

I sent my aunt a letter that outlined my project and asked her permission to get started. A few weeks later, I received a positive reply. I couldn't believe my luck when an Internet search located an apartment for rent on Leidsegracht, right across the canal from Gisèle's home on Herengracht. I formulated my questions and designed my research methodology. I looked forward to working with Leo van Santen and becoming familiar with Gisèle's extensive archive.

I flew to Amsterdam in September 2009, and as soon as I recovered from my jet lag, I had my first interview with Leo. The pieces were falling into place.

Leo began working with Gisèle on her archives and correspondence in 1986. The two respected each other and enjoyed their time together.

"I like going to see her each week because she is different from me, and she has made my life more complete. We complement one another because I see in her a role model, who can bring me out of myself a bit. And she needs me to be sort of an anchor," Leo said.

Watching them together could be quite entertaining. As she flew around the studio, he tried to keep up with her quick hands moving his carefully filed items from where they belonged. "You are so tall," I said, "and she is tiny."

"Yes," he replied. "Her body is small, but she is big in other ways."

When they met in 1986, Gisèle and Leo both agreed that Saturday would be the best day to work on her archive, and they carried on the tradition for twenty-seven years.

For a long time, *Casa di David* was her favorite restaurant in Amsterdam, and when she and Leo finished their session each week, she liked to go there with him.

"She always insisted on paying. She would pass her wallet to me under the table, and firmly instruct me to take the money from there," Leo said.

He shook his head and said he never knew what he'd find at her house. But he organized her treasures and recorded her history with total dedication. He laughed

and then looked at me intently.

"Sometimes she would decide she wanted everything put into a different system. Can you imagine that once she asked if we could organize her letters, pictures, and other memorabilia by color? Only an artist would suggest such a thing!"

Over time, I'm sure Leo learned every intimate detail about Gisèle, but he respected her privacy. Leo cherished Gisèle, and it was easy to see that the feeling was reciprocated. I am sure she considered him her truest male friend.

I spent a delightful afternoon in the company of my cousin Walther van der Does de Willebois, who told me about the first time he met Gisèle.

"In 1953 I'd gone to see the collection of windows Gisèle made for the Begijnhof Chapel, and as the editor of a university student newspaper, I thought a profile piece on her would make a vivid lead story. I went to her house and after opening the door, she took my hand and led me to a settee by a tall window facing the canal. She had an intense look on her face, and told me she wanted to know all about our family. I asked if she knew that her grandmother and my grandfather were sister and brother."

"I remember my grandmother! She illustrated beautifully," Gisèle said.

She then jumped up and reached for a small teacup and saucer in the cupboard behind us. She held them out to me. A hand-painted scene of the Dunes near Bergen was featured on both pieces.

"Grandmother painted these. As you can see, I inherited my abilities from her," Gisèle told Walther.

He threw his hands in the air and laughed. "My cousin fascinated me, but how she frustrated me. I saw that getting a story from her would not be happening that day. Her conversation flitted from one topic to the next, just like a sparrow flying from branch to branch. She had no interest in talking about her work. After three hours, I left without any notes I could use in a story. It turned out that she had interviewed me!" Walther said.

I got to know more extended family members when I traveled to southern Austria and visited Hainfeld. Aunt Cleo had already died, and the Hammer-Purgstall family home passed into the hands of Annabella Dietz, an adopted granddaughter. As she gave me a tour through Hainfeld's rooms, patios, and cellars, the poem Gisèle wrote about the year she spent there came to life before my eyes.

*When I Was Ten* vividly illustrates the Austrian aristocracy's way of life in the early twentieth century. After meandering slowly past the onion-domed chapel and across the square courtyard, where peacocks strutted on the lawn, I came to the library. I studied the portraits of illustrious barons and counts, and I could imagine Baron Joseph Hammer-Purgstall, "the Orientalist," bent over his desk working on Arabic translations.

Annabella told me that in 1799, while stationed at the Austrian embassy in Constantinople, the Baron developed an appreciation for Middle Eastern writings. He spent the next fifty years translating the literature into German. I could see his multiple leather-bound tomes lined up on the shelves, along with those of esteemed eighteenth century writers like Sir Walter Scott, Daniel Defoe, and Voltaire.

Later that day, I felt honored to meet Gisèle's cousin, Maria Pranckh, the admirable lady with the story about the Australian airman who met his Russian wife while recuperating from battle wounds.

Maria invited me to spend a night at her home. I looked around at the profusion of medieval armor, silver trays and antique porcelain. I asked how she had managed to hang onto the valuable pieces when the Russian army sacked the estate.

Swinging her arm towards the fields and forest, Maria looked nostalgic. "Everything was buried outside, deep in the ground," she said. "Those were difficult times, but my mother set a strong example."

From Maria, I heard more stories about Gisèle. "We had a magical time with her when she brought Arnold to meet us," she said. "Out here in the country, I suppose we lived more conservatively than my cousin was used to. She always tried to shock us and loosen us up. To that end she came to the breakfast table one morning dressed up like a frog. What a character!"

Another afternoon, Joke Haverkorn van Rijsewijk and I sat on her sun-dappled patio. As she poured tea, I commented on Gisèle's amazing ability to adapt to her advanced age.

A smile lit up Joke's face and her eyes twinkled. "You know, many people don't realize that she has grown profoundly deaf. Being unable to follow the conversation is frustrating for her, so she keeps talking and avoids having to listen at all. This is just one of the ways she copes."

"She has such interesting stories," I said. "I feel lucky to hear her tell them."

Joke leaned back and observed me. "I can see that you are under her spell too. Gisèle collects leaves, butterfly wings, shells—and she collects people."

I enjoyed the straightforward, but intimate way she spoke about my aunt.

"Gisèle is tolerant," Joke said, "but if displeased, she immediately lets her opinion be known, especially with regards to art."

Joke remembered *Aura*, an exhibit mounted in Claus' apartment as a memorial to his passing. The artist used plastic to cover Claus' belongings, which she thought illustrated the ephemeral aspect of life.

"Gisèle went to see the show," Joke said, "and at first exclaimed how much she liked the way the light reflected off the plastic. Then she asked, 'Now, where's the exhibition?' When she realized that was it, she exploded. 'This plastic? NO!' She had her ideas and at her age, in her own house, she felt free to say whatever she wanted."

Michael Defuster, the director of *Castrum Peregrini*, told me that he and Gisèle had always been mutually congenial.

"She has enriched my life with her example," he said. "Her bravery and personal integrity are inspiring. She is a very positive person and I have learned from her creativity.

"But Gisèle can be a control freak," he added. "She gets over-stimulated and then nearly kills herself and the rest of us trying to do things perfectly. Many years ago, when the wife of President Pompidou was to visit here, Gisèle went through the whole house arranging and perfecting the setting for their encounter. There was road repair work being done outside, and so when she had the house as she wanted it, her efforts extended to outside. She ordered the city workers, 'Clean up this mess—NOW!'"

He continued, "She has a lot of friends and admirers who come and go. I am not usually involved with these people unless asked by Gisèle. She likes to keep her different circles separate from one another. But life is an open door for her."

Michael told me another story about Gisèle that he felt illustrated her stubbornness.

"She wanted to go to the workshop of a tradesman," he began. "I could not take her at that exact moment and for her, 'later' would never do. I tried to stop her, but she insisted on going by herself. She agreed to take the tram, but the shop she went

looking for had moved. She then got disoriented and fell. A woman passing by helped her up, and once Gisèle got back on her feet, she explained what she wanted. Apparently, the woman's son worked for the very company Gisèle was talking about. The young man went to Herengracht 401 and did what was needed. 'Everything worked out,' said Gisèle. 'Just as I knew it would.'"

With his appointment as *Castrum Peregrini*'s director, Michael Defurster also took on the responsibility of caring for Gisèle. He felt her needs were completely met and that his attention allowed her to remain in the home she loved.

Henk and Jan offered to show me the North Sea. When we got there, I rolled up my jeans and walked along the edge thinking about the generations of family members who also had frozen their toes in this frigid brine. A little later, we walked along the dunes. Although the sea felt cold, the sun was warm for the end of September, so we enjoyed an ice cream in the shade of one of the country's oldest windmills. *How Dutch is this!* I thought.

Towards 3:00 p.m., we parked near the Berlage Bridge—the same bridge my father told me he'd crossed during the liberation of Amsterdam. Henk and Jan waited in the car while I took a closer look.

When I saw the commemorative marker set into a column at the entrance to the bridge, the emotion running through me felt overwhelming. I walked solemnly over to the metal plaque and read:

> *THE FIRST ALLIED LIBERATORS*
> *WHO ON 7 MAY ALONG THIS BRIDGE*
> *ENTERED AMSTERDAM, BELONGED TO THE*
> *BRITISH 49th W.R. RECONNAISSANCE REGIMENT*
> *ON 8 MAY FOLLOWED BY THE*
> *CANADIAN FORCES*

I covered my eyes with my hands, but I couldn't keep the tears from leaking through the spaces between my fingers.

An older man, dressed in work clothes, moved from the bench where he'd been

sitting, and stood beside me. He waited for a minute, and then addressed me in heavily accented English. "Why are you upset?" he asked.

I had to choke out the words, but I managed to explain that my father had been one of the Canadian soldiers to cross the bridge on May 8, 1945. He nodded his head up and down. "I remember well," he began.

I stared at him. "You were here?"

His eyes looked like two bright blue marbles. "I was just a boy at the end of the war. I got as close as I could and cheered for the Canadians. One of them gave me a chocolate bar. I'd never tasted such a delicious thing."

And with his next breath he told me that as soon as there were no cars coming, I should run all the way across the bridge. I should then wait until I saw a second break in the traffic and run back again.

I didn't question him, but obviously, if I wanted to complete the round trip without getting run over, I'd have to move quickly. I managed the feat, and when I returned to the starting place, he put his hand on my shoulder and smiled.

"Think about this," he said, "at some point during your run across the bridge or when you came back to me, your feet stepped in exactly the same place that your father's did in 1945."

After hearing that, it took at least ten minutes to get myself under control again and make my way back to the car.

A couple of days before my month's stay in the Netherlands would end, the weather turned cold. I visited Gisèle on one of those rainy September afternoons. When she welcomed me into her studio, her alert eyes and excited voice belied her ninety-seven years.

"Come over here," she said as she teetered over to a windowsill where some of her shells, stones and other treasures lay spread out. Her balance could be tricky, and when she moved she spread her arms out for balance. She looked like a tightrope walker or a dancer.

Gisèle picked up a twisted stick and asked me if I could "see" a wondrous and fanciful being. Truthfully, I saw nothing more than a stick. She grew agitated and scolded me. "No, you need to look closer. See, there's an eye." Several centimeters further down along the stick, she pointed to the other "eye."

"But how can you say that?" I asked. "Those 'eyes' are nowhere near each other."

She reared back her head, "And so what? Why do eyes need to be right close by each other? It would be better if they were in different places. That way this crooked stickman could see all around at the same time!"

After that "explanation," she pranced around her studio, looking this way and that, just the way she described her stickman should do.

I felt grateful that during my month in Amsterdam I'd enjoyed so many days with my aunt. I feel I got to know her well. She sometimes acted silly—she liked to have fun—but at others, her words had the poignancy of a poet. I remembered a couple of weeks back, while driving with her down a shady street, she pointed at the trees.

"Oh look! It's a procession!" she said.

I had to admit that the stately elms certainly resembled a conclave of cardinals.

Such moments added first-hand observation to the facts I had researched. I felt well-prepared to begin my book about Gisèle's life.

However, while in Amsterdam I realized that not all of Gisèle's circles got along with one other. Neither did all of them like the idea of me exposing personal history.

Some of the people around Gisèle worried about how I would present the details of her complex life, and how I would write about their involvement. Although my aunt had chosen me to tell her story, I got the impression she was under pressure not to open—what my father had once called—Pandora's Box.

With much sadness, I decided to postpone writing the book. When I returned home to Mexico, I reluctantly put away my notes for another day.

In 2011, my husband and I traveled to Norway for our son's wedding. On the way, we stopped for a day in Amsterdam to see Gisèle. I admitted to Jorge that I felt nervous about visiting Herengracht 401.

"You shouldn't," he said. "She's well along in years, and she'll be happy to have company."

We met Gisèle coming out of Mass at the Krijtberg, and as she linked her arm in mine, I realized she had no idea who I was. As well, she seemed to have grown even more deaf.

Michael Defuster managed to help her understand that I was her niece who lives in Mexico.

"How lovely to meet you," she said with a bright smile. It broke my heart that such a vibrant woman had lost her memories, including those of me.

But in reality, she hadn't lost them, they were simply jumbled up. When we sat down in her studio, she commenced to tell us about her art, as though she had put down her paint brush just an hour ago. And then, midway through a description of the circular stones in Greece, she seemed to lose track and talked about her circle of friends.

She knew the Nazi occupation was over, but seemed unclear as to when it had ended. She spoke in a mix of English, French, and Dutch—in present and past tense. She didn't seem sure if Claus, Buri, Manuel, and Wolfgang would be home for dinner that evening.

She looked perplexed. "They have been away," she said, "I don't know when they're coming back." She did understand, though, that her parents and her husband had passed away. She looked at me with the happy anticipation of a child and gripped my knee. "Soon I will be flying up to heaven and I'll see them again," she said.

During our final visit, Gisèle was enchanting—her demeanor was gentle, her thoughts were random, and her smile, so infectious. She knew she would turn ninety-nine in a few weeks, but she didn't think she'd see one hundred.

When she started to nod off, Jorge and I took our leave. I hugged her tightly. I knew I'd never see her again in this realm, but felt grateful that I could look back on the day and know our circle had closed on a tender note.

Gisèle did indeed celebrate her ninety-ninth birthday that fall and she made it to one hundred in 2012.

Jorge and I toasted her accomplishment with a party at home in Mexico.

We invited some of our friends who enjoy hearing stories about Gisèle. I made *móle*, a rich chicken dish I thought she'd enjoy, and I served a tart lemon pie for dessert. Many glasses were raised in Gisèle's honor, and in her stead, we all blew out the candles I had placed on top of the pie. I made a video of the party and sent it to her.

She saw my cinematic effort, but according to Leo van Santen, it confused her. "If that is my party," she had asked him, "where am I?"

By all accounts, the Dutch one-hundred-year celebration greatly pleased

Gisèle. Friends from many different periods of her life attended. As is usual in the Netherlands when a person celebrates their centennial, the mayor showed up to pass on the city's best wishes.

In the *Stichting Memoriaal* newsletter dated February 14, 2014, Joke Haverkorn van Rijsewijk wrote a synopsis of Gisèle's hundredth birthday celebration. My friend Hanneke read the piece, and translated it into English:

*We celebrated Gisèle's 100th birthday on the 11th of September 2012. Those in attendance will never forget that day because you could see just how far her love reached, and to how many different circles of loved ones had gathered. It was as though you stood on the edge of a vortex that shot up images from time to time. The original friends are mostly gone now, but many others, like the current mayor of Amsterdam, Eberhard van der Laan, along with her Dutch, American, German, and English families, the neighbors, her church friends, and even the employees of the sandwich shop around the corner were all there to wish her happy birthday.*

*She received everyone with equal loving attention, but because of her deafness and forgetfulness, I suspect she wasn't too sure of who stood in front of her at any given time. Everyone left happily, though, with a feeling that their presence was the most important at the party. The evening was like a fairy tale—and so typically Gisèle—wherever she went, she was always the center of attention.*

Marianne Stern also wrote about the last year of Gisèle's life. In some ways, she reminds me of Gisèle. She is as inquisitive as my aunt, and is also extremely accomplished.

One evening, she invited me to her home. I admired her walls of books, the lush plants hanging in the windows, and her wonderful collection of blown glass. Of course, we talked about my aunt. "What quality do you think kept Gisèle going through the hard times?" I asked.

Marianne tucked her graying pageboy behind her ears and looked directly at me. Without missing a beat, she replied, "Her drive. Her lack of fear. She knew what

she wanted and went after it."

Her eyes softened and the corners of her mouth turned up. "Would you like to see something I've written about Gisèle?" she asked.

I assured her I certainly did, and Marianne picked up a folder off the table. "Here," she said, passing it to me. "You can take it home with you, if you like."

I felt grateful that she wanted to share her writing. But knowing that Marianne reads beautifully, I asked if I could hear the words from her lips. She seemed pleased, and as I listened to her lilting voice, I felt as though Gisèle was in the room with us.

*Until the end, Gisèle could surprise with a lucid remark. I tried to visit her regularly. The older and deafer she got, the more difficult it became to communicate, especially after her memory began to fail. When looking at picture books together was no longer an option, we played games with the shadows made by our hands. We traced fantasies with our fingers on each other's faces, or just sat next to each other on the couch, holding on tight.*

*Gisèle always smelled agreeably fresh. It is strange to think how my friends and I used to fear her sharp tongue. Now she was sweet and gentle and welcomed me by saying how happy she was to see me again. Even if it had been much longer than usual since my last visit, her words never sounded like a rebuke. I can only hope that when I am old and decrepit I will be able to make visitors feel as welcome as Gisèle did.*

*One day, as I bent over to greet her, she couldn't see me clearly because the light from the window behind us was too bright. She asked, "Who are you?"*

*"I am Marianne," I said, "And who are you?"*

*She smiled. "I was Gisèle."*

# CHAPTER NINETEEN

# Requiem

*Amsterdam, The Netherlands: May 27, 2013*

A s she always said she would, on May 27, 2013, Gisèle "flew up to heaven." She is now with her husband, mother, father, and the other family and friends who predeceased her.

Her stained-glass windows, collages, and paintings are a lasting legacy to her talent and exceptional creativity. They can be seen in multiple Dutch venues, especially in Amsterdam at Herengracht 401.

Gisèle also lives on through the stories and memories we have of her. She made every day count, even when surrounded by terror during World War II.

My aunt challenges us to listen to the creative voice we all have inside—that quiet, but insistent murmur that urges us to dream, to live, and love. If we follow her prodding, we discover that the path to happiness is most easily traveled when we are generous with our possessions and ourselves.

Gisèle, the small woman with a huge heart, bequeathed us a stellar example of a life well-lived.

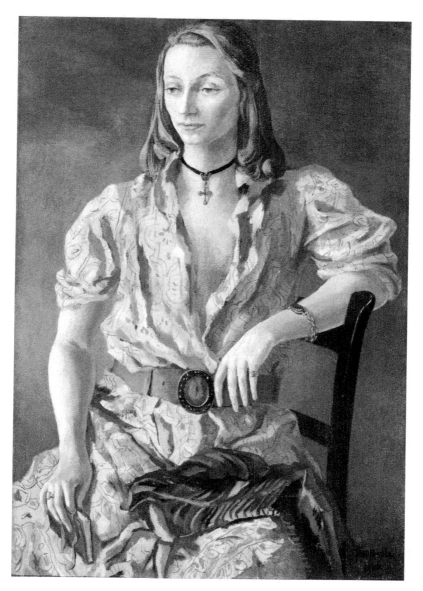

Gisèle's portrait by Joep Nicolas
(Courtesy of Roermond Foundation 1880. Photo by Hennie Reter)

# Postscript

*Mérida, Yucatán, Mexico: July 2015*

In the summer of 2013, I returned to Norway to see my son, his wife, and baby daughter. Happily, my return ticket allowed for a week's stopover in Amsterdam.

I couldn't resist a post-Gisèle visit, and yes, from the moment the plane touched down, I sensed her presence, especially when walking past Herengracht 401.

Henk and Jan had written to me earlier in the summer. We'd made tentative plans to go see my aunt's grave, yet when I called their home no one answered.

*They must have gone on a last minute trip,* I reasoned.

A few days later, I learned by email that Jan had suddenly passed away on August 30. Henk was in shock, but he managed to tell me that the memorial Mass would be held just one day before my scheduled flight back to Mexico.

I made plans to attend the burial with Leo van Santen. Gisèle had been important to Jan, and Henk seemed glad the two of us would be there. In a way, we would be representing my aunt.

Saying farewell to Jan led me to reflect on Gisèle's death. She was never part of my everyday activities, so I do not miss her physical presence in the same way that I miss the people I saw frequently while they were alive. Yet I often hear her voice—and my father's too—chattering away in a corner of my mind.

Dad always warns me to be sensible and to keep my feet firmly planted on the ground. He counsels me to be careful and save myself a lot of heartache, but not Gisèle. She urges me to cut loose, to read, to travel, to paint, and to write.

It took a while for me to figure out that both attitudes are valid. It is all a question of timing and of place. I have come to understand that I am happiest when I maintain a good balance between the love I give to my relationships and the energy I put into my creativity.

Leaving Amsterdam, my thoughts felt as dark as the rain-soaked clouds hover-

ing over the runway. Four years earlier I had stopped writing Gisèle's story because I did not want to cause arguments among her different circles of friends. Yet I never felt at peace with that decision.

To compound my frustration, in Amsterdam I bought a newly released novel loosely based on my aunt's wartime experiences. In a magazine interview, I read that *Castrum Peregrini* gave the author access to my aunt's letters. I also learned that another writer working on a biography about Gisèle would have full access to my aunt's archive. The novel has already been released in Dutch, and I heard that the biography would soon be published in the same language.

My aggravation intensified. I thought that I too should have been allowed to see the historical data about my own ancestors. I regretted that I hadn't pursued what I set out to do.

Resolution came about a few months later when I ran into my friend, the writer Michael Schuessler.

"So how's the book about your aunt coming along?" he asked.

I rolled my eyes. "It's not," I told him.

Michael looked thoughtful. "You need to ask yourself what Gisèle would do if she was in your place."

That comment resonated with me. When my aunt pursued a goal, she did not let others' opinions stand in her way. I felt like I do when my feet are ready to push off the side of the pool for a fast swim. As soon as I got home, I started poring over my notes.

And slowly, this book started taking shape. However, I have limited Dutch comprehension and many of the books I needed to research were written in that language. A friend, Ed Buss, helped me when he could, but I had a great deal to learn, and Google translator was not quite cutting it.

I wrote to my friend Hanneke and asked if she could help. She agreed and also urged me to go to the Netherlands with her. "There is still much you have to understand," she said.

I arrived in Amsterdam in early June 2014, a week before Hanneke. I wanted to have some time with my friend, Henk, and follow a few leads before she arrived.

The tulips had finished blooming, but the colors and scents of cyclamen, roses,

and peonies drifted past the wooden bench where Henk and I sat. He served tea made from the fresh mint growing in a shady corner of the garden. "We are here together because of your aunt," my friend said. "When she was alive, she drew people around her, and even though she's gone, her circles are timeless."

Absolutely right, and through Henk, I met more of Gisèle's friends. He told me that Diego Semprun, Joep Nicolas' grandson, had invited us to a retrospective of his grandfather's work in Roermond.

"It's a 180-kilometer drive from here, so we'll need to spend the night," he said. "Luckily, the museum's former curator has invited us to stay at his home."

I felt blissful to be back in Gisèle's world.

The drive through the Netherlands would have been picturesque, but the number of giant-sized trucks speeding in and out of the lanes kept my eyes glued on the road. However, Henk and I survived, and got to Joep Nicolas' exposition just as Princess Beatrix was taking her leave of the *Het Cuypershuis*. Obviously, she had a private showing prior to the other guests. Along with the rest of the crowd, I craned my neck for a glimpse, and she rewarded us all with a bright smile and a regal wave. I was startled when a fellow bystander slapped her hand across my shoulder. I couldn't make out her words, but clearly she felt pleased to be acknowledged by the king's mother. The Royals are revered in the Netherlands.

The scope and quality of Joep's work, made me fully appreciate his reputation as one of the country's premier twentieth-century stained-glass artists. The show included stained-glass panels, paintings, and family photographs.

To me, Joep Nicolas' exhibition seemed to be as much about Gisèle's life as it was about his. I saw two portraits he painted of her, and many photographs of places where she had been a part of his family's life.

Diego came over and reintroduced himself. "We met at Jan Stam's funeral," he reminded me.

My memory needed no jogging, and I thanked him for the invitation to see his grandfather's work. I couldn't help but notice how Gisèle's stained glass, and his, show the influence of their mentor, Joep.

"Glass is tricky to work with, but the way it captures light is unique," Diego

explained, "and light is what it's all about." He then took my arm and we crossed the room to meet Mariska Dirkx. "Mariska and her husband now own the property where my grandparents lived and worked. They have set up a wonderful gallery in my grandfather's former studio," Diego said.

Mariska laughed and her auburn curls bounced. "One and the same," she said, then invited us to come the next day and see the space. "We've made only minimal changes to Joep's place."

That evening, Henk and I dined at the home of our hosts, Ridsert Hoekstra, and his wife Do'. Although we sat in a Dutch garden, not a French one, the summer night air, conversation, food, and wine reminded me of the descriptions in Peter Mayle's memoir, *A Year in Provence*. I thought how much the evening would have delighted Gisèle.

The next morning our host accompanied me to the *Munsterkerk*, where four of Gisèle's windows depicting the New Testament evangelists form a backdrop for the front altar. Another three of her windows can be seen in different parts of the church.

Later that week my cousin Walther took me to see his home. Spending the day with him gave me insight into the history of my Dutch family, a long and complicated saga that can be traced back to the eleventh century. Walther has fond memories and deep admiration for Gisèle. He showed me letters, programs from her expositions and old family photographs. We both felt grateful that because of my book, we'd gotten to know each other.

Another day, Henk drove me to Bergen, the artists' colony where Gisèle met Wolfgang Frommel at Jani Roland-Holst's home. We also visited the thatch-roofed cottage in the village of Groet, where Joep and Suzanne Nicolas lived for a time. I climbed up to the loft and looked over a railing into the large salon below. With a start, I realized that Gisèle had painted the very same scene.

At the cemetery next to *De Stompe Toren* Church in Spaarnwoude, Henk and I stood beside Gisèle's place of rest. She overlooks a broad grassy field and Arnold lies beside her. Her *Castrum Peregrini* circle of friends is also close by. As she would say—*What could be better?*

Later in the week, I called on the director of the *Castrum Peregrini* foundation. I

wanted him to know I had resumed my project, and I requested the use of certain images to include in the book. Publishing used to be the focus of *Castrum Peregrini*, but now hosting and exhibition seem to be the main activities.

While in *Castrum Peregrini*'s office, I asked if I could visit Gisèle's home and studio, but one of the staff said I could not because construction work was in progress there. It seems that much of Herengracht 401's space is now used as a guest lodging. Furthermore, I read that it is possible for researchers to consult Gisèle's archive. When I asked Leo if it had been kept intact, he said he believed so, but reminded me that he has not been there since Gisèle's death.

*Castrum Peregrini* inherited the legal right to do as they see fit with Gisèle's legacy. Unfortunately, they would not allow me to reproduce any images of Gisèle's artwork nor any family photographs I had not taken myself. They said for this to be approved, I would need to hand over my manuscript so they could be the editors. I could not agree to this, and I elected to draw my own illustrations to accompany each chapter of this book. The pursuit of creative expression is a trait shared by many van der Grachts.

During my 2014 visit with Joke, she told me, "You could say Gisèle had rings of love that circled around her. The circles were prone to change, as was her art."

Then Joke turned quiet for a moment. "And, like most people, Gisèle craved love. She knew that she had missed out in some ways."

"Perhaps she regretted not having children?" I suggested.

"Well, maybe," Joke agreed. "Shortly before Gisèle died, she commented that I was lucky to have children and grandchildren. 'I wish I wasn't the end of the line,'" she said.

When Hanneke arrived in the Netherlands she helped me read the material that Henk owns—biographies about the lives of people who had been close to Gisèle, art books, and architectural digests. During his lifetime, Henk's partner Jan compiled scrapbooks of newspaper clippings, photographs, and magazine articles about my aunt's public appearances. As well, he recorded details of his almost-weekly visits with her right down to what she ate and how she dressed. I took notes as my friend translated more than fifty of his personal entries.

Hanneke clarified historical and cultural nuances for me. Through her eyes, I

received a firsthand glimpse of what life had been like for the Dutch in the Nazi-occupied Netherlands. She also shared personal memories that helped me further understand the era.

"One day early in 1944, we heard a truck racing up our street," Hanneke said. "I ran to hide in the backyard, and I heard my father dive into the secreted alcove under the floor boards of our living room. But the soldiers caught him and dragged him away. From then on, he worked for the enemy and we didn't know if he would survive."

As my friend talked, she absentmindedly pulled and twisted the chain around her neck. "On that same day, the doctor across the street was shot and killed as he tried to escape over the rooftop with his sixteen-year-old son."

I could see how the memory of that raid terrified her still.

"All on her own, my mother had to take care of us. We had a bit of property, and prior to being taken away to the work camp, my dad had planted tobacco and sugar beets," Hanneke said. "Mom harvested everything. She stored the beets safely and hung the tobacco leaves to dry in the attic.

"'These beets are what we have to eat. We need to be careful to keep them from spoiling and we can never tell a soul that we have them,' she warned us."

When I asked about the tobacco, Hanneke said, "Mother found someone who knew how to roll cigars and she bartered them for more food."

"How did she do that?" I asked, "I thought there was none."

"There was little to be had in the southern part of the country," she answered. "Mom rode her bike all the way to Gelderland—the old Dutch farmers loved those cigars."

After being with my friend for two weeks, I realized that Gisèle's telling and retelling of stories about the war was not unique to her. Many I met who lived through the experience behaved in the same way. I don't think any of them have completely recovered from the trauma.

Hanneke's niece, Reneé, who lives over in the next town, invited us for tea one afternoon. We sat together in her cozy living room, and Hanneke asked about her father who suffers from Alzheimer's disease.

Renée's mouth fell open. "You won't believe what happened the other day," she

began. "I had taken him to his sister's funeral—"

"What aunt is that?" Hanneke interrupted. "I didn't know there were any aunts left."

"I don't think you ever met her. She wasn't really our aunt, not by birth, but my father always called her his sister, so we called her our aunt," Renée said. "My father cannot express himself much anymore, but he stood up during the memorial service and said he wanted to tell us about her. Everyone shifted in their seats. We had no idea what to expect, but if he wanted to talk, we would listen."

By the wide-eyed look on Renée's face, Hanneke and I knew we'd be hearing quite a story.

"All on his own my father shuffled to the front and told the room full of people about a day when he was eight," she said. "He'd been sent to forage for anything his family could burn for fuel, but when he heard a truck stop in the square, he ducked behind a wall."

Renée looked at us with brimming eyes. "Everyone feared the *razzia*—but Dad found the courage to poke his head up over top and saw soldiers lifting little bundles out of their truck. Then they drove away. When the townspeople could not even hear the whine of the motors anymore, they ran over to see what the soldiers had left.

"The bundles were moving, so I went closer," Renée recalled her father saying.

"He explained as best he could that 'the bundles' were actually children, really young ones—laid out on the hard dirt—like trash. He saw the women pick them up and take them home. He kept watching. One bundle had been left behind."

I thought back to Gisèle's story of riding overnight with a truck full of sickly children—some of them had not made it. I wondered if Renée would tell us that her father found a dead child.

"Dad's voice strengthened and he looked straight out into the crowd," Renée said. "He brought his arms to his chest to show how he had lifted up that baby. According to him, she was so skinny and weak, she couldn't even cry. She had red hair sticking up in the few places where her head wasn't bald. He couldn't leave her there, so he stopped looking for wood chips and took her to his house.

"'She will be my sister,' he'd said to his mother and that's what she was."

Renée said his eyes searched wildly around the room. "Come get me," he called out to his daughter and spoke no more.

Hanneke and I stared at Renée. We couldn't speak either. Finding that child had affected her father so powerfully that nearly seven decades later he had managed to shed his mental confusion and honor her.

I told Renée and Hanneke that I could understand his need to talk about his sister. When I met my aunt she drew me into her circle and once that happened, I felt compelled to tell the world about her. Reconstructing her century-long life has been an honor.

Gisèle was and will always be—unforgettable.

# Glossary

Circles makes numerous references to expressions, people, places, and institutions that may be unfamiliar to some readers. For clarity, here is a glossary:

## FAMILY MEMBERS

**Arnold d'Ailly:** Post-WWII Mayor of Amsterdam; Gisèle's husband

**Arthur van Waterschoot van der Gracht:** Gisèle's brother

**Arthur Wilhelm von Hammer-Purgstall:** Gisèle's maternal grandfather

**Barbara van der Gracht-Stout:** Joanna's sister

**Djavidan Hanum:** AKA Countess Marianne May Torok von Szendro; Gisèle's cousin

**Florence Ethel Ross:** Joop's wife, John's mother; Joanna's paternal grandmother

**Gisèle (Gisy) d'Ailly van Waterschoot van der Gracht:** The protagonist of this family memoir. Gisèle and Joanna are actually first cousins once removed, but because of their age difference and out of affection, the author refers to Gisèle as "Aunt Gisèle."

**Gisella Maria Sophia Josephine Vetter von der Lilie:** Gisèle's maternal grandmother

**Ides van Waterschoot van der Gracht:** Gisèle's brother

**Joanna van der Gracht de Rosado:** Author of Circles

**John Robert van der Gracht:** First cousin of Gisèle; Joanna's father

**Jorge Carlos Rosado Baeza:** Lawyer and educator; Joanna's husband

**Joseph (Joop) van Waterschoot van der Gracht:** Geologist; Gisèle's uncle and Joanna's paternal grandfather. He moved to the U.S. with his brother Willem and family in 1914.

**Josephine von Hammer-Purgstall:** Gisèle's mother

**Lewis van der Gracht:** John's older brother; Joanna's uncle

**Margaret (Powell) van der Gracht:** John's wife; Joanna's mother

**Maria Cornelia van Waterschoot van der Gracht:** Gisèle's paternal grandmother

**Maria (Missy) van der Gracht Toomer:** John's sister; Joanna's aunt

**Mies van Waterschoot van der Gracht:** Gisèle's aunt, paternal family

**Paula von Hammer-Purgstall:** Josephine's sister, Gisèle's aunt, maternal family

**Walther van der Does de Willebois:** Gisèle's cousin, paternal family

**Walter van Waterschoot van der Gracht:** Gisèle's brother

**Walter Simon van Waterschoot van der Gracht:** Gisèle's paternal grandfather

**Willem van Waterschoot van der Gracht:** Geologist, Gisèle's father

**William (Bill) van der Gracht:** John's youngest brother; Joanna's uncle

## FRIENDS AND NON-FAMILY

**Adriaan (Jani) Roland-Holst:** The Netherlands' poet laureate at the time of WWII and close friend to the van Waterschoot van der Gracht family

**Alexander van Bormann:** A professor friend of Gisèle's who introduced her to Leo van Santen

**Buri Wongtschowski:** Draftsman who hid in Gisèle's home during the occupation

**Charles Eyck:** A friend who sheltered Buri until he could be taken to Gisèle's home

**Chris Dekker:** He helped Jewish people escape and go into hiding. He often went to Gisèle's home during the occupation of Amsterdam. Later, he helped finance the launching of *Castrum Peregrini*.

**Claire Nicolas:** Joep's daughter and author of his biography, *Fragments of Stained Glass*.

**Claus Victor Bock:** Student from the Quaker school who hid in Gisèle's home during the occupation. Later, he became a university professor and writer.

**Diego Semprun Nicolas:** Stained-glass artist; Joep's grandson, Silvia's son

**Eddy du Perron:** An acclaimed writer; Gisèle's friend who died during the evacuation of a district of Bergen

**Etha Fles:** Owner of *De Zonnebloem*, a guest house and gathering place for artists in Bergen

**Guido Teunissen:** Gisèle's neighbor on the fourth floor of her building. He helped

her hide and get food for the *onderduikers*.

**Hanneke Siewe-Corbet:** Joanna's friend from the Netherlands; author of *Forward*

**Harry (a pseudonym):** John's friend and fellow soldier in the Canadian Army who helped take food to Gisèle

**Henk Hoedemaker:** Textile artist; Gisèle's friend

**House of Orange:** The Netherlands' Royal Family. The current king is Willem Alexander. During WWII his mother, Princess Beatrix, and her siblings lived with their mother, Queen Juliana, in Ottawa, Canada. The grandmother, Queen Wilhelmina, and father, Prince Bernhard, remained in London, England, in order to be closer to their homeland.

**Ineke Schierenberg:** Decorator and designer; Gisèle's friend

**Jan Stam:** Religious icon artist; Gisèle's friend

**Joep Nicolas:** Stained-glass artist and painter; Gisèle's mentor

**Joke Haverkorn van Rijsewijk:** Writer, weaver; Gisèle's longtime friend and her partner in the *De Uil* studio

**Jaap Gardenier:** One of the young men painted by Gisèle

**Leo van Santen:** Germanist and church historian; Gisèle's friend and archivist

**Manuel Goldschmidt:** Second director of *Castrum Peregrini*; friend who often went to Gisèle's home during the occupation

**Mari Andriessen:** Sculptor and prominent member of the Dutch Resistance. After the war ended, he was commissioned to create a monument to those who staged a massive strike during the occupation.

**Marianne May Torok von Szendro (also known as Djavidan Hanum):** Gisèle's cousin who lived in an Egyptian harem

**Marianne Stern:** Classicist and blown-glass specialist; Gisèle's friend

**Max Beckmann:** A celebrated German painter; friend of Gisèle

**Michael Defuster:** Third director of *Castrum Peregrini*

**Miep Benz:** Guido's wife

**Peter Goldschmidt:** Manuel's brother, often at Gisèle's home during the occupation

**Quappi von Kaulbach:** Sculptor; Max Beckman's wife

**Reinout van Rossum du Chattel:** Often at Gisèle's home during the occupation

**Silvia Nicolas:** Sculptor and stained-glass artist; Joep's daughter

**Simon van Keulen:** Friend who often went to Gisèle's home during the occupation. Simon escaped transport to a concentration camp by jumping from the train, as Gisèle told him to do.

**Stefan George:** German poet greatly admired by Wolfgang

**Suzanne Nicolas:** Sculptor Joep's wife

**Sven Schacht:** Wolfgang's friend who was murdered by the Nazis

**Vincent Weyand:** He helped Jews to find refuge. He often went to Gisèle's home during the occupation.

**Wolfgang Frommel:** Gisèle's friend who lived in her home during the occupation. Later, he was the founding director of *Castrum Peregrini*.

## PLACES AND ORGANIZATIONS

*Agios Ioannis:* The monastery on the Greek island of Paros where Gisèle and Arnold lived together; after his death she continued to spend time there for seventeen years.

**Amstel River:** A river in the Netherlands that runs through the city of Amsterdam.

**Atlantic Wall:** An extensive system of coastal fortifications built by the Nazis between 1942 and 1945 along the coast of continental Europe and Scandinavia.

**Auschwitz:** A network of German concentration/extermination camps.

**Beverwijk:** Location of the cemetery where Gisèle's parents are buried.

**Begijnhof Chapel:** A church in downtown Amsterdam where a large collection of Gisèle's stained-glass windows can be seen.

**Bussum:** A town that lies about a half-hour's distance by train from Amsterdam.

*Castrum Peregrini:* The code words used to gain access to Gisèle's home during the occupation. After WWII, Wolfgang started a foundation to promote German culture and literature, and a magazine; both are called *Castrum Peregrini*.

**Jonas Daniël Meijer Square:** Jews were gathered here prior to being transported to concentration camps.

**De Krijtberg:** Gisèle's church in Amsterdam

**De Stompe Toren:** The name of the church near the cemetery where Gisèle and other members of the *Castrum Peregrini* circle are buried.

**Delft:** A city in the Netherlands famous for its fine quality blue and white china. The

churches there contain many painted glass widows by Joep Nicolas.

**De Uil:** "The Owl," the weavers' studio set up by Gisèle and Joke

**De Zonnebloem:** "The Sunflower," an artist's home and studio in Bergen

**Eerde Castle, Ommen:** The building where an international school run by Quakers was housed

**Hainfeld:** Gisèle's maternal ancestral home in Styria, southern Austria

**Hantberg Castle:** Aunt Paula's property that Gisèle and her brothers inherited

**Hampstead:** The district of London where Gisèle had a studio for a short while

**Herengracht 280:** Gisèle's paternal ancestral home in Amsterdam

**Herengracht 401:** Gisèle's home in Amsterdam

**Het Cuyperhuis:** The city museum in Roermond

**Holland America Line:** The Netherlands' premier shipping and passenger line

**IJ Bay:** The IJ is actually a "former bay." Today, it is known as Amsterdam's waterfront.

**Jachtduin:** The house in Bergen that Gisèle's family rented after they were evicted from their home in Wijlre.

**Leeuwen-Maasniel:** The town near Bergen where Gisèle had a studio.

**Mauthausen Camp:** Nazi concentration camp in upper Austria

**Munsterkerk:** The church in Roermond where some of Gisèle's windows can be seen

**Prinsengrachtziekenhuis:** The hospital on the Prinsengracht

**Rotterdam:** In 1940, this important Dutch port was air bombed by the Nazis, leading to the Netherlands' surrender.

**Royal Dutch Shell Company:** The Netherlands' most important petroleum company

**Staatsmijnen:** The Dutch Mining Bureau

**Stichting Memoriaal:** Private literary foundation with its own newsletter

**Vught:** Transit/Concentration camp in the Netherlands during the occupation

**Westerbork Transit Camp:** The camp about 15 km from a village of the same name

## NON-ENGLISH WORDS AND EXPRESSIONS

***Bundesverdienstkreuz:*** A federal cross of merit given by Germany to people of great valor.

***Carpe Diem* ("Seize the day—put away your fear"):** The Dutch consider this their motto.

***Hongerwinter:*** Winter 1944 to spring 1945, a period of famine in the Netherlands.

***Landerziehungsheim* ("An educational home in the countryside"):** a German concept for the education of young people

***Nacht und Nebel* ("Night and Fog"):** the Nazi rule of terror

***Officierskruis met de zwaarden van de Orde van Oranje-Nassau:*** Officer's Cross of the Order of Orange Nassau

***Razzia:*** Nazi lightning raids

***Yad Vashem:*** The official authority in Israel for the commemoration of the Holocaust and its victims

# ACKNOWLEDGEMENTS

The writing of this book has involved an international cast; so many generous people have lent me their support.

First of all, I thank my family. My husband, Jorge Rosado, read umpteen chapter drafts, brewed hundreds of pots of coffee for me, and kept his patience while I plucked away on the keyboard at all hours of the day and night. My son, Carlos, lent his IT skills and my daughter, Maggie, helped me proofread the manuscript.

Without access to Gisèle's archive, I would not have been able to continue telling her story if not for the assistance of my aunt's circle of friends who live in the Netherlands. Diego Semprun Nicolas, Jan Stam, Joke Haverkorn van Rijsewijk, Marianne Stern, and Walther van der Does de Willebois met with me, confirmed information, and offered insight—Henk Hoedemaker offered this, and his hospitality as well. Each time I went to Amsterdam, Leo van Santen answered my questions, and later, he continued to help me via email.

My home is in Mexico, and luckily I have three Dutch-speaking friends here. Erik Slebos, Ed Buss, and Ypke van der Haring offered their knowledge and corrected my atrocious Dutch spelling. Writing colleagues—Marianne Kehoe, Linda Lindholm, Rainie Baillie, and Michael Schuessler—shared their time and expertise

throughout the whole writing process.

My portrait was taken by Colleen Casey Leonard, a well-known photographer living in Merida.

In Canada, Hanneke Siewe-Corbet and Barbara van der Gracht checked details and made suggestions. Both of these women also spent time with me in the Netherlands. Longtime readers, my other siblings, aunts, and uncles clarified points of view. My cousin, Pat Maddox, provided me with invaluable family memorabilia that enhanced my research.

Manuel Ontiveros Chan, my art teacher; and graphic designer Juan Adiel Yam Hidalgo have my deep appreciation for digitalizing my sketches and the photographs included in the book. I value the contribution of the Roermond Foundation 1880. They allowed me to include the photograph of Joep Nicolas' portrait of Gisèle, taken by Hennie Reter. The Nicolas family provided me with the image of Joep and anecdotes about Gisèle.

After six years, I finally handed my writing to Eileen Fischer and Lee Steele of Hamaca Press. They turned my manuscript into the book you're reading—I owe both of them so many thanks.

My husband often says, "Reminiscing about the past helps us appreciate the present."

Aunt Gisèle and my father, John, shared their story with me, and I learned to value my heritage. For that blessing, my final thank you is for them.

Photo by Colleen Casey Leonard

## ABOUT THE AUTHOR

While Joanna van der Gracht de Rosado's most recent book, *Circles*, is set primarily in the Netherlands, she has written two books about cultural adaptation to life in Mexico, and a novel that showcases Yucatan and Mexico City. Additionally, Joanna has contributed to short story anthologies, and she blogs at www.writingfrommerida.com

As a child growing up in North Vancouver, BC, Canada, she loved listening to her grandfather's tales about his Dutch boyhood and his geological explorations to faraway lands. At an early age, she made up her mind to travel as much as she could.

Joanna taught English in Peru and trekked through South America. She visited Europe, and saw still more of the world while working for a Canadian airline. She met her husband, Jorge Rosado, in Merida, Yucatan, Mexico—where they made their home, and raised their family.

For more on the author, visit:
**hamacapress.com/jvdg**

Printed in Great Britain
by Amazon

43492460R00111